The

WORLD'S WORSTS

A **COMPENDIUM** OF THE
**MOST RIDICULOUS FEATS, FACTS,
& FOOLS** OF **ALL TIME**

LES KRANTZ AND SUE SVEUM

HarperResource
An Imprint of HarperCollins*Publishers*

HarperCollins books may be purchased for educational, business, or sales promotional use. For information please write: Special Markets Department, HarperCollins Publishers, Inc., 10 East 53rd Street, New York, NY 10022.

CONTRIBUTING WRITERS:
Tim Knight
Kristin Todd

FIRST EDITION

Designed by Renato Stanisic

Library of Congress Cataloging-in-Publication Data

ISBN 0-06-077652-8

05 06 07 08 09 WBC/QW 10 9 8 7 6 5 4 3 2 1

**TO DADDY MAXWELL'S ARCTIC CIRCLE DINER, WHERE
PHILOSOPHERS, ROMEOS, ANGELS, AND I MEET TO
EAT, AND WHERE I THOUGHT THIS THING UP AT
TABLE NUMBER EIGHT.**

—Les Krantz

SPECIAL ACKNOWLEDGMENT:
We are especially grateful to our contributing writers, Tim Knight and
Kristin Todd. Tim, who also served as our manuscript editor, injected
such intelligence and depth into our text. Kris, you made us laugh and
still do, every time we read the text you contributed. Your sense of hu-
mor was a marvelous asset. Our editor at HarperCollins, Matthew Ben-
jamin was a pleasure to work with and helped make this a better book
in every way imaginable. Other folks at our publisher's office, namely
Ryu Spaeth and Steve Hanselman, we also thank you for your involve-
ment and support.

Contents

CONTENTS

3
THINGS 153

CONTENTS

Introduction

There's not much good news these days. There's a war going on, the country is divided on the most important issues of the day, and the economy is not great. With all the grief we have to endure, sometimes it helps to learn that there are some worse predicaments we could be in. This is what our book is really all about: how bad things can get, and often do. We document it with examples of the best—I guess I really mean the worst—sordid feats, first-rate flops, and the last-place finishes.

My coauthor Sue Sveum and I spent the better part of a year finding them. Among other things, we combed libraries, culling the most demoralizing historical events we could find. The daily newspapers were another source of "inspiration," since they are fabulous repositories of today's most depressing news. We also looked beyond the celebrity façade of famous individuals, discovering some had pretty dubious achievements in their past. What a wonderful surprise it was to learn that so many of them are misfits and malcontents, just like the rest of us.

Take General Manuel "the Pineapple" Noriega for example, one of the worst generals of all time. Remember him, the pockmarked head of state in Panama? When he was defending his nation against the American invasion of 1989, he hid in the Vatican embassy. Within hours of the troops landing, he was on the phone negotiating surrender. He was caught and tried (on drug charges), and he's still in the slammer. Read about him here. It'll make you feel good to know what a better guy you are than him.

People aside, there's inanimate stuff that can also lighten your mood. Take eel-flavored ice cream, or the Yugo (the worst car ever made), or spam from Nigerian conmen. Or have you heard about the golf course in South Africa with 15-foot crocodiles running about? Do you know what the dumbest dogs are? Now you can look it up, right here in this book.

You get the gist. In this life where everyone stumbles now and then, some of us need a little assurance that there are people, places, and things worse off than us. Isn't that a relief!

—Les Krantz

1

People

ACADEMY AWARDS
Most Prominent "Losers"

In 2002 the Motion Picture Academy finally righted a wrong and gave Peter O'Toole an honorary Oscar for his body of work. Along with the late Richard Burton, O'Toole shares the dubious honor of being the most-nominated loser in the acting categories, with seven nominations apiece.

Many of the all-time greats in cinema remain Oscar also-rans, like Greta Garbo, Cary Grant, and Edward G. Robinson, to name just three of the more notable oversights. That said, winning an Oscar doesn't always guarantee lasting fame or decent roles. In the 1930s, Luise Rainer won back-to-back Oscars, but her career effectively ended shortly thereafter, giving rise to the Hollywood legend of an Oscar curse.

Curse or no curse, here are the actors who've racked up the most nominations without ever getting the chance to clasp the gold statuette and thank the Academy through grateful tears:

1. Richard Burton: 7 nominations
2. Peter O'Toole: 7 nominations
3. Deborah Kerr: 6 nominations
4. Thelma Ritter: 6 nominations
5. Glenn Close: 5 nominations
6. Irene Dunne: 5 nominations
7. Albert Finney: 5 nominations
8. Arthur Kennedy: 5 nominations

And the following 10 actors have each received 4 nominations: Jane Alexander, Warren Beatty, Charles Boyer, Montgomery Clift, Greta Garbo, Marsha Mason, Claude Rains, Mickey Rooney, Rosalind Russell, and Barbara Stanwyck.

ATHLETIC PERFORMANCES
So Bad It Was Good

All athletes have their ups and downs. No matter how successful they are, there is always the occasional bump in the road. For some it's a bad day, for others it's a bad season. For a few, it's their claim to fame.

Olympic athletes often attract positive attention when they finish last. They are seen as the underdogs, the brave hearts who dare to try, the ones the world is cheering for. Who can forget the Jamaican bobsled team and their spectacular rise to movie fame?

Here is a ranking of record-setting performances and the athletes who might like to forget them:

1. EDDIE "THE EAGLE" EDWARDS, OLYMPIC SKI JUMPING

1988: The first and only Olympic ski jumper from Great Britain, The Eagle finished in 57th place, second from last. The 58th finisher would have beaten him, but was disqualified.

2. BRUCE "THE MOUSE" STRAUSS, BOXING

1970s: The Mouse lost nearly 200 of his 250 boxing matches. He was knocked out on every continent, one time twice in the same night, under two different names.

3. ANGELO SPAGNOLA, GOLF

Won the "Worst Prize" in his Florida club's Avid Golfer Contest by shooting a 66 . . . on one hole, the infamous 17th, at Jacksonville's TPC at Sawgrass. On the 12th green, he shouted to a heckler that he'd give up his new Mercedes just to get a triple-bogey. His 18-hole score: 257.

4. JOE SULLIVAN, BASEBALL

1893: While 4 or 5 errors a season is acceptable, some players keep their jobs with a dozen or more. The Washington Senators' Sullivan, however, committed 106 errors in one season, a record that still stands more than 100 years later. It was rumored fans came to the ballgame as much to watch Joe drop the ball as they did to see the game. That year the Senators set an attendance record.

5. KERRY COLLINS, AMERICAN FOOTBALL

2001: This New York Giants quarterback holds the title for the most fumbles in one season. He

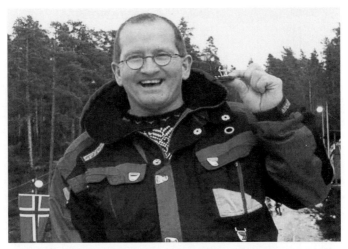

Eddie "The Eagle" became Eddie the celebrity when the Olympics were over. His qualifications for the British Olympic ski jumping team? No one else applied. He finished in 57th place (second from last)—the 58th finisher would have beaten him, but was disqualified.

had 23. The average number in the NFL is between 2 and 3.

6. JAMAICAN BOBSLED TEAM

1988: The first Winter Olympics entry for this tropical island, the team was unable to practice on ice due to the tropical climate at home. Their grit and determination made them a crowd favorite. Their skills and training, however, delivered no better than a last-place finish, but garnered a 1993 Disney movie about them, the smash hit *Cool Runnings*.

7. DAVE SCHULTZ, HOCKEY

1974: One of the "Broad Street Bullies" of the Philadelphia Flyers, Schultz was know as "The Hammer" by his fans. Living up to his image, he set a record for most penalty minutes, 472 in one season.

8. ERIC "THE EEL" MOUSSAMBANI, OLYMPIC SWIMMING

2001: One of the few athletes ever to represent Equatorial Guinea at the Olympic games, "The Eel" swam the 100-meter freestyle race

in 1:52.07, a full minute slower than the world record. He finished last.

9. ANTHONY YOUNG, BASEBALL
1993: This pitcher set a major league record of 0-27 while with the New York Mets in 1993. Traded to the Cubs in spring 1994, he won his next two starts.

10. MARIO MENDOZA, BASEBALL
1974–82: While playing for three major league teams, this infielder had a consistently low batting average (around .200) that became known as "the Mendoza Line," a statistical mark to avoid.

AUTHORS
The Most Boring Writers

Although most academics hail Fyodor Dostoevsky as one of the all-time literary greats, the Russian novelist's gloomy fiction left vitriolic critic H. L. Mencken ice cold. Never one to pass up an opportunity to topple sacred cows, the writer known as the "Bard of Baltimore" listed Dostoevsky as one of the literature's ten most boring authors.

Such pronouncements are vintage Mencken. During a career that spanned nearly 60 years, Mencken took aim and fired at everything from politics to religion with gleeful nastiness. While he occasionally praised writers such as Theodore Dreiser and Sinclair Lewis, he panned American icons like Hemingway and Faulkner. But at least Mencken spared them the indignity of being listed with the following most boring authors (listed in alphabetical order), whose ranks include two Nobel Prize winners for literature:

1. Bjornstjerne Bjornson—Norwegian poet. Winner of the 1903 Nobel Prize in literature.

2. Robert Browning—English poet/playwright best known for *Dramatis Personae*.

3. James Fenimore Cooper—American novelist best known for *Last of the Mohicans*.

4. Fyodor Dostoevsky—Russian existentialist novelist whose books include *Crime and*

Punishment and *The Brothers Karamazov.*

5. George Eliot—English novelist whose novels include *Middlemarch* and *Silas Marner.*

6. Johann Wolfgang von Goethe—German writer/poet/scientist/humanist whose works include the epic poem *Faust.*

7. Selma Lagerlof—Swedish novelist. Winner of the 1909 Nobel Prize in literature.

8. D. H. Lawrence—British novelist whose books include *Sons and Lovers* and *Lady Chatterley's Lover.*

9. Eden Phillpotts—British novelist and poet who wrote extensively about the Dartmoor region in the county of Devon.

10. Gertrude Stein—avant-garde American writer/poet probably

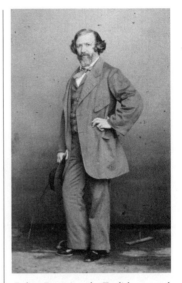

Robert Browning, the English poet and playwright best known for Dramatis Personae, *is among the top-10 most boring writers of all time.*

best known for her Paris salons and enduring partnership with Alice B. Toklas.

BASEBALL PITCHERS
Most-Losing Major League Hurlers

One of the true giants of American baseball, Hall of Fame player Denton True "Cy" Young won 511 games during his career—more than any other player in the sport's history. Young's legendary brilliance on the mound led to the creation of the Cy Young Award, given annually since 1956 to the best pitcher.

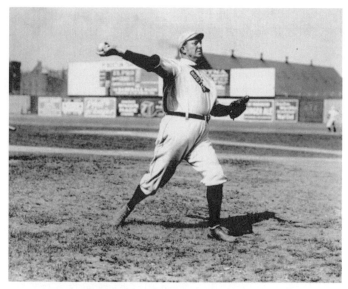

American baseball Hall of Fame player Denton True "Cy" Young holds the record among major league pitchers for the most games lost, 316.

For all his achievements, however, Young also heads the list of pitchers who've *lost* the most games in the sport's history—a whopping 316, to be exact. Of course, he's in very good company, since the following list of 10 "losers," ranked in terms of most defeats, includes no less than 8 pitchers in the National Baseball Hall of Fame (asterisks):

Pitcher	Losses	Pitcher	Losses
1. Cy Young	316★	6. Gaylord Perry	265★
2. Pud Galvin	308★	7. Don Sutton	256★
3. Nolan Ryan	292★	8. Jack Powell	254
4. Walter Johnson	279★	9. Eppa Rixey	251★
5. Phil Niekro	274★	10. Bert Blyleven	250

BASKETBALL BAD BOYS
Most Personal Fouls in the NBA

During his stellar, 20-year career in the NBA, the 7-foot 2-inch Basketball Hall of Fame inductee Kareem Abdul-Jabbar set some astonishing records for the game. No other player in the NBA has logged more minutes on the court (57,446), scored more points (38,387) or made more field goals (15,837). Named the NBA's Most Valuable Player six times, the basketball legend also tops another, less trophy-worthy list: the NBA player who's racked up the most personal fouls over the course of his career. However, it's unlikely that Jabbar will retain first place on the list much longer, given Karl Malone's hyper-aggressive brand of play. In 2001, readers in a *USA Today* poll named Malone the "dirtiest player" in the NBA in dubious tribute to some of the stunts he's pulled on the court. But

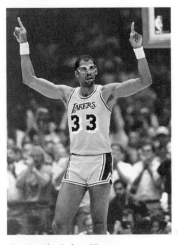

Los Angeles Lakers Kareem Abdul-Jabbar set many NBA records, including the most personal fouls: 4,657.

for now, Malone must settle for second place on the following list of basketball players with the most personal fouls as of 2004:

Player	Personal Fouls
1. Kareem Abdul-Jabbar	4,657
2. Karl Malone	4,462
3. Robert Parish	4,443
4. Charles Oakley	4,413
5. Hakeem Olajuwon	4,383
6. Buck Williams	4,267
7. Elvin Hayes	4,193
8. Otis Thorpe	4,146
9. Kevin Willis	4,047
10. James Edwards	4,042

BRITISH MONARCHY REIGNS
The Shortest-Time Rulers of Great Britain

On the British throne 52 years and counting, Queen Elizabeth II shows no signs of stepping down anytime soon to let Prince Charles become king. If she can hold out to 2015, she'll beat Queen Victoria's record of 63 years as the longest-reigning British monarch in history. Poor old Charles will probably have to forcibly pry that royal scepter from Mummy's hands if he's ever going to fulfill his royal destiny without benefit of a walker! Back in the day of court intrigue and Byzantine plots to take the throne, British monarchs had a difficult time holding onto their day jobs. For every Queen Elizabeth II or Queen Victoria, there were kings and queens who barely had time to try on the crown before they were gone, either by assassination or choice, as in the case of Edward VIII, aka The Duke of Windsor, who famously gave up being king to marry American divorcée Wallis Simpson in 1936.

Queen Jane? If you don't remember this British monarch, it may be because she lasted just nine days, the shortest reign in British history.

Here are the ten British monarchs who reigned briefest:

Monarch	Date(s)	Length of Reign
1. Jane	1553	9 days
2. Edward V	1483	75 days
3. Edward VIII	1936	325 days
4. Richard III	1483–85	2 years
5. James II	1685–88	3 years
6. Mary I	1553–58	5 years
7. Mary II	1689–94	5 years
8. Edward VI	1547–53	6 years
9. William IV	1830–37	7 years
10. Edward VII	1901–10	9 years

CELEBRITY ATTIRE
The Worst Duds

According to the nasty Mr. Blackwell, self-appointed chief of world fashion police, Cameron Diaz "looks like she was dressed by a color-blind circus clown." Think that's harsh? The giggly actress gets off easy compared to fashion designer Donatella Versace, whom Blackwell lambasts as a "flash-fried Venus, stuck in a Miami strip mall." Me-ouch!

Since 1960, Mr. Blackwell (real name: Richard Seltzer) has been spewing his special brand of vitriol at celebrities who commit unpardonable fashion faux pas. That inaugural year, he took aim and fired at Lucille Ball, Brigitte Bardot, and Shelley Winters, among other unfortunates. Since then, he has tossed off bitchy quips at everyone from quirky trendsetter Diane Keaton ("Dowdy, dumpy and frumpy!") to cross-dressing basketball star Dennis Rodman ("In fishnet and feathers, he's a unisex mess."). Whether you agree or disagree with his withering assessments of celebrities' wardrobe choices, Mr. Blackwell never fails to ruffle more than a few feathers—even if feathers are so over as a fashion accessory!

Here are the celebrities who had the dubious honor of topping Mr. Blackwell's annual Worst Dressed list for the last ten years:

1. CAMILLA PARKER-BOWLES, 1994

"Packs the stylistic punch of a dilapidated Yorkshire pudding!"

2. HOWARD STERN, 1995

"Your Miss America looks like Godzilla impersonating Gypsy Rose Lee."

3. DENNIS RODMAN, 1996

"In fishnet and feathers, he's a unisex wreck."

4. THE SPICE GIRLS, 1997

"They are the only spices on the planet that have no taste."

5. LINDA TRIPP, 1998

"A shaggy sheep dog in drag."

6. CHER, 1999

"A million beads and one overexposed derriere."

7. BRITNEY SPEARS, 2000

"Her bra-topped collection of Madonna rejects are pure fashion overkill!"

8. ANNE ROBINSON, 2001

"Looks like Harry Potter in drag. A Hogwarts horror!"

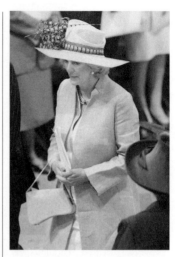

Camilla Parker-Bowles, Prince Charles's wife, is seen at Westminster Abbey in London in her usual dreadful attire, firmly establishing her place at the top of the worst-dressed list.

9. ANNA NICOLE SMITH, 2002

"Don't bother with a new designer, Anna, just hire a structural engineer."

10. PARIS HILTON, 2003

"Grab the blinders, here comes Paris. From cyber disgrace to red carpet chills—she's the vapid Venus of Beverly Hills!"

CELEBRITY FALLS FROM GRACE
PR *Nightmares Personified*

Lately, it seems rock singer/actress Courtney Love has spent more time in the courtroom than the recording studio. The grunge rock icon and full-time bad girl's constant legal troubles have become a tabloid staple, right up there with Elvis sightings and alien babies. While Love has become the poster child for celebrity bad behavior, she's hardly alone in her legal woes, as the following alphabetical list of celebrities who've fallen from grace indicates:

1. KOBE BRYANT

Charismatic, articulate, and handsome, LA Laker phenom Bryant seemed to have it all—until a 19-year-old girl accused him of raping her in a Colorado hotel room in 2003. He admitted to adultery, but claimed the sex was consensual. The "he said, she said" case was dismissed after the accuser decided she was unwilling to take the stand.

2. ALLEN IVERSON

In the battle of basketball bad boys, Allen Iverson caused a stir off the court when he was charged with 14 offenses in 2002 after storming into an apartment building looking for his wife. He faced 65 years in jail if found guilty, but two key witnesses refused to testify and all charges were dropped.

3. BEN JOHNSON

The Canadian track and field star set a world record in the 100 me-ters, winning gold for his country in the 1988 Summer Olympics. After he tested positive for steroids, Johnson was stripped of his gold medal and banned from the sport for life.

4. R. KELLY

R & B singer R. Kelly went from singing for his supper to singing the blues when he was charged with 12 counts of child pornography in 2002. He had several prior brushes with the law—for his brushes with young girls. Although his taste in women tends to run to jailbait, at least he believed in matrimony. He married fellow singer Aaliyah when she was still the tender age of 15.

5. GEORGE O'LEARY

Appointed to the dream job of head football coach at Notre Dame in 2004, O'Leary lost his job with dizzying speed after it was discovered that he did not

have a masters degree from NYU or three football letters from New Hampshire as he claimed. He may have been a good coach, but he didn't learn the game on the field. In fact, he didn't play a single game in college.

6. PETE ROSE

If you were a betting person, would you put your money on Pete Rose getting into the Baseball Hall of Fame? One of the best ballplayers in the history of the game, Rose fell from grace when he was accused of betting on his own team. For years he denied the charges, but he has recently confessed and asked for forgiveness.

7. WINONA RYDER

Was it a desperate need to match a new purse to her pumps that prompted Winona Ryder to shoplift more than $5,000 worth of merchandise from Saks Fifth Avenue? Or was it the thrill of the adventure? Whatever the reason, Ryder was convicted in 2003 and sentenced to three years probation and a fine of $10,000.

8. O. J. SIMPSON

Football great turned Hertz Rent-A-Car pitchman, O. J. Simpson became a pariah after he was arrested for the murder of his ex-wife and her friend. Although found innocent by a jury of his peers, O. J. was convicted by the jury of public opinion.

9. MARTHA STEWART

In 2003 the domestic diva's tastefully decorated world collapsed when she was accused of conspiracy and obstruction of justice in an insider stock trading case. Convicted in 2004, the queen of gracious living was sentenced to five months in prison.

10. MIKE TYSON

The heavyweight champion had the world by the tail. Then he was convicted of rape, and everything fell apart. Wife Robin Givens admitted she was afraid of him and they divorced. Oh yeah—and he bit off a portion of his opponent Evander Holyfield's ear during a boxing match. Hmm. What do you think he'll be most remembered for?

CELEBRITY MARRIAGES
Short Stuff, from Altar to Falter

While a celebrity's performance endures for eternity once it is caught on film or videotape, many of their marriages have a considerably shorter duration. Falling in love is easy in the fantasy world of Hollywood, but the pressures of stardom and the pressures of marriage are not a match made in heaven. Here's a few less-than-heavenly matches, ranked by duration, that looked so promising at first, but a month or two later . . . make that a day or two later . . .

1. ROBIN GIVENS AND SVETOZAR MARINKOVIC, 1 DAY

Always attracted to athletes, the actress's marriage to her tennis coach lasted a day. A 1988 marriage with boxer Mike Tyson lasted 11 months.

2. BRITNEY SPEARS AND JASON A. ALEXANDER, 55 HOURS

Carried away by the glitz and glamour of Las Vegas, these childhood friends said their wedding vows and agreed to an annulment just over 2 days later.

3. CARMEN ELECTRA AND DENNIS RODMAN, 9 DAYS

A $75 Las Vegas wedding in 1998 couldn't buy happiness for the *Baywatch* sexpot and the cross-dressing basketball star, who called it quits after nine days.

4. DREW BARRYMORE AND JEREMY THOMAS, 19 DAYS

Barrymore learned a lot about

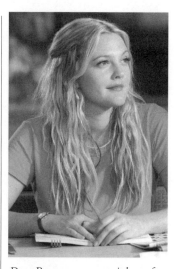

Drew Barrymore was married once for 19 days and another time for 5 months, which earned her two spots on the list of celebrity marriages with the shortest durations.

choosing a mate. Her next marriage after this 19-day affair was a marathon, comparatively speaking (see # 8).

5. R. KELLY AND AALIYAH, 3 MONTHS

The singers made sweet music for just three months in 1994 before the courts discovered that Aaliyah lied about her age on the marriage certificate. She was 15.

6. LISA MARIE PRESLEY AND NICOLAS CAGE, 3½ MONTHS

Saying the 2001 marriage was a "big mistake," the pair split. Compared to Presley's 1994 marriage to Michael Jackson, it still looked like a match made in heaven. That bizarre union lasted a whopping 20 months.

7. COLIN FARRELL AND AMELIA WARNER, 4 MONTHS

Instead of a ring, Farrell ended the 2001 ceremony by getting his bride's name tattooed on his finger. Four months later, he was investigating dermatologists who specialize in tattoo removal.

8. DREW BARRYMORE AND TOM GREEN, 5 MONTHS

This 2001 union marks Barrymore's second entry on this list and was a record for her. Her previous marriage to Jeremy Thomas lasted only 19 days.

9. SHANNEN DOHERTY AND ASHLEY HAMILTON, 5 MONTHS

Short marriages are the norm for these two love zealots, whose 1993 union lasted only 5 months. Doherty moved on to a 9-month marriage to Rick Salomon.

10. JENNIFER LOPEZ AND CRIS JUDD, 10 MONTHS

Known for her short relationships, Lopez lasted 10 months with Judd in 2001. Before that, she lasted 13 months with first husband Ojani Noa, and never actually made it to the alter with fiancé Ben Affleck.

10. JIM CARREY AND LAUREN HOLLY, 10 MONTHS

Already fighting before the 1996 ceremony, Carrey says he and his bride should never have said "I do." It took only 10 months for them to say "I don't."

CELEBRITY PHOBIAS
Oddest Fears of the Scared and Famous

When it comes to irrational fears and anxieties, F. Scott Fitzgerald was right: "The rich are different from you and me." Take Billy Bob Thornton—the Oscar-winning actor/writer/director is a walking compendium of strange phobias. In addition to suffering from chromophobia—the fear of bright colors—Thornton admits that antiques give him the willies! And you thought Woody Allen was a basket case!

Today, in this age of full disclosure, celebrities think nothing of sharing their innermost fears and anxieties with the media. Here are ten celebrities, listed in alphabetical order, in the grip of unusual or little-known phobias, as reported by Buck Wolf at ABCNews.com:

1. WOODY ALLEN
Cinema's reigning urban neurotic claims he fears just about everything, but he may really have anhedonia, which is the inability to feel pleasure.

2. DAVID BECKHAM
The British soccer superstar suffers from ataxophobia, or the fear of disorder. Everything is color coordinated in his closets and arranged just so.

3. SID CAESAR
The comic struggles with tonsurphobia: a fear of haircuts.

4. JOHNNY DEPP
Clowns strike fear in the heart of the movie star, who suffers from clourophobia.

5. DAVID GEST
Afflicted with phonophobia, Liza Minnelli's ex-husband/record producer dreads the sound of the phone ringing.

6. ALFRED HITCHCOCK
The Master of Suspense reportedly couldn't stand to see or eat eggs. His malady? Ovophobia.

7. LYLE LOVETT
The lanky country singer/actor is said to fear cows.

8. ELLE MCPHERSON
The Australian supermodel/*Sports Illustrated* swimsuit model is terrified of radiation in the skies. When flying, she wraps her newborn in a lead-lined coat to protect him from deadly rays.

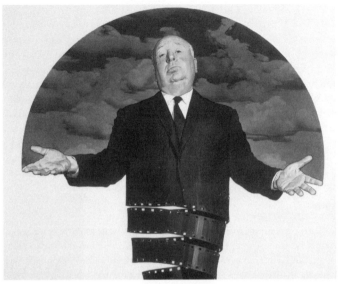

Alfred Hitchcock, an ovophobia sufferer, had all the classic symptoms of this rare and obviously quirky phobia—he couldn't stand to see or eat eggs—earning him a place on the list of the oddest fears of the scared and famous.

9. ROGER MOORE
Firing a gun leaves the former James Bond star shaken and stirred.

10. CHRISTINA RICCI
Houseplants unnerve the actress, who also worries that sharks will attack her through a secret hole in a swimming pool.

CELEBRITY SUICIDES
"I am leaving you because I am bored."

An Oscar-winning actor whose autobiography was entitled *Memoirs of a Professional Cad*, George Saunders exuded world-weary sophistication in all of his movies—even *The Jungle Book*, in which he provided the voice of the evil tiger Shere Khan. So when he committed suicide in

1972 by swallowing a bottle of pills, few were surprised by the note he left behind: "Dear World, I am leaving you because I am bored."

By overdosing on barbiturates, Saunders chose a relatively civilized way to end it all, particularly in comparison to the methods chosen by the following celebrities. Here, in alphabetical order, are ten celebrities who committed suicide under bizarre and unsettling circumstances. Not included is Marilyn Monroe, whose death was never officially deemed to be by suicide, although there are suspicions she took her own life.

1. CLARA BLANDICK
Best known for playing Auntie Em in *The Wizard of Oz*, Blandick later swallowed sleeping pills and tied a plastic bag over her head.

2. ALBERT DEKKER
A character actor and outspoken critic of Joseph McCarthy, Dekker was found dead with a noose around his neck, hypodermic needles in each arm, and obscenities scribbled in lipstick across his torso. It was ruled a suicide, but some questions persist.

3. PEG ENTWISTLE
A struggling actress in 1930s-era Hollywood, Entwistle leapt to her death from the "H" on the giant "Hollywood" sign.

4. ELIZABETH HARTMAN
In an eerie case of life imitating art, the actress jumped to her death, just like the character she portrayed in the 1966 film *The Group*.

5. MARGAUX HEMINGWAY
On the 35th anniversary of her grandfather Ernest Hemingway's suicide, the actress/model took an overdose of sleeping pills.

6. MICHAEL HUTCHENCE
The lead singer of the popular Australian rock group INXS hung himself with his belt in his hotel room.

7. TERRY KATH
A member of the band Chicago, Kath killed himself playing Russian roulette.

8. FLORENCE LAWRENCE
The first movie star of the American silent screen, Lawrence took a fatal dose of poison in her Beverly Hills home.

9. FREDDIE PRINZE
At the height of his fame in the hit sitcom *Chico & The Man*, the profoundly depressed actor shot himself in the head.

10. GIG YOUNG
Three weeks after getting married to a much younger woman, Young shot his wife to death and then turned the gun on himself.

DEATH BY DRINK
Alcohol-Related Celebrity Deaths

When he died at 39 from alcohol poisoning, Welsh poet Dylan Thomas most certainly did "not go gentle into that good night," to quote one of his most famous lines. He was merely adding his name to the voluminous list of writers, artists, musicians, actors, and dancers who've literally drunk themselves to death over the years. For rock stars especially, to crash and burn in an alcoholic haze is like some perverse rite of passage. Here are ten celebrities, listed alphabetically, who died from alcohol-related causes:

1. Jon Bonham, drummer, Led Zeppelin
2. Truman Capote, novelist/essayist
3. Alexander Godunov, ballet dancer/actor
4. Lorenz Hart, lyricist
5. Billie Holiday, jazz singer
6. William Holden, Oscar-winning actor
7. Jack Kerouac, beat novelist
8. Edgar Allan Poe, writer/poet
9. Dylan Thomas, poet/novelist
10. Dennis Wilson, musician, The Beach Boys

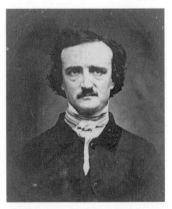

EDGAR ALLAN POE 1809–1849

A famous drunk, and dead by his 40th year, 19th century poet and writer Edgar Allan Poe is among a stellar list of artists and writers who died by drink.

DICTATORS TODAY
Biggest Bullies and Butchers

Except for die-hard Baathist loyalists and government cronies on the take, most Iraqis celebrated the end of Saddam Hussein's brutal reign of terror, which had begun in a bloody purge of political enemies in 1979. Over the next 25 years, Hussein gassed, tortured, and murdered thousands to consolidate his power, all the while proclaiming that he was leading his terrified subjects on to greater glory.

Hussein's delusions of grandeur crashed and burned with the arrival of U.S.-led forces in Iraq in March of 2003. No longer the swaggering tyrant, he is now just another war criminal like Serbia's Slobodan Milosevic, aka "The Butcher of the Balkans." But for every brutal dictator overthrown or assassinated, scores more wield absolute dominion over millions of oppressed people worldwide. In 2004, writer David Wallenchinsky compiled a list of the 10 worst living dictators for *Parade* magazine. Here are his choices, which he ranked with the assistance of human-rights organizations such as Amnesty International and Reporters Without Borders:

1. KIM JONG II OF NORTH KOREA

Under his decade-long rule, North Korea continues to be the most repressive regime in the world. Many North Koreans are starving while Kim Jong II spends billions to develop his country's nuclear weapons program.

2. THAN SHWE OF BURMA

A shadowy figure who flies under the radar, General Than Shwe is a hard-line military dictator whose forces include more child soldiers than anywhere else in the world. Under his rule, Nobel Peace Prize–winner Aung San Suu Kyi has been under house arrest for most of the past fourteen years.

3. HU JINTAO OF CHINA

Although China has emerged as an economic powerhouse in recent years, Jintao maintains rigid control over the country's media and strictly monitors Internet use. Nearly half a million Chinese serve "re-education" sentences in harsh labor camps.

4. ROBERT MUGABE OF ZIMBABWE

Elected prime minister of Zimbabwe in 1980, Mugabe stops at nothing to maintain his power. An

estimated 70,000 people have been killed, tortured, or displaced since he took office. In recent years, he's taken farms owned by whites and given them to his supporters.

5. CROWN PRINCE ABDULLAH OF SAUDI ARABIA

Saudi women are virtual chattel under Crown Prince Abdullah, who's been the oil-rich country's ruler since 1995. In addition to being denied the right to vote, women cannot testify in divorce proceedings. Torture is quite common in Saudi Arabia, where many get arrested without rhyme or reason.

6. TEODORO OBIANG NGUEMA OF EQUATORIAL GUINEA

Sitting atop vast oil reserves, Nguema pockets most of the money pouring into his country while 60 percent of the people live in miserable poverty. Believing himself divine, Nguema ordered the state-controlled radio to announce that he can kill anyone he wants without fear of eternal damnation.

7. OMAR AL-BASHIR OF SUDAN

Since seizing power in a military coup in 1989, Al-Bashir has disbanded the Sudanese government and presides alone over this civil-war-torn country. While millions die, Al-Bashir extends sanctuary to terrorists. He also bombs non-Muslims and induces famine to undermine opposition to his regime.

8. SAPARMURAT NIYAZOV OF TURKMENISTAN

You can't turn around in Turkmenistan without seeing the flattering likeness of Niyazov in statues, billboards, and currency. Religious and ethnic minorities particularly suffer under Niyazov, who rules uncontested since there are no opposition parties.

9. FIDEL CASTRO OF CUBA

Still going strong since coming to power in 1959, Castro recently sentenced several political dissidents to lengthy prison terms. It's merely the latest in a long and terrible line of human-rights abuses Castro has committed in this country of one-party, one-man rule.

10. KING MSWATI III OF SWAZILAND

At 18, Mswati assumed the throne of this absolute monarchy and announced that he was basically above the Swazi law. Although he

gave his royal consent to the creation of a constitution, said document forbids political parties, creates debtors' prisons, and makes any criminal offense punishable by death.

DUMBLY DEPARTED
Most Outlandish Demises of All Time

Each year, writer Wendy Northcutt pays posthumous tribute to the dumbly departed in the Darwin Awards, a compilation of the most embarrassing and ridiculous ways people accidentally kill themselves. A perversely funny tribute to Charles Darwin, the father of evolutionary theory, the Darwin Awards "commemorate those who improve our gene pool by removing themselves from it." For instance, there was the drunken couple who ignored repeated warnings and let passion overtake them while lying in the middle of the street, where a bus promptly ran over them in a fatal case of coitus interruptus. Or how about the rocket scientist who died while reportedly trying to open a hand grenade with a chainsaw? The mind boggles at the sheer idiocy of these poor dead saps, but at least they're rubbing elbows in purgatory with the following ten historical figures who died under extremely embarrassing circumstances. In alphabetical order, they are:

1. AESCHYLUS
The ancient Greek playwright died around 500 BC when an eagle dropped a tortoise on his noggin. Apparently, the eagle mistook the playwright's bald head for a rock.

2. ATILLA THE HUN
On his wedding night, he got so drunk he didn't realize that his nose was bleeding profusely. Mrs. Hun awoke the next morning to find the groom dead, drowned in his own blood.

3. SIR FRANCIS BACON
To see if snow would preserve meat, the 17th century philosopher/statesman/scientist killed a chicken and then spent hours in a snowstorm trying to stuff the carcass full of snow. When it was all over, there were two bodies in the snow.

4. TYCHO BRAHE
In 16th century Denmark, it was considered rude to leave a banquet table before the meal had

ended. The heavy-drinking astronomer suffered in polite agony rather than excuse himself to heed the call of nature. As a result, his bladder burst and he died a slow and painful death.

5. JIM FIXX

The author of the late seventies bestseller *The Complete Book of Running* touted running and a healthy diet as the key to longevity. He died from a heart attack while jogging. An autopsy revealed massive blockage in three coronary arteries.

6. HOLY ROMAN EMPEROR FREDERICK I

Clanking through the desert of the Holy Land in heavy armor, 12th century Holy Roman Emperor Frederick was so happy when he reached the Saleph River, he jumped in to quench his thirst. Unfortunately, he forgot to take his armor off and therefore sank to the bottom like an anvil.

7. JEAN BAPTISTE LULLY

During a rehearsal of his latest composition, the 17th century composer got so excited he accidentally thrust his conductor's baton deep into his right foot. As a result, Lully subsequently died of blood poisoning.

8. POPE JOHANN XII

Only 18 years old when he died in AD 963, Pope Johann XII was knocking at the pearly gates after his lover's enraged husband beat him to death.

9. JEROME IRVING RODALE

The founder of the organic food movement and the publisher of the Rodale Press told interviewer Dick Cavett in 1971 that he'd live to 100. Moments later, the 72-year-old Rodale slumped dead in his chair from a heart attack. This episode of *The Dick Cavett Show* was never broadcast.

10. TENNESSEE WILLIAMS

Years of alcohol and drug abuse took a fatal toll on the noted playwright, who choked to death on an aspirin bottle cap while inebriated in 1983.

FINANCIAL FIASCOS
The ~~Rich~~ and Famous

The rich and famous are virtually guaranteed to stay famous, but rich is another story. Most of us have our financial ups and downs. So why are we so fascinated when celebrities have their financial woes? Probably because the sums of money involved are outlandish and—let's face it—there's a bit of evil pleasure here, seeing the big guns squirm.

Here are famous people who had money problems, listed in order of debt size, along with some of the delicious details:

1. DONALD TRUMP
Some years back in the pre-*Apprentice* era, Mr. He-of-the-Infamous-Coiffure ran into troubles to the tune of about $900 million. His casinos and the Plaza Hotel filed for bankruptcy protection. He roared back, however (probably not just from clipping coupons), and is richer than ever. Easy come, easy go, easy comeback, but it's rumored that it might happen all over again.

2. MIKE TYSON
The boxer was more successful in the ring than with managing his money—can you imagine blowing through a $300 million fortune?

3. MICHAEL JACKSON
A lawsuit says that the pop singer has $200 million of debt, but you wouldn't know it from his lavish lifestyle. What a thriller!

4. ELTON JOHN
His legendary spending sprees got him into trouble a few years back, when it was reported that he asked a bank to lend him $40 million to pay off debts. Now that's a lot of fancy eyeglasses.

5. WILLIE NELSON
His money woes are now ancient history, but back in 1990 the IRS swooped into his Texas home and seized everything. His stuff was even auctioned off, but friends and fans bought much of it and gave it back to him. He eventually settled his $16.7 million delinquent tax bill.

6. BURT REYNOLDS
In 1996 he declared bankruptcy, claiming more than $8 million in debts. And he once dated a flying nun.

7. MC HAMMER
The rapper lived a lifestyle of excess that caught up with him in 1996, when he declared bankruptcy. The legal system didn't agree with Hammer's standard, "U Can't Touch This."

8. THOMAS JEFFERSON
Hey, as a president he may have excelled, but watching his own wallet was another story. His lavish house, Monticello, didn't help his debt load, which at $107,000 was a fortune at the time. After his death, his entire estate was auctioned off to pay creditors.

9. MARK TWAIN
The beloved author (real name: Samuel Clemens) was not skillful at making good investments, and he eventually became effectively bankrupt. After delivering lectures to earn money, he paid all his debts—wonder why he didn't just get people to paint fences for him?

10. WOLFGANG AMADEUS MOZART
The poor guy was a musical genius but lived an unenviable life. By his early thirties he was in serious debt, and then died at age 35.

GENERALS
Military Strategists to Die For

Some men are born incompetent, some gradually become incompetent, and others suddenly become incompetent when thrust into a military command position during wartime. This is about generals who fell into at least one of those categories.

Following are the worst generals of all time, listed in chronological order. Not only did they lose decisively, many either died (one by his own hand), probably before their own troops turned on them, or they were relieved of command so they could not inflict further damage on their own forces.

1. MARCUS CRASSUS (CA. 115–53 BC) OF THE ROMAN EMPIRE
Lost two-fifths of his force of 50,000 and was killed in battle during the Roman-Parthian War.

2. PHILIP VI (1293–1350) OF FRANCE
Lost 4,000 men (one-third of his force) to a mere 100 English soldiers in the Battle of Crecy.

3. WILLIAM H. WINDER (1775–1824) OF THE UNITED STATES

In the Battle of Stony Creek in the war of 1812, he snatched failure from the jaws of victory, despite having a three-to-one advantage over his foe.

4. A. LOPEZ DE SANTA ANNA (1794–1876) OF MEXICO

In the Mexican-American War, one of two wars he lost for his country, Santa Anna lost every battle he waged.

5. GEORGE ARMSTRONG CUSTER (1839–1876) OF THE UNITED STATES

Court-martialed twice, Custer had the highest casualty rates of any Union division commander during the Civil War. Arrogant and foolhardy in the extreme, he later died with 250 of his men in the infamous Battle of Little Big Horn, which lasted less than an hour.

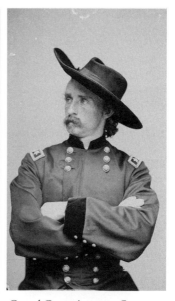

General George Armstrong Custer was caught napping at the infamous Battle of Little Big Horn. When his reinforcements arrived, they found all of his 250 men dead, qualifying him as one of the 10 worst generals in military history, and the very worst American one.

6. SIR IAN HAMILTON (1853–1947) OF GREAT BRITAIN

Losing commander-in-chief of the Mediterranean Expeditionary Force in the disastrous campaign against Turkey at Gallipoli. Under his command, nearly 250,000 died or were wounded at this battle.

7. ROBERT NIVELLE (1856–1924) OF FRANCE

France's commander-in-chief during World War I, Nivelle thought he could win the war with his "creeping barrage techniques." The Nivelle Offensive of 1917 was an utter failure, but Nivelle continued to use this strategy

despite heavy losses, until he was finally relieved of command.

8. ALEKSANDR SAMSONOV (1859–1914) OF RUSSIA

Under his hopelessly confused command, Russian forces suffered a catastrophic loss to the Germans in the Battle of Tannenberg. Humiliated in defeat, Samsonov shot himself on the battlefield.

9. MAURICE GAMELIN (1872–1958) OF FRANCE

Commander of the Allied forces on the western front in 1940, he held the Maginot Line under the erroneous belief that the Blitzkrieg was a "diversion." When France

fell to Germany, Gamelin was removed from command.

10. MANUEL NORIEGA (1942–) OF PANAMA

Nicknamed "Pineapple" for his pockmarked complexion, Panamanian dictator and former CIA puppet Manuel Noriega declared a state of war with the United States in December 1989. When the U.S. troops invaded a few weeks later, the macho dictator abandoned his forces and fled to the Vatican's embassy, where he surrendered to U.S. authorities in early January. He was tried on drug charges and sentenced to 30 years in prison, and is still in the joint.

HOLLYWOOD FEUDS
The Nastiest Celebrity Catfights

Outspoken political observer and presidential daughter Alice Longworth Roosevelt (child of Theodore) once quipped, "If you haven't got anything nice to say about anybody, come sit next to me." And so goes celebrityhood and all interested in learning about it. True to that creed, nothing generates buzz like a well-placed potshot at a rival or enemy in Hollywood, where the only thing worse than bad publicity is no publicity at all. Gossip columnists and tabloid reporters have long regaled film fans with juicy tidbits about stars' bad behavior—the snubs, catty remarks, screaming matches, and temper tantrums that are often referred to as "creative differences." In a look back at 20th century showbiz, E! Online writer Bruce Newman ranked the all-time nastiest Tinseltown feuds, rivalries, and cold wars:

1. JOAN CRAWFORD VS. BETTE DAVIS

The dueling Warner Bros. divas engaged in one of the longest and most entertaining feuds in Hollywood history. When Crawford died in 1977, Davis had the last word: "My mother always said it was polite to say something good about the dead. Joan Crawford: She's dead. Good."

2. JACKSONS VS. JACKSONS

Michael Jackson, aka "Wacko Jacko," and his siblings have slung mud at each other for years in what must be a family tradition. His older sister LaToya has provided the most copy, particularly when she denounced the King of Pop as a child molester in a 1993 press conference.

3. JERRY LEWIS VS. DEAN MARTIN

The comedy team became estranged as their fame and bank accounts grew. On their last movie together, Lewis professed his love to Martin, who replied, "You can talk about love all you want. To me, you're nothing but a [expletive] dollar sign."

4. OLIVIA DE HAVILAND VS. JOAN FONTAINE

The Hollywood sisters' long-simmering rivalry took a nastier turn after Fontaine beat her more established sister in the 1941 Oscar race for Best Actress. Five years later, De Haviland won the prize for *To Each His Own*, but when Fontaine attempted to embrace her, de Haviland coldly stared at her and exited without a word.

5. LEE MARVIN VS. MICHELLE TRIOLA

Hell hath no fury like a kept woman scorned. When Marvin gave his live-in girlfriend the boot after six years together, she hired an attorney and sued the star in the first palimony case. Triola won a token amount of money and Marvin's name went into the lawbooks.

6. HEDDA HOPPER VS. LOUELLA PARSONS

For decades, Hollywood's reigning gossip columnists waged war against each other in private, public, and print. Only Hopper's death in 1966 brought an end to their mudslinging.

7. MICHAEL EISNER VS. JEFFREY KATZENBERG

After serving Eisner loyally for years at Disney, Katzenberg was furious when his former boss, mentor, and friend refused to reward him his due. Leaving Disney

in an ugly huff, Katzenberg sued Eisner, who stated, "I hate the little midget."

8. BORIS KARLOFF VS. BELA LUGOSI

After turning down *Frankenstein*, Lugosi was incensed to see his replacement become the bigger star. Forced to work together in several horror films, they maintained a working relationship that was icy at best.

9. JAY LENO VS. DAVID LETTERMAN

When Johnny Carson announced his retirement, Leno and Letterman vied to host *The Tonight Show*. It quickly turned into a bitter fight, egged on by Leno's manipulative manager Helen Kushnick.

10. JFK VS. FRANK SINATRA

Sinatra *thought* he was a member of JFK's inner circle. But the singer's alleged mob connections made their continued friendship too dicey for the president. Sinatra was so angry, he destroyed a heliport at his Palm Springs estate built specifically for JFK.

LITERARY FEUDS
Deadliest Poison Pens

Not since the Hatfields and McCoys has a feud generated as much ink as the infamous Oprah Winfrey/Jonathan Franzen run-in of 2001. When Franzen's family magnum opus *The Corrections* received near-universal critical acclaim, Winfrey selected the novel for her book club. Franzen, however, was less than thrilled by her endorsement and complained—not once, but twice!—to the press about *The Corrections* being lumped in with some of her prior selections, which he dismissed as "schmaltzy and one-dimensional." Ouch! Although Winfrey took the high road, Franzen was roundly criticized for being elitist. He got off easy compared to some of these other writers, who've traded blows, both verbally and physically. Here are ten of the nastiest feuds that shook the book world, listed in chronological order:

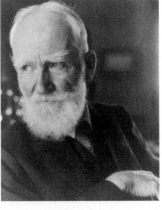

Oscar Wilde (left) and George Bernard Shaw (above), outraged they had to even share the same planet, were opposing sides in one of the nastiest literary feuds among English-language writers.

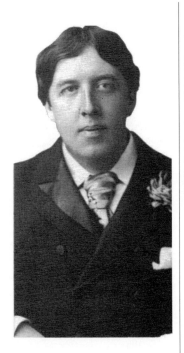

1. RALPH WALDO EMERSON VS. ALGERNON SWINBURNE

These two mid-19th century writers detested each other. Swinburne pronounced Emerson "a gap-toothed, hoary-headed ape." In retaliation, Emerson called his nemesis "a leper and a sodomite."

2. GEORGE BERNARD SHAW VS. OSCAR WILDE

Victorian-era wits and rivals who took every chance to dismiss each other, preferably in public. According to Wilde, the famously irascible Shaw "hasn't an enemy in the world, and none of his friends like him."

3. GEORGE MOORE VS. OSCAR WILDE

Wilde also tangled with Moore, who regarded the Irish bon vivant as nothing more than a plagiarist. Always quick with the quip, Wilde said this of Moore's writ-

ing: "He leads his readers to the latrine and locks them in."

looked like "a truck driver in drag."

4. WILLIAM FAULKNER VS. ERNEST HEMINGWAY

There was no love lost between these 20th century American writers, who took regular potshots at each other, probably fortified by booze. According to Faulkner, "Hemingway has never been known to use a word that would send a reader to the dictionary." Hemingway replied, "Poor Faulkner. Does he really think big emotions come from ten-dollar words?"

5. CLARE BOOTH LUCE VS. DOROTHY PARKER

Bitter rivals and members of New York's smart set, Luce and Parker once bared their fangs when entering a building. Deferring to Parker, Luce said, "Age before beauty." Smiling thinly, Parker replied, "And pearls before swine."

6. TRUMAN CAPOTE VS. JACQUELINE SUSANN

Susann made the mistake of imitating Capote's famous lisp and mannerisms on a late-night talk show in the sixties. Never at a loss for a well-placed barb, the diminutive Capote got even soon after, when he said that Susann

7. NORMAN MAILER VS. GORE VIDAL

Although their bickering sometimes resembles that of an old, especially bitter married couple, the two made tabloid headlines when Mailer split Vidal's lip at a Los Angeles cocktail party in 1974.

8. TRUMAN CAPOTE VS. GORE VIDAL

Their antagonistic relationship took a legal turn in 1975, when a vodka-swilling Capote told an interviewer that Robert Kennedy had once thrown Vidal out of the White House. Vidal sued for Capote for defamation and malice in a case that dragged on for years until Capote apologized in writing in 1983.

9. LILLIAN HELLMAN VS. MARY MCCARTHY

In a 1980 interview with Dick Cavett, McCarthy pulled no punches in her withering assessment of Hellman, saying that "every word she writes is a lie, including *and* and *the*." Outraged, Hellman immediately sued McCarthy for defamation of character, but died before the case went to court.

10. JOHN IRVING VS. TOM WOLFE

Reviewing Wolfe's 1998 novel *A Man in Full*, Irving wrote that every page revealed a "sentence that would make me gag." Wolfe shot back: "Irving is a great admirer of Dickens. But what writer does he see now constantly compared to Dickens? Not John Irving, but Tom Wolfe . . . it must gnaw at him terribly."

MOVIE ACCENTS
All-Time Worst Accents in Cinematic History

Hollywood legend has it that when Tony Curtis was just starting out at Universal Pictures in the early 1950s, he was cast as a suave Middle Eastern prince, but spoke with an accent that sounded more like the Bronx than Baghdad: "Yondah lies duh castle of my faddah." Although Curtis never said this line in any movie, the actor formerly known as Bernard Schwartz was unmistakably a product of New York's mean streets. Except for his tongue-in-cheek parody of Cary Grant in *Some Like It Hot* (1959), Curtis rarely, if ever, attempted to speak with an accent other than his own.

Today, when screen chameleons like Meryl Streep try on foreign accents ranging from Australian to Polish to appear as authentic as possible, audiences expect all movie stars to follow Streep's lead and break out the Berlitz tapes to pass accent muster. Of course, not everyone has Streep's facility. And some, like Kevin Costner, don't even try. As the title character in *Robin Hood: Prince of Thieves* (1991), Costner spoke his florid lines in the same California surfer dude accent he uses in every movie. Given that Costner made absolutely no attempt to sound British, it's then all the more surprising that the readers of England's *Empire Magazine* didn't include him in their 2003 ranking of the all-time worst movie accents. Their pick for the star with the worst movie accent? None other than Sean Connery, whose strong Scottish burr rings out loud and clear in every movie, whether he's playing an Irish cop in *The Untouchables (1987)* or a Russian submarine captain in *The Hunt for Red October (1990)*.

Here are the ten actors *Empire*'s readers deemed as having the all-time least-convincing movie accents:

Actor	Film	Accent Attempted
1. Sean Connery	*The Untouchables*	Irish
2. Dick Van Dyke	*Mary Poppins*	Cockney
3. Brad Pitt	*Seven Years in Tibet*	Austrian
4. Charlton Heston	*Touch of Evil*	Mexican
5. Heather Graham	*From Hell*	Irish
6. Keanu Reeves	*Bram Stoker's Dracula*	English
7. Julia Roberts	*Mary Reilly*	Irish
8. Laurence Olivier	*The Jazz Singer*	Yiddish
9. Peter Postlethwaite	*The Usual Suspects*	Japanese
10. Meryl Streep	*Out of Africa*	Danish

MOVIE STARS
Entertainers Less Talented

Some actors effortlessly radiate so much charisma, talent, and intelligence they practically have "movie star" stamped on their foreheads. From Humphrey Bogart to Marlon Brando to Sean Penn, they're the stars whose best performances are truly unforgettable.

And then there are those talent-lite would-be thespians who parlay brawn or a camera-friendly mug into a film career that defies the odds and critical slams to endure long past its expiration date. Reviled by critics, they somehow rise phoenix-like from the ashes of each flop to torment audiences again and again. Based on the Golden Turkey Awards, the Razzies, the Harvard Lampoon movie worsts, and critics' choices, here is an alphabetical list of the 10 actors who've earned their place in Hollywood infamy. The envelope, please . . .

Actors:

1. JOHN AGAR

Who? Agar, aka the first Mr. Shirley Temple, got his foot in Hollywood's door after marrying the former child star in the late 1940s. Seemingly incapable of expressing anything resembling emotion, Agar starred in such winners as *The Mole People* and *The Daughter of Dr. Jekyll.*

2. RICHARD BURTON

Yes, that's right. While he certainly gave some magnificent performances over the years, the Welsh-born Burton also embarrassed himself regularly, hamming

it up in countless bombs to the point that he was named "Worst Actor" in The Golden Turkey Awards.

3. TONY CURTIS

Another Golden Turkey Award "honoree," Curtis occasionally rose above his dramatic shortcomings in films like *Some Like it Hot* and *Sweet Smell of Success*, only to flounder anew in junk like *The Manitou* or *Boeing-Boeing*.

4. VICTOR MATURE

A slab of stone-faced beefcake, Mature lumbered through many a flick in the forties and fifties to Golden Turkey Award recognition.

5. CHUCK NORRIS

As long as he's kicking the crap out of bad guys, Norris is watchable in grade-B action epics. But when it comes to emoting, Norris is *Missing in Action*.

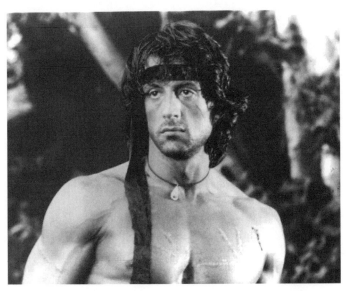

Despite Sylvester Stallone's Academy Award nomination for his role as Rocky Balboa in 1976, he still earned a spot on the list of 10 worst actors in the movies.

6. KEANU REEVES

The slacker doofus of cinema, Reeves is fine in parts that don't require him to be articulate, intelligent, or awake. Yet for some bizarre reason, filmmakers have cast him as a scientist (*Chain Reaction*), hotshot lawyer (*The Devil's Advocate*), and Shakespearean villain (*Much Ado About Nothing*).

7. STEPHEN SEAGAL

The increasingly pudgy martial arts star and reincarnated Buddhist lama (according to Seagal, anyway) has an even more narrow range than Chuck Norris, if that's possible.

8. PAULY SHORE

Oh, the inhumanity of suffering through a Pauly Shore film. A singularly unfunny "comic" who's so irritating, he would drive a pacifist to violence.

9. SYLVESTER STALLONE

Yo Rocky, what happened? A smash hit in the 1976 Best Picture winner *Rocky*, Stallone gradually became a monosyllabic self-parody in overblown, idiotic action epics like *Cobra* and *Tango & Cash*. The all-time Razzies champ, with 9 wins for Worst Actor.

10. SONNY TUFTS

Another name from the movies' not-so-glorious past, Tufts was singled out by the writers of the Golden Turkey Awards for chronically disgracing himself onscreen in *Cat Women of the Moon* and *Cottonpickin' Chickenpickers*, among other gems on his resume.

Actresses:

Never let it be said that *The World's Worst* is a sexist book! Since we named the worst actors, it's only fair to list the 10 worst film actresses. And you thought chivalry was dead!

1. LINDA BLAIR

Watching this Razzie honoree onscreen in duds like *Hell Night* and *Roller Boogie* may inspire projectile vomiting, just like her possessed character in *The Exorcist*.

2. CANDICE BERGEN

Before she redeemed herself on television's "Murphy Brown," Golden Turkey Award honoree Bergen was the world's most beautiful sleepwalker in bombs like *The Day the Fish Came Out*

and *The Adventurers*, among many, many others.

3. BO DEREK
A 10 in the beauty department, Derek is an absolute zero in terms of acting talent. Inflatable dolls are more expressive than this blonde sex symbol, whose motto seems to be, "When all else fails, strip!"

4. ZSA ZSA GABOR
The "ageless" Hungarian sexpot is better at racking up marriages than acting. According to nasty critic John Simon, she even has trouble playing herself onscreen!

5. ALI MCGRAW
A frequent Harvard Lampoon target, McGraw of *Love Story* fame does all of her acting by flaring her nostrils and uttering her lines in the same, affected tone of voice.

6. MADONNA
After a decent start in *Desperately Seeking Susan*, the Material Girl/Razzie favorite fell into a deep coma. At least it seems that way, given her stiff, monotone performances in bombs like *Shanghai Surprise*, *Who's That Girl?*, and worst of all, the steamy erotic thriller *Body of Evidence*.

7. VERA RHUBA RALSTON
Who? Forgotten by all except the writers of the Golden Turkey Awards, Ralston was an ice skater who appeared, rather than acted, in grade-Z movies in the forties and fifties.

8. MAMIE VAN DOOREN
The trailer park answer to Marilyn Monroe, the bosomy star of fifties-era drive-in flicks like *High School Confidential* and *Sex Kittens Go to College* can't chew gum, drone her lines, and walk at the same time.

9. RAQUEL WELCH
Deemed the all-time worst actress for her "body of work" by the authors of the Golden Turkey Awards, Welch earned this perverse tribute for stinkers like the aptly titled *Lady in Cement* and the legendary disaster *Myra Breckinridge*.

10. PIA ZADORA
As a whiny child star wannabe, she first appeared in *Santa Claus Conquers the Martians* (1964). Little did she know that this would be the height of her film career!

Years later, Zadora made good on the lack of promise by giving laughably bad performances in *The Lonely Lady* and *Voyage of the Rock Aliens*.

MOVIE VILLAINS
The Most Sinister Rogues in Filmdom

She's green. She's mean. And she hates little dogs, too. She's the hydrophobic, ruby slipper–craving Wicked Witch of the West, who ranks 4th on the American Film Institute's list of all-time greatest movie villains.

So what could be scarier than an evil, ugly witch with an entourage of flying monkeys at her beck and call? Well, how about a flesh-eating serial killer with a taste for fava beans and human liver, which he washes down with a nice bottle of Chianti? Dr. Hannibal Lecter, aka "Hannibal the Cannibal," tops the AFI list, thanks to Anthony Hopkins's terrifying, Oscar-winning performance in the brilliant creepfest *The Silence of the Lambs*.

Here's a look at the AFI's 2004 ranking of movie villains, in descending order:

1. Dr. Hannibal Lecter (*The Silence of the Lambs*)

2. Norman Bates (*Psycho*)

3. Darth Vader (*The Empire Strikes Back*)

4. The Wicked Witch of the West (*The Wizard of Oz*)

5. Nurse Ratched (*One Flew Over the Cuckoo's Nest*)

6. Mr. Potter (*It's A Wonderful Life*)

7. Alex Forest (*Fatal Attraction*)

8. Phyllis Dietrichson (*Double Indemnity*)

9. Regan MacNeil (*The Exorcist*)

10. The Queen (*Snow White and the Seven Dwarfs*)

PRESIDENTIAL ASSASSINATIONS AND NEAR MISSES

In the Line of Fire

It may be the most celebrated job in the country, but there are definite risks that go with being the President of the United States. And we don't mean catching cold from kissing all those screaming babies.

Four U.S. presidents were assassinated in office. Another four survived assassination attempts. Franklin D. Roosevelt escaped assassination in Miami while he was president-elect. And Theodore Roosevelt survived an attempt on his life after his term in office was over.

The following presidents were targets of assassins. Half of them survived the attack. In chronological order:

1. ANDREW JACKSON, 7TH PRESIDENT

Andrew Jackson was the first president attacked by an assassin. Near the end of his second term, Jackson attended a congressional funeral at the capitol. Richard Lawrence, an unemployed house painter, aimed a pistol at Jackson, but it didn't discharge. Jackson tried to protect himself with his cane, but the assassin tried again. Fortunately, the second shot also misfired and the president escaped unharmed. Lawrence was sentenced to life in prison.

2. ABRAHAM LINCOLN, 16TH PRESIDENT

John Wilkes Booth, a Confederate sympathizer and actor, shot the president as he watched a play at Ford's Theater on April 14, 1965. Lincoln was carried to the boarding house across the street, and died early the next morning.

3. JAMES GARFIELD, 20TH PRESIDENT

Charles Guiteau followed the president to a railroad station and fired two shots. One grazed Garfield's arm and the other lodged inside his body. Here's where the story gets strange. Physicians, who did not typically wash their hands or use sterilized instruments back then, touched Garfield's wound and probed for the bullet. Inventor Alexander Graham Bell tried to help by rigging up a metal detector to find the bullet. Unfortunately, all that was detected was a bedspring. Ultimately, a small wound was made larger and infection set in. Garfield died ten weeks after

the shooting and Guiteau was hanged.

4. WILLIAM MCKINLEY, 25TH PRESIDENT

Less than a year into his second term, McKinley made an appearance at the Pan-American Exposition in New York, where 28-year-old Leon Czolgosz was waiting in line to shake the president's hand. Czolgosz approached McKinley with a bandaged hand hiding a .32-caliber revolver that he then used to fire two shots at the president. McKinley died eight days later.

5. HARRY S TRUMAN, 33RD PRESIDENT

Unrest in Puerto Rico precipitated the attempt on Harry Truman's life. Puerto Rican nationals Oscar Collazo and Griselio Torresola tried to attract worldwide attention to their cause by shooting the president at Blair House, his temporary residence. Torresola and one guard were killed. Collazo served 29 years in prison for the attempted assassination.

6. JOHN F. KENNEDY, 35TH PRESIDENT

On November 22, 1963, in Dallas, Texas, two shots fired from the Texas School Book Depository struck JFK as he waved to onlookers from the Presidential motorcade. Lee Harvey Oswald was soon arrested for the murder. In a strange turn of events, he was later shot at close range by nightclub owner Jack Ruby. President Lyndon B. Johnson ordered an investigation into the possibility of a conspiracy in the president's death, but none was ever proven.

7. GERALD FORD, 38TH PRESIDENT

September 1975 may have been the worst month of Gerald Ford's life as he dodged not one, but two attempts on his life. On September 5th, Ford was in Sacramento, California, when Lynette (Squeaky) Fromme pointed a .45-caliber pistol at him, but did not fire the gun. Seventeen days later, Sara Jane Moore fired one shot from her .38-caliber handgun at Ford while he was in San Francisco. Happily, the bullet was deflected and Ford walked away from both attempts unscathed.

8. RONALD REAGAN, 40TH PRESIDENT

Ronald Reagan was leaving the Washington DC Hilton after delivering a speech to the Construction Trades Council when he heard a popping sound to his left.

A Secret Service agent threw him into the car and fell on top of him, but it was too late. John Hinckley had shot Reagan in the chest. He was rushed to the hospital where a bullet was removed from his lung.

ROMAN EMPERORS
Worst Tyrants of Ancient Rome

Being thrown to the lions might have been preferable to spending any time in the company of these Roman Emperors, whose acts of cruelty and wretched excess would give even Saddam Hussein pause. Executing perceived enemies on a whim, plundering the Roman treasury to throw lavish fêtes, proclaiming themselves divine—it was all in a day's work for these spectacularly evil despots, hell-bent on leaving their scurrilous mark on the ancient world. Even today, thousands of years after the Roman Empire fell to those pesky barbarians at the gate, your average Joe or Jane in the street will recognize the names Caligula and Nero. Just goes to show you that William Shakespeare was right: "The evil that men do often lives after them; the good is oft interred with their bones."

Here are the ten Roman Emperors generally acknowledged as among the most evil, corrupt, and perverse, in alphabetical order with their reign in parentheses:

1. CALIGULA (AD 37–41)

Arguably the worst of the worst, Caligula reportedly impregnated his sister Drusilla and then disemboweled her to get the baby. Sexually insatiable, he opened a brothel in the palace and raped the wives of his closest advisors. When not torturing anyone he deemed treasonous, Caligula spent his way through the Roman treasury in a matter of months.

2. CARACALLA (AD 211–217)

After he knocked-off his brother Geta to insure his rule, Caracalla massacred 20,000 of his late brother's supporters and friends. Later ordered his troops to kill thousands in Alexandria, Egypt, for reasons lost to history.

3. COMMODUS (AD 180–192)

A slovenly, laissez faire ruler who basically let the praetorian pre-

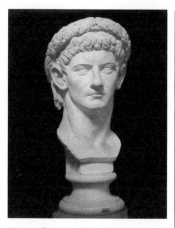

Worst of the worst Roman Emperors, Caligula impregnated his sister, disemboweled her to get the baby, opened a brothel in the palace, and raped the wives of his advisors, not to mention depleting Rome's ample treasury in almost nothing flat.

fects dictate policy, Commodus spent more time fighting gladiators and wild animals to prove that he was the Roman incarnation of Hercules.

4. DIOCLETIAN (AD 284–305)
Initially friendly to Christians, Diocletian soon instituted a wave of persecutions that killed thousands, reportedly 17,000 in a single month. A bona fide sadist, Diocletian used some of the most heinous forms of torture against Christians, whom he crucified,

forced to drink molten lead, and suffocated with smoke.

5. DOMITIAN (AD 81–96)
A rabid conspiracy theorist, Domitian tortured philosophers and Jews, whom he saw as out to get him. Anyone who opposed him was summarily executed and his property confiscated. In the depths of his madness, Domitian buried sacred vestal virgins alive for alleged immorality.

6. ELAGABALUS (AD 218–222)
While not as infamous as Caligula, Elagabalus certainly rivaled him in the sexual debauchery department. A transvestite who reportedly toyed with castrating himself, Elagabalus offended even his most reliable followers by marrying a vestal virgin.

7. GALBA (AD 68–69)
After Nero killed himself, this veteran soldier reigned for only 6 months before the army slew him for being such a monumentally cruel and petty emperor.

8. MAXIMINUS (AD 235–238)
Rumor has it that Maximinus was a veritable giant who allegedly ate 40 pounds of meat a day. A harsh warmonger who raised taxes to

finance his campaign against German tribes, he killed or exiled anyone who opposed his brutal policies. His own men finally killed him.

9. NERO (AD 54–68)

Contrary to legend, Nero did not play the fiddle while Rome burned—he sang as the city went up in flames. Although it's not known if Nero was involved in setting the fire, he blamed it on the Christians, who suffered horribly under his wrath.

10. TIBERIUS (AD 14–37)

During his reign, Tiberius looked the other way while Sejanus, the vicious head of the praetorian guard, terrorized the citizens, who suffered under especially harsh treason laws. He also maintained a large network of informants to root out any enemies, real or imagined.

ROYAL MONIKERS
Most Unflattering Sobriquets

During his ten-year reign as king of England from 1189 to 1199, Richard I was so revered for his bravery both at home and during the Crusades that he was christened Richard the Lionhearted. Today, some eight hundred years after his death, Richard the Lionhearted has achieved mythic status, thanks to Sir Walter Scott's *Ivanhoe* and popular legends passed down through the ages, like the saga of Robin Hood.

Unlike Richard the Lionhearted or Alexander the Great, the following rulers were burdened with highly unflattering, if not downright insulting sobriquets. If they are remembered at all today, it's for their nicknames, which each of them earned through monumental ineptitude, wanton cruelty, or both. From the *Book of Lists Vol. 2*, here

Ivan the Terrible, Czar of Russia (1530–1584), earned one of the 10 most unflattering nicknames in the history of world monarchies.

are the rulers saddled with ten of the worst sobriquets in history, in alphabetical order:

Ruler	Dates	Kingdom
1. Charles the Bad	(1332–1387)	King of Navarre
2. Charles the Mad	(1368–1422)	King of France
3. Charles the Simple	(879–929)	King of the Franks★
4. Ethelred the Unready	(968–1016)	King of England
5. Ferdinand the Inconstant	(1345–1383)	King of Portugal
6. Ivan the Terrible	(1530–1584)	Czar of Russia
7. Louis the Fat	(1081–1137)	King of France
8. Louis the Quarreler	(1289–1316)	King of France
9. Louis the Sluggard	(966–987)	King of the Franks★
10. Louis the Stammerer	(877–879)	King of France

★*A Germanic tribe that eventually became the French.*

SERIAL FAILURES AND SOMETIMES FLOPS
Rich and Famous . . . Eventually

If you're down in the dumps after being canned from your job, you may want to take heart from the following stories. You know their names—you just might not be aware that even some golden boys and girls have rough patches in their backgrounds. According to Laura Morsch at CareerBuilder.com, these eight celebrities endured some of the all-time worst career setbacks. They're listed below in alphabetical order.

1. LANCE ARMSTRONG

The six-time Tour de France champ was dropped by a French cycling team in '97 after he began cancer treatments. The team actually reneged on paying Armstrong's salary and medical bills.

2. WALT DISNEY

The king of amusement parks and much-loved animated cartoons was actually fired by a newspaper early in his career for lack of creativity. Perhaps the same people who fired him later spent their vacations at Disneyland.

3. STEVE JOBS

He cofounded Apple Computer (which literally got started in his garage) and was later fired by his own company. He went on to become a prime owner of Pixar, and in 1996, he returned to Apple.

4. LARRY KING

His CNN show isn't King's only professional undertaking. He used to write a column for the *Miami Herald*, but he was fired for socializing with column subjects. Now that same schmoozing ability works well for him on "Larry King Live."

5. ABRAHAM LINCOLN

Honest Abe had many setbacks prior to assuming the presidency. He had two business failures, lost a nomination to Congress in 1843, and was defeated in congressional elections in 1848 as well as 1855. He lost the U.S. vice presidency in 1856 and lost a Senate race in 1858. His 1860 election to the presidency certainly illustrates his perseverance.

6. ELVIS PRESLEY

Mr. Rock 'n' Roll was fired from a music studio in 1954 and was told, "You ain't goin' nowhere, son." Well . . . not *every* Elvis record was number one.

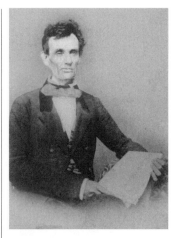

Before being elected U.S. President, Abraham Lincoln failed with two businesses, lost a nomination, lost two elections to Congress, and lost the vice presidency, earning him a spot on the biggest serial failure list.

7. BURT REYNOLDS

Before he became a box-office superstar, Reynolds was fired from an acting job. His later fame and top box-office status were undoubtedly all the sweeter.

8. JOANNE KATHLEEN (J. K.) ROWLING

Harry Potter's creator was dismissed from a job after she was caught writing stories on the company computer. Now fabulously wealthy, Rowling got the last word.

SPORTS FANS
Craziest Behavior at Athletic Events

There are sports fans and there are sports *fanatics*—the overzealous and obsessive spectators whose antics cross the line from obnoxious to unnerving. No, not the boisterous goofs who paint their faces, wear wigs, or strip off their shirts to reveal painted messages on their torsos (although their judgment may be seriously impaired). We're talking about the certified lunatics whose irrational behavior inspires almost as much water cooler talk as the game itself.

In 2004, Dayn Perry of FoxSports.com identified the 10 all-time craziest sports fans, ranked in order of lunacy quotient. Pray that one of these nutjobs isn't sitting anywhere near you the next time you take in a game.

1. GUNTHER PARCHE
In 1993, this wacko Steffi Graf fan stabbed Monica Seles during a tennis match in Germany. That's way more than you bargain for when you're playing a game.

2. WILLIAM LIGUE AND SON
This shirtless duo, fueled by alcohol, attacked the Royals' first-base coach during a Cubs baseball game in 2002.

3. CORNELIUS HORAN, IRISH DEFROCKED PRIEST
This bereted, kilted guy threw himself at the leader of the marathon in the 2004 Summer Olympics, knocking him down. No word as to whether he was wearing anything under the kilt.

4. ARIZONA STATE STUDENT BODY
During the classic basketball matchup between Arizona State and the University of Arizona in 1984, freshman Steve Kerr entered the game for U of A. He went on to score 20 points in the first half alone, but ASU "fans" were heard chanting "PLO" during the game. Kerr's father had just been murdered in Lebanon by members of that group. Disgusting.

5. STEVE BARTMAN
You know you made an impression when they wear Halloween costumes representing you, which Chicago residents did in 2003. Bartman grabbed a foul ball during a National League Champi-

onship game that may have cost the Cubs a spot in the World Series. Jaw-dropping, isn't it?

6. FAN MAN

During the 1993 Riddick Bowe-Evander Holyfield title bout, he flew into Caesar's Palace powered by an actual fan. As he sat tangled in the ropes, he was beaten by Bowe's entourage. Yeah, that was a good idea.

7. JEFFREY MAIER

This 12-year-old kid grabbed a sure out from an Orioles outfielder during the 1996 American League championship series, hosted by the Yankees. He did a Bartman in reverse and became a hometown hero.

8. SPIKE LEE

Perennial Knicks fan Lee is one of the most visible celebrity fans out there. After a verbal exchange between Reggie Miller and Lee in 1994, Miller led the way to beat-ing the Knicks. Lee might reconsider yakking with opponents during games.

9. MORGANNA

"The Kissing Bandit" used to run onto the field and plant a smooch on various baseball players. George Brett received a kiss from the buxom fan during the 1979 All Star game, as many will recall. She retired around 1999, and if you do the math, that's a lotta years of kissin'.

10. ROBIN FICKER

This Washington Wizards fan used to harass opposing players from his seat behind their bench in the U.S. Airways Arena. The NBA even started printing warnings against abusing players on the back of game tickets. But after the new MCI Center was built, Ficker no longer had courtside seats. Maybe the Wizards waved their magic wand and made them disappear.

STRIKEOUT KINGS
Take Me Out of the Ball Game

With 703 home runs to date, San Francisco Giants slugger Barry Bonds keeps knocking them out of the park and straight into the record books. A chip off the old block, Bonds has far surpassed the home run tally of his dad, former San Francisco Giants player Bobby Bonds. But

there's one baseball stat where Dad comes out on top, much to his chagrin. Known for swinging for the bleachers, Bobby Bonds unfortunately racked up the National League's highest number of strikeouts in a single season: 189 in 1970.

Here are the American and National League baseball players who struck out the most per season:

American League

Strikeouts	Player
1. 186	Rob Deer, Milwaukee, 1987
2. 185	Pete Incaviglia, Texas, 1986
	Jim Thome, Cleveland, 2001
3. 182	Cecil Fielder, Detroit, 1990
4. 181	Mo Vaughn, Anaheim, 2000
5. 176	Mike Cameron, Seattle, 2002
6. 175	Jay Buhner, Seattle, 1997
	Gorman Thomas, Milwaukee, 1979
	Dave Nicholson, Chicago, 1963
	Rob Deer, Detroit, 1991
7. 172	Bo Jackson, Kansas City, 1989
8. 171	Jim Thome, Cleveland, 1999
	Reggie Jackson, Oakland, 1968
9. 170	Gorman Thomas, Milwaukee, 1980
10. 166	Gary Alexander, Oakland and Cleveland, 1978
	Steve Balboni, Kansas City, 1985

National League

Strikeouts	Player
1. 189	Bobby Bonds, San Francisco, 1970
2. 188	Jose Hernandez, Milwaukee, 2002
3. 187	Bobby Bonds, San Francisco, 1969
	Preston Wilson, Florida, 2000
4. 185	Jose Hernandez, Milwaukee, 2001
5. 182	Jim Thome, Philadelphia, 2003
6. 180	Mike Schmidt, Philadelphia, 1975
7. 174	Sammy Sosa, Chicago, 1997

Strikeouts	Player
8. 171	Sammy Sosa, Chicago, 1999
	Sammy Sosa, Chicago, 1998
9. 169	Andres Galarraga, Montreal, 1990
10. 168	Juan Samuel, Philadelphia, 1984

TEAM TROUBLE
Worst Player-Coach Feuds

Although he often berated and bullied them to victory, legendary Alabama football coach Paul "Bear" Bryant inspired fierce loyalty among his players. Other coaches have inspired different strong feelings in their players—and vice versa—like festering anger or hatred that occasionally explodes into violence.

Battles between athletes and their coaches have raged as long as sports have been played. According to Dayn Perry of foxsports.com, here are ten of the most memorable player-coach feuds of the modern era. The rankings are ours.

1. LATRELL SPREWELL VS. P.J. CARLESIMO

During this infamous 1997 incident, Sprewell physically attacked Coach Carlesimo during basketball practice for the Golden State Warriors. Sprewell was pulled off, but not before choking Carlesimo and threatening his life. A second attack 20 minutes later was more reason for his 68-game suspension, which cost him $6 million in salary. Needless to say, he never again played for the Warriors.

2. BOBBY KNIGHT VS. NEIL REED

Never known for a calm temperament, Coach Knight mixed it up with basketball player Reed at a Hoosier practice in 1997. Knight grabbed Reed's throat, according to a video of the practice, after which Reed transferred schools and accused the coach of choking him.

3. LOU PINIELLA VS. ROB DIBBLE

During a 1992 interview, manager Piniella was asked why he hasn't used Reds' closer Dibble in a recent key situation. Piniella responded that Dibble had been complaining of a sore shoulder, but Dibble didn't cotton to that answer. Their subsequent wrestling match was recorded on camera.

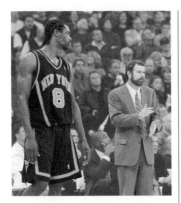

New York Knicks' Latrell Sprewell looks at his former coach, Golden State Warriors' P. J. Carlesimo at Sprewell's first appearance in Oakland since the infamous choking incident that earned them first position on the "Team Trouble" list.

4. REGGIE JACKSON VS. BILLY MARTIN

The legendary clashes between outfielder Jackson and manager Martin were epitomized during a 1977 game with Boston. Martin replaced Jackson mid-inning because he thought he wasn't working hard enough. Their subsequent screaming match was cut short before they came to blows.

5. ROBERT HORRY VS. DANNY AINGE

In 1997 coach Ainge pulled Phoenix Suns' player Horry from a game with the Boston Celtics. Furious, Horry threw a towel and swore at Ainge. Suspended, Horry was traded to the Lakers a few days later.

6. BILL PARCELLS VS. TERRY GLENN

Coach Parcells had already fought with Patriots owner Bob Kraft about selecting Glenn in the 1996 draft. Kraft won and Glenn was taken by the Patriots, but coach and player had a tough time warming up to each other. Their problems came to a head when Parcells told a reporter about the injured Glenn, "She's making progress."

7. CARL EVERETT VS. JIMY WILLIAMS

Midseason in 2000, Red Sox player Everett and his manager Williams had a blowout argument just before outfielder Everett was to return to the lineup after a 10-game suspension for bumping an umpire. It was reported that they argued about Everett leaving early from a three-game trip to Seattle earlier that week.

8. JUNE JONES VS. JEFF GEORGE

In 1996 Falcons quarterback George was leading the team nowhere. He exploded at coach Jones after getting pulled in the

third quarter of the season's third game, an eventual loss to the Eagles. George followed Jones on the sidelines, reportedly swearing at him, and was told by the coach to leave. He was suspended the next day.

9. PATRICK ROY VS. MARIO TREMBLAY

They used to room together as teammates of the Montreal Canadiens. But when Tremblay became coach in 1995, their relationship soured. During a game against the Red Wings, Roy suggested that Tremblay was giving special treatment to certain players, which Tremblay denied. The coach then left Roy in the

game until he was scored on nine times in less than two periods. Later, Roy stormed past Tremblay to tell the team president that he was done playing for the Canadiens. He was traded to the Avalanche a few days later.

10. TROY AIKMAN VS. BARRY SWITZER

Switzer spent four seasons in Dallas coaching quarterback Troy Aikman. The quarterback often left the practice field to protest what he perceived as Switzer's lax player discipline. In 1997 Switzer supposedly started a rumor that Aikman was gay—not that there's anything wrong with that.

TOURISTS "TERRIBILIS"

Most Loathed Vacationers by Nationality

Anyone who's traveled abroad has seen, heard, and probably given a wide berth to the stereotypical "ugly American": loud, rude and garishly dressed, he or she makes no attempt to speak anything but English. If a "foreigner" doesn't understand, he simply speaks louder, as if cranking up the volume to ear-splitting levels will close the language gap.

Yet according to a poll of 17 international tourist boards conducted by online travel service Expedia, the "ugly American" is actually a lot prettier than the average British traveler, who tops the list as the world's worst tourist. In fact, the Yanks were deemed the most courteous, whereas the boozy, arrogant, and loutish Brits were named the rudest, stingiest, and least likely to try local cuisine or speak the native language. Of the 24 nationalities evaluated by tourist boards on everything

from manners to tipping, here are the tourists who most inspire fear, loathing, and resentment among beleaguered hotel and wait staff around the world.

In descending order of awfulness:

1. British
2. Israelis (tie)
 Irish (tie)
4. Indians
5. Finnish
6. Czechs (tie)

New Zealanders (tie)
Argentineans (tie)
9. Russians
10. Poles (tie)
 Danes (tie)
 Brazilians (tie)

VP SPEAK

U.S. Vice President Dan Quayle and the English Language

Humorists and political commentators regularly assail President George W. Bush for his mangling of the English language, but compared to former vice president Dan Quayle, "Dubya" is a wordsmith of extraordinary verbal dexterity. Apparently born with both feet and hands in his mouth, Quayle offered a seemingly endless supply of gaffes and tactless remarks during his one term as the nation's number two in command under the first president Bush. Given the ridicule he inspired, you'd think that Quayle would have done the sensible thing and gone quietly after leaving office in 1992, but the master of malaprops and inappropriate comments has continued to embarrass himself with entertaining regularity.

Here are samples of the peculiar wit and wisdom of Dan Quayle, our esteemed 44th vice president, in ascending order of stupidity:

1. "We are on an irreversible trend towards more freedom and democracy—but that could change."

2. "If we do not succeed, then we run the risk of failure."

3. "One word sums up probably the responsibility of any governor, and that one word is 'to be prepared'."

4. "Mars is essentially in the same orbit . . . Mars is somewhat

the same distance from the Sun, which is very important. We have seen pictures where there are canals, we believe, and water. If there is water, that means there is oxygen. If oxygen, that means we can breathe."

5. "The Holocaust was an obscene period in our nation's history. I mean in this century's history. But we all lived in this century. I didn't live in this century."

6. "Illegitimacy is something we should talk about in terms of not having it."

7. "I have been asked who caused the riots and the killing in LA, my answer has been direct and simple: Who is to blame for the riots? The rioters are to blame. Who is to blame for the killings? The killers are to blame."

8. "For NASA, space is still a high priority."

9. "Verbosity leads to unclear, inarticulate things."

10. "Potatoe."

VICE PRESIDENTS
Hell to the Chief

After serving as FDR's vice president from 1933 to 1941, the famously crusty Texas congressman John Nance Garner summed up the post as "not worth a pitcher of warm piss." Never one to mince words, Garner later referred to joining FDR on the 1932 ticket as "the worst damn fool mistake I ever made." So much for the glory of being "a heartbeat from the presidency" of the most powerful nation on earth! Then again, until recently being vice president was widely acknowledged as a thankless job consisting of attending state funerals and serving as the president's "adviser" (translation: lapdog).

For all his bile, Garner at least didn't disgrace himself during his eight years as vice president, which is far more than can be said for the following list of liars, traitors, and knuckleheads whom *George Magazine* in 1999 ranked the worst veeps in presidential history, in descending order of awfulness:

1. SPIRO AGNEW (1969–73)

Deemed the absolute worst vice president, Tricky Dick's blowhard veep pleaded no contest to a criminal charge of tax evasion. While governor of Maryland, Agnew reportedly accepted nearly $30,000 in bribes. Fined $10,000 and placed on probation, Agnew became only the second vice president ever to resign from office.

2. DAN QUAYLE (1989–93)

Quayle's embarrassing slips of the tongue were almost a daily fixture on the news. Tactless to the point of lunacy, he told starving Samoans that "you look like a bunch of happy campers to me."

3. NELSON ROCKEFELLER (1974–77)

Appointed vice president by accident-prone Gerald Ford, the zillionaire politician from New York so alienated the party faithful that he was dropped from the 1976 ticket. In response, Rockefeller gave the finger to Republican convention delegates.

4. HENRY A. WALLACE (1941–45)

FDR's second vice president, Wallace was highly regarded for his business acumen. Diplomacy, however, was not his strong suit. On a trip abroad, he criticized U.S. foreign policy. Talk about biting the hand that feeds you!

5. CHARLES G. DAWES (1925–29)

Literally caught sleeping on the job, Calvin Coolidge's vice president missed voting on the president's nominee for attorney general.

6. HENRY WILSON (1873–75)

Ulysses S. Grant's second vice president, Wilson did nothing of consequence except die of a stroke while in office.

7. HANNIBAL HAMLIN (1861–64)

While serving as Lincoln's first vice president, Hamlin worked as a cook in the Coast Guard. Fed up, Lincoln gave him the heave-ho in 1864.

8. WILLIAM RUFUS DEVANE KING (1853)

Died a month after being sworn in by proxy because he was in Cuba at the time of the inauguration.

9. RICHARD M. JOHNSON (1837–41)

A braggart par excellence, Martin Van Buren's veep always claimed that he had killed the Shawnee Indian leader Tecumseh in battle, but there was scant evidence to prove it. He scandal-

ized Washington by having an affair with a slave, who bore him two children.

10. AARON BURR (1801–05)

While serving under Thomas Jefferson, Burr shot and killed Alexander Hamilton in a duel. Fleeing the scene, Burr conspired with an accomplice to establish a nation west of Appalachia that he would rule. Arrested for treason, he was later acquitted and spent the rest of his days in European exile.

2

Places

ADOLESCENT DEATHS BY VIOLENCE
U.S. States with the Highest Violent Death Rates for Teens

Teen homicide, suicide, and firearm death rates have all dropped over the last few years, but they are still the second leading cause of death among 15- to 19-year-olds in the United States. Only accidents rank higher.

Risk factors such as depression and bipolar disorders often lead to teen suicide. Girls are more likely to attempt suicide, but boys are more likely to succeed. Teens and firearms are deadly together. Firearms were the cause of deaths in 60% of teen suicides and 80% of teen homicides. And in firearm accidents, a quarter of the cases result in death.

You might think that large, crime-plagued cities like New York or Los Angeles would boost their states to the top of the violent teen-death list, but that isn't the case. In fact, the opposite is true. New York has the 4th lowest rate and California is tied for 6th lowest.

Here are the states that rank highest in teen deaths from suicide, homicide, and accidents, in descending order, according to *Kids Count 2004 Data Book*. In descending order:

1. Alaska
2. Arkansas
3. Idaho
4. Alabama
5. Louisiana
6. Mississippi
7. Missouri
8. Oklahoma
9. South Carolina
10. Arizona

AIRPORTS FROM HELL
The Worst Here and Abroad

There's not much rest for the weary world traveler at these airports—just aggravation and confusion, usually cloaked in a thick, foul-smelling layer of cigarette smoke. Or so says business travel writer Christopher Elliott, who appears regularly on National Public Radio and writes an online column for Microsoft. With the liberal input of disgruntled travelers, Elliott compiled this ranking of the 10 worst airports both here and abroad. Given some his withering assessment of these travel hubs, Elliott better keep a close eye on his luggage the next time he passes through any of the following airports, which he pronounced "terminally bad."

Domestic Airports:

1. NEW YORK CITY'S THREE AIRPORTS (NEWARK, LAGUARDIA, AND JFK):

The three airports servicing the Big Apple are the absolute, rock-bottom worst, according to Elliott. Newark is "a dreadful, disorganized mess," and nearly a fourth of all flights arriving at JFK are late. Even worse is La-Guardia, which Elliott blasts for "dark terminals, predictable delays, and reports of lax security."

2. MIAMI INTERNATIONAL AIRPORT

Perpetual bumper-to-bumper traffic jams outside the airport, abnormally long security lines, and check-in areas Elliot brands "claustrophobic." Adding insult to injury, the food offered in Miami's departure areas is inferior.

3. SAN JOSE INTERNATIONAL AIRPORT

Headed to Northern California's Silicon Valley? Then steel yourself for an airport too small and poorly designed to handle the influx of passengers and tightened security measures.

4. LOS ANGELES INTERNATIONAL AIRPORT

Growing pains afflict LAX, which is squeezed into a tract of land too small to accommodate much-needed expansion. Freeway traffic creates more headaches.

5. BOSTON LOGAN INTERNATIONAL AIRPORT

Logan is in desperate need of remodeling, since it's often cramped and lacks much in the way of shops and other airport amenities. It also seems to be forever under

construction and forces passengers to wait in lines that seemingly never move.

International Airports:

1. LONDON'S HEATHROW AIRPORT

God save the queen if she ever has to find her way through London's vast, maze-like Heathrow, according to Elliott. Security guards merely stare daggers or look away while tourists stumble like lab rats through the dimly-lit terminals.

2. MEXICO CITY'S BENITO JUAREZ AIRPORT

Once you choke your way through the fog of cigarette smoke, another joy awaits you at Benito Juarez Airport in Mexico City: baggage claim. Inefficient in the extreme, baggage claim sometimes resembles an ugly mob scene.

3. FRANKFURT'S AIRPORT

Getting from the gate to baggage claim seemingly takes longer than your flight at Frankfurt's airport says Elliott, who cautions travelers to factor getting lost into their travel time.

4. MOSCOW'S SHEREMETYEVO AIRPORT

A relic of the Communist era, Moscow's Sheremetyevo Airport offers travelers a grimy and oppressively crowded introduction to Russia. Getting through customs can take an eternity, and the only public transportation available is Moscow's prehistoric bus system.

5. PARIS'S CHARLES DE GAULLE AIRPORT

Rude Parisians and a confusing layout make this airport a particular chore to navigate for many travelers, who also object to—voilà!—the perpetual cigarette smoke.

ATTORNEYS TO SPARE
Countries with the Most Lawyers

In *Henry VI*, William Shakespeare expresses his deep, abiding love for the legal profession: "The first thing we do, let's kill all the lawyers."

Dream on. Lawyers aren't going away anytime soon, despite the immortal Bard's clarion call for rather drastic measures to curtail frivolous lawsuits. According to *The Virginia Law Review*, the following six countries have the highest ratio of attorneys per 1,000 people.

No figures are included on how the stats correlate with the number of ambulances in the given countries. But wherever there are ambulances, a posse of ethically challenged lawyers won't be too far behind.

Country	Lawyers per 1,000 people
1. United States	3.11
2. Great Britain	1.49
3. Germany	0.83
4. France	0.41
5. Sweden	0.31
6. Japan	0.11

AVALANCHES
Here's Mud in Your Eye

In *Merriam-Webster's Collegiate Dictionary*, an avalanche is defined as "a large mass of snow, ice, earth, rock or other material in swift motion down a mountainside or over a precipice." What that definition fails to convey is any sense of the devastation wrought by an avalanche, both in terms of damage to the landscape and the loss of human life. Just imagine millions of tons of snow and ice hurtling towards you without warning down a frozen slope, gathering terrible speed as it pulverizes everything in its path. Suddenly, that old Christmas Carol "Let It Snow, Let It Snow, Let It Snow" takes on a faintly ominous ring, doesn't it?

Here is a ranking of the 10 most devastating avalanches in recorded history in terms of fatalities:

Location	Date	Fatalities
1. Mount Huascaran, Yungay, Peru	May 31, 1970	20,000
2. Tyrol, Italian-Austrian Alps	December 13, 1916	10,000
3. Mount Huascaran, Ranrahirca, Peru	January 10, 1962	3,500
4. Plurs, Switzerland	September 4, 1618	1,500
5. Blons, Austria	January 12, 1954	315

Location	Date	Fatalities
6. Alpine region, Europe	1950–1951	265★
7. Bingol, Turkey	1991	255
8. Lahoul Valley, India	1979	200
9. Republic of North Ossetia, Caucasus	2002	150
10. Wellington, Washington	March 1, 1910	118

★*265 people died in a series of avalanches during a 3-month period.*

BIRTH CONTROL
Lowest Contraceptive Usage

With all those people crowding the streets of China, you might think they would rank pretty low in terms of contraceptive use. But you'd be surprised—they're ranked second highest, with 84% usage.

There may be a lot of people in China, but overall, it isn't a by-product of low contraceptive use. In the countries listed below, contraceptives are not readily available and neither is the money to buy them. More importantly, information about contraception—what it is, what it does, and what types are out there—is not widely disseminated.

The following list ranks countries based on the lowest contraceptive use among married women according to 2003 research by the United Nations Department of Economic and Social Affairs. If the rate is this low among married women, just imagine what the rate is for teenagers.

Country	Contraceptives Use
1. Chad	4%
2. Eritrea	5%
3. Mozambique	6%
Guinea	6%
5. Mali	7%
6. Niger	8%
Ethiopia	8%
8. Burkina Faso	12%
9. Senegal	13%
Rwanda	13%

BURGLARIES
Breaking In Is Not Just for New Shoes

A way of life? In America, some might think so. The United States is tops in the world for burglaries.

Is it because people in the United States have stuff burglars want, or does its moral fiber foster thievery? So you think the United States with its almost 300 million people tops the list because it's the third most populous nation? India with its *one billion* population has nearly 20 times *fewer* break-ins! And Australia with its mere 20 million folks is third on the list. And hey, where's China? How did its 1.25 billion inhabitants, the world's largest population, fail to make the top-10 list?

No attempt to explain it—these are just the facts, ma'am, according to the United Nations Survey of Crime Trends in 2000, from which the list of the top-10 burglarized nations is culled:

Country	Total Burglaries
1. United States	2,099,700
2. United Kingdom	836,027
3. Australia	436,865
4. South Africa	394,557
5. France	370,993
6. Poland	364,786
7. Japan	296,486
8. Canada	293,416
9. Mexico	139,679
10. India	111,296

CANCER
Highest Death Rates

The homeland of such diverse figures as composer Franz Liszt, Nobel Peace Prize winner Elie Wiesel, and the ageless Zsa Zsa Gabor, Hungary has undergone an economic renaissance in recent years since the end of Communism. Sadly, there's also been a spike in the number of cancer fatalities. In the World Health Organization's four-year study of cancer deaths in 26 countries on four continents, this tiny central Europe country approximately the size of Indiana came out on top; Finland had the lowest rates, which speaks well for the health benefits of vodka and midnight sun. The United States ranked 15th with 143.4 deaths per 100,000.

Given these grim statistics, it should come as no surprise that Hungary has one of the lowest life-expectancy rates in the world. At birth, men only have a 59% chance of reaching the age of 65. For women, the numbers are better—81.1%—but the sad fact remains that terminal cancer strikes Hungarians of all ages at substantially higher numbers than the second country on the list, the Czech Republic.

Country	Cancer Deaths Per 100,000 People
1. Hungary	219.4
2. Czech Republic	182.9
3. Denmark	173.6
4. Slovakia	172.3
5. Poland	165.2
6. Belgium	162.8
7. Ireland	159.3
8. New Zealand	157.1
9. The Netherlands	156.3
10. United Kingdom	151.7

CAR THEFTS
Countries with the Most Automobiles Stolen

Forty-five to ninety seconds—that's roughly how long it takes a professional car thief to break into your car, disarm the security system, and make a fast getaway. And just what hi-tech gizmo does he use? Why your basic screwdriver, since if he were to use a saw and get arrested, he'd get

slapped with an additional felony charge on top of grand theft auto. In the United States, a car is stolen every 27 seconds. Think that's bad? Consider the car theft stats for Australia, which has the world's highest rate of car thefts. On average, seven cars are stolen for every 1,000 Aussies in the Land Down Under. Here's a look at which countries have the most car thefts, according to the 2000 United Nations Survey of Crime Trends:

Country	Car Thefts Per 1,000 People
1. Australia	7.04
2. Denmark	5.98
3. United Kingdom	5.63
4. New Zealand	5.56
5. Norway	5.13
6. France	5.01
7. Canada	4.97
8. Italy	4.20
9. United States	3.95
10. Ireland	3.78

CHILD ABUSE DEATHS
Most Reported Cases

America has the highest rate of child abuse in the world.

While it may be the richest and most powerful nation on the face of the earth, the United States is not necessarily the safest for children under the age of 15. In a deeply troubling report commissioned by UNICEF, the United States ties Mexico as the country with the highest rate of *reported* child maltreatment deaths; one can only speculate about the cases that go unreported elsewhere in the world.

Of the 27 countries in the report, Spain fares best, with a rate of 0.1 child maltreatment deaths per 100,000. Hopefully, these grim statistics will

serve as a wake-up call in these 10 countries, some of which ironically boast remarkably high standards of living, like the United States, Switzerland, and Denmark.

Country	Child Abuse Deaths Per 100,000
1. United States	2.2
2. Mexico	2.2
3. New Zealand	1.2
4. Hungary	1.2
5. Austria	0.9
6. Switzerland	0.8
7. Australia	0.7
8. Finland	0.7
9. Canada	0.7
10. Denmark	0.7

CHILD POVERTY, USA
The United States of Hunger

Did your mother tell you to clean your plate because there are starving children in China? Well, she may have been right—but what she failed to mention is that there are children living in poverty right here in the United States.

In his 1928 presidential campaign, Herbert Hoover vowed to make America a country with a chicken in every pot and a car in every garage. As a nation, we've attained that and more. In fact, most foreigners view the United States as a wealthy nation—with two or three cars in our garages and food overflowing on our dining-room tables.

But despite this overall wealth, the child poverty rate in the United States is among the highest in the developed world. According to the Luxembourg Income Study, American children have a greater likelihood of growing up poor than children in 17 of the wealthiest industrialized nations.

Here is a ranking of the worst child poverty levels by state (and District of Columbia), as determined by the U.S. Census Bureau in 2000. Poverty level is considered income of $14,494 for a single parent and

two children. The District of Columbia tops the list, with 31.7% of children under the age of 18 living below the poverty line.

State	% Below Poverty Line
1. District of Columbia	31.7%
2. Mississippi	27.0%
3. Louisiana	26.6%
4. New Mexico	25.0%
5. West Virginia	24.3%
6. Arkansas	21.8%
7. Alabama	21.5%
8. Kentucky	20.8%
9. Texas	20.5%
10. New York	20.0%

CHURCHGOERS
Worst Church Attendance, by Nation

Going to church used to be a weekly ritual. You'd get all dressed up in your Sunday best, greet your friends, and nod off during the sermon, waking only to place your offering in the collection plate. But if the church attendance statistics compiled by religioustolerance.org are accurate, a whole lot more people prefer sleeping in to salvation these days. According to that Web site's latest poll figures, 44% of Americans and 38% of Canadians *claim* they go to church once a week. Sounds fairly devout, right? But as the Web site reports, most people tend to exaggerate their church attendance when speaking with a pollster. In reality, only 20% in the United States attend church once a week, whereas in Canada the figure drops to a sinful 10%. Still, a higher percentage of Canucks squeeze into pews regularly than the citizens of the following ten countries, which have the lowest percentage of regular churchgoers in the world:

Country	Church Attendance
1. Russia	2%
2. Japan	3%
3. Sweden	4%

Russia's most famous landmarks are churches, but don't expect to find very many worshippers there. The former Soviet nation has the lowest percentage of church-goers in the world.

Country	Church Attendance
4. Iceland	4%
5. Estonia	4%
6. Finland	4%
7. Denmark	5%
8. Norway	5%
9. Latvia	5%
10. Azerbaijan	6%

CIGARETTE SUCKERS
World's Heaviest Smokers

Looking to take a smoke-free holiday abroad? Better scratch the Greek isles off your itinerary. According to World Health Organization statistics, the Greeks are the world's heaviest smokers. The average Greek smoker lights up just over 4,300 cigarettes a year—that breaks down to approximately 12 a day, or 216 packs of 20 cigarettes annually. Yet sur-

prisingly, the Greeks' fondness for smoking isn't reflected in substantially higher incidents of cancer; the same cannot be said for Hungary, number 2 on the list. In fact, the Greeks are statistically much less likely to die from cancer than people in the United States, where smoking is now verboten in most public places, much to the chagrin of Big Tobacco and chain-smoking barflies. Maybe all that nasty tar and nicotine in cigarettes is no match for the healing powers of the Greeks' prized olive oil.

Here are the ten countries whose citizens puff away on the highest number of cigarettes yearly:

Country	Yearly Number of Cigarettes Per Person
1. Greece	4,313
2. Hungary	3,265
3. Kuwait	3,062
4. Japan	3,023
5. Spain	2,779
6. Malta	2,668
7. Bulgaria	2,574
8. Belarus	2,571
9. Belgium	2,428
10. Turkey	2,394

CITY DRIVING
America's Toughest Burgs to Navigate

It takes nerves of steel to drive in Boston, which is a congested blur of bridges, tunnels, and narrow streets. And then there are the infamous Boston drivers, who would give NASCAR champ Jeff Gordon a run for his money.

In 2004 researcher Bert Sperling compiled a list of the hardest U.S. cities to navigate. Beantown heads the list for the aforementioned reasons. Another factor Sperling considered was weather. Snow doesn't deter the drivers in Minneapolis, where snow is nearly as common as sunshine. But try driving in New York City or Washington DC during a rush-hour snowstorm. The thought is enough to send chills down your spine. Here's Sperling's 10 hardest U.S. cities to navigate. Better

In Boston, it's as bad as it gets for driving, the hardest city in the United States to navigate by car.

get a cab or good Global Positioning System if you plan to visit them anytime soon.

1. Boston, Massachusetts
2. Washington DC
3. San Francisco, California
4. Baltimore, Maryland
5. New York, New York
6. Fort Lauderdale, Florida
7. Los Angeles, California
8. Seattle, Washington
9. Providence, Rhode Island
10. Charleston, South Carolina

CITY LIFE
Worst Places to Live

Looking to relocate to some far-flung locale where every day is an exotic adventure out of a novel? Then you might want to take off those thick rose-colored glasses and read the following entry before dusting off your passport and getting vaccinated. Each year, the British company Mercer Human Resources Consulting conducts a survey of 215 cities worldwide to determine the best and worst places to live. Using a

base score of 100, the company evaluates cities on 39 factors in 10 categories: consumer goods, economic environment, housing, medical/health considerations, natural environment, political/social environment, public services/transportation, recreation, schools/education, and socio-cultural environment.

Given the ongoing turmoil in Iraq, it should surprise no one that Baghdad comes in dead last in the rankings, with an overall score of just 14.5! As for the best, Swiss efficiency triumphs again, with Zurich and Geneva tying for first place; each scored 106.5 points. In the United States, Southern hospitality apparently doesn't count for much, since Atlanta ranks lowest, coming in 66th with a score of 94.5. Honolulu and San Francisco are the most livable American cities, tying for 24th place with a score of 102.

Here are the world's cities where daily life is a grim struggle to survive:

City/Country	Livability Score
1. Baghdad, Iraq	14.5
2. Bangui, Central African Republic	28.5
3. Brazzaville, Congo	29.5
4. Pointe Noire, Congo	33.5
5. Khartoum, Sudan	33.5
6. Sanaa, Republic of Yemen	38.5
7. Ouagadougou, Burkina Faso	38.5
8. Nouakchott, Mauritania	38.5
9. Ndjamena, Chad	38.5
10. Luanda, Angola	38.5

CITY NAMES
Most Unflattering Names for Cities and Towns

It's been said that you are what you do. It's also been said that you are what you eat. Thank heavens there's no known saying that you are where you live. If there were, how would you like to claim being from Bastard, Ontario, in Canada? Or Hell, Norway? And just try to win

friends and influence enemies once they find out you hail from Repulse Bay!

Apparently, civic pride runs fairly low in the following communities, which rank as the worst cities to foster self-esteem both in the United States and abroad. One look at this list and you have to ask yourself: what the #!*$ were the town fathers thinking?

U.S. Cities	*Cities of the World*
1. Boring, Oregon	1. Bastard, Ontario, Canada
2. Eek, Alaska	2. Boring, Vejle, Denmark
3. Embarrass, Wisconsin	3. Condom, Gers, Midi-Pyrénées, France
4. Greasy, Oklahoma	
5. Gripe, Arizona	4. Dum Dum, West Bengal, India
6. Hardscrabble, Delaware	5. Economy, Nova Scotia
7. Oddville, Kentucky	6. Fucking, Austria
8. Okay, Oregon	7. Hell, Cayman Islands
9. Peculiar, Missouri	8. Hell, Norway
10. Why, Arizona	9. Repulse Bay, Nunavut, Canada

CIVIL WAR FATALITIES
World-Record Rebel Rousing

Nearly 140 years after Robert E. Lee surrendered to Ulysses S. Grant at Appomattox, the Civil War continues to exert a powerful hold on the American imagination. Yet while it remains the bloodiest war ever fought on American soil, the epic struggle between the Union and the Confederacy can't compare in terms of fatalities to China's Taiping Rebellion, which was taking place at roughly the same time. An estimated 20 million people died in this 14-year war, in which peasants organized by Hung Xiuquan rose up against the forces of the Qing dynasty. While the exact death toll is probably lost to history, the Taiping Rebellion undeniably tops the list of the 10 deadliest civil wars of the last 200 years according to estimated total fatalities:

Country	Dates	Estimated Total Fatalities
1. China (Taiping Rebellion)	1850–64	20,000,000
2. Russia (Russian Revolution)	1917–22	9,000,000
3. China (Communist Revolution)	1946–50	2,500,000
4. Sudan	1983–99	1,500,000
5. United States	1861–65	600,000
6. Somalia	1991–93	400,000
7. Congo	1998–2003	350,000
8. Spain	1936–39	270,000
9. Liberia	1989–2003	220,000
10. Sierra Leone	1991–2002	50,000

COLD NOSES, USA

Record Lowest Temperatures in America

What most of us in the lower 48 would consider unbearably cold, Alaskans usually take in their snowy stride. But even the hardiest of the state's residents shiver at the frigid memory of January 23, 1971. On that bone-chilling day, the mercury plunged to 80 degrees below zero—the coldest recorded temperature in U.S. history. And that's not including the wind chill. Brrr!!!

The next lowest temperature doesn't even hold a candle to that Alaskan deep freeze. It was a balmy 70 degrees below zero in Montana in the winter of 1954. Most of the other states with record cold spells won't be much of a surprise.

Oh, but if you plan to sleep out under the stars in the dry heat of New Mexico, you might just want to take along an insulated sleeping bag. The Land of Enchantment hit 50 below zero in February of 1951. Surprisingly, it didn't make the National Climatic Data Center's 2004 ranking of the 10 coldest temperatures in U.S. history.

State	Degrees Fahrenheit	Location
1. Alaska	80 below	Prospect Creek camp, January 23, 1971
2. Montana	70 below	Rogers Pass, January 20, 1954
3. Utah	69 below	Peter's Sink, February 1, 1985
4. Wyoming	66 below	Riverside, February 9, 1933
5. Colorado	61 below	Maybell, February 1, 1985
6. Idaho	60 below	Island Park Dam, January 18, 1943
6. Minnesota	60 below	Tower, February 2, 1996
7. South Dakota	58 below	McIntosh, February 17, 1936
8. Wisconsin	55 below	Couderay, February 4, 1996
9. Oregon	54 below	Seneca, February 10, 1933
10. New York	52 below	Old Forge, February 18, 1979

CONVENTION CENTERS, USA
Most Crime-Ridden Convention Centers

Attending a business convention is an opportunity to network and learn new strategies. More importantly, it's a great excuse for getting out of the office and treating yourself to lavish dinners on the company dime—all in the name of business, right?

Yet there's a possible downside to attending a convention in any of the following cities—and it's not explaining the hefty room-service tab on your expense report. According to the 2004 CAP Index, which specializes in crime forecasting, convention attendees might want to stock up on mace before going to any of these convention centers. At Chicago's McCormick Place, the crime rate is a hair-raising *thirteen* times the national average. And in Washington DC, the convention center was built on a site frequented by drug dealers. On the flip side, Orlando's Orange County Convention Center has one of the lowest crime rates in the nation. That's one of the perks of being located near the happiest place on earth.

Here are America's 10 most dangerous convention centers according to the 2004 CAP Index:

Convention Center	Crime Rate, Times National Average
1. McCormick Place, Chicago	13
2. Cobo Conference/Exhibition Center, Detroit	10
3. Washington Convention Center, Washington DC	10
4. Jacob K. Javits Convention Center, New York	9.5
5. Miami Beach Convention Center, Miami Beach	9
6. San Diego Convention Center, San Diego	9
7. Los Angeles Convention Center, Los Angeles	9
8. Seahawk Stadium & Exhibition Center, Seattle	8.5
9. Ernest N. Morial Convention Center, New Orleans	8.5
10. Georgia World Congress Center, Atlanta	8

COSMETIC SURGERY
Countries with the Most Plastic Surgery Procedures

Growing old gracefully used to mean accepting the wrinkles, double chins, and gray hairs of age with good-natured forbearance. But for the thousands of Americans getting nipped, tucked, and lifted annually, the goal is to turn back the clock—or at least stop it for a while—thanks to the wonders of plastic surgery.

The obsession with looking youthful—sometimes unnaturally so—has swept the globe. More and more people are going under the plastic surgeon's knife to defy the ravages of time and gravity. Sometimes the results are stunning. And then there are those actresses of a certain age whose faces are stretched tighter than snare drums.

It probably doesn't surprise you that the United States leads the

world in the number of plastic surgery procedures. As the baby boomers approach retirement age, expect these numbers to swell further, along with the wallets of the plastic surgeons.

According to The International Society of Aesthetic Plastic Surgery, here are the 10 countries where the most plastic surgery procedures were performed in 2002:

Country	Number of Procedures
1. United States	90,992
2. Mexico	52,956
3. Brazil	47,957
4. Japan	42,842
5. Spain	40,164
6. Germany	23,140
7. France	21,170
8. Argentina	17,698
9. Switzerland	16,073
10. Italy	14,784

COST OF LIVING
Places You Probably Can't Afford

Think it's expensive in New York City or that Beverly Hills might be the most expensive place in the world? If so, you don't get out of house much—there are no U.S. cities in the top-10 most expensive places on the globe.

The list below compiled by the Mercer Human Resource Consulting *Cost of Living Survey, 2004* easily explains why so many Japanese make rice one of their main staples. The cities are ranked in descending order of expense.

1. Tokyo, Japan
2. London, United Kingdom
3. Moscow, Russia
4. Osaka, Japan
5. Hong Kong
6. Geneva, Switzerland
7. Seoul, South Korea
8. Copenhagen, Denmark
9. Zurich, Switzerland
10. St. Petersburg, Russia

COST OF LIVING, USA
Most Overpriced American Cities

Thinking of moving to Honolulu? Well, unless you've got gobs of cash or a great job lined up, say aloha to affordable living, 'cause paradise don't come cheap.

In 2002, writers at *Forbes* magazine named Honolulu America's most overpriced city. Housing costs are sky-high and the general cost of food and recreation is steep, yet job and salary growth is bleak.

The cities that made the list below are the most overpriced metropolitan areas in the United States. Unfortunately, instead of rising to meet the ballooning cost of living, the average salaries seem to be shrinking.

1. Honolulu, Hawaii
2. Bergen-Passaic, New Jersey
3. Salinas, California
4. Los Angeles, California
5. Anchorage, Alaska
6. Nassau, New York
7. Ann Arbor, Michigan
8. Chicago, Illinois
9. Miami, Florida
10. Reno, Nevada

CRIME CAPITALS
Most Dangerous Cities

Home to the 2004 NBA Champs Detroit Pistons, soul diva Aretha Franklin, and the Ford Motor Company, Detroit, Michigan, is hardly a tourist magnet. The Motor City is the most dangerous city in the United States, according to the rankings of 350 cities in the 2004 Morgan Quitno Safest City Award listings. Based on its showing in six categories—murder, rape, aggravated assault, robbery, burglary, and motor vehicle theft, Detroit came in—pun intended—dead last.

1. Detroit, Michigan
2. St. Louis, Missouri
3. Atlanta, Georgia
4. Camden, New Jersey
5. Washington DC
6. Compton, California
7. Dayton, Ohio
8. Baltimore, Maryland
9. Tampa, Florida
10. Gary, Indiana

It looks good in spots, but watch where you take your next stroll in Detroit. The Motor City is ranked as the most dangerous big city in America.

DEEP FREEZES
Lowest Recorded Temperatures

If you can't afford the heating bills in some locales, the only alternative is a heavy sweater. But there are spots on the globe where even two or three woolen pullovers won't help. Here are the lowest temperatures recorded in various areas, according to the *Almanac of Science & Technology*:

Location and Date	Degrees Fahrenheit
1. World: Vostok, Antarctica, July 21, 1983	−129
2. Asia: Oimekon, Russia, Feb. 6, 1933	−90
3. Greenland: Northice, Jan. 9, 1954	−87
4. North America (excl. Greenland): Snag, Yukon, Canada, Feb. 3, 1947	−81

Location and Date	Degrees Fahrenheit
5. United States: Prospect Creek, Alaska, Jan. 23, 1971	−80
6. United States (excl. Alaska): Rogers Pass, Montana, Jan. 20, 1954	−70
7. South America: Sarmiento, Argentina, June 1, 1907	−27
8. Africa: Ifrane, Morocco, Feb. 11, 1935	−11
9. Australia: Charlotte Pass, N.S.W., June 29, 1994	−9
10. Oceania: Mauna Kea, Hawaii, May 17, 1979	12

DIVORCE RATES

Highest Incidences of Marriage Dissolution

The divorce rate in the United States attracts a lot of attention, possibly because of the high rate of celebrity divorce. It seems each issue of *People* magazine announces a new couple calling it quits. But the United States in general? It doesn't even make the top 20. For whatever reason, the majority of countries with the highest divorce rate are northern European nations, plus a couple down under (Australia and New Zealand). All of them are wonderful places to visit, maybe even honeymoon. But be careful about falling for a native. Your marriage might not last as long as your tourist Visa.

Here's a look at the countries with the highest divorce rate according to the Organisation for Economic Co-operation and Development, 2002:

Country	Divorces Per 100 Marriages
1. Belgium	59.8
2. Sweden	53.9
3. Czech Republic	53.7
4. Finland	53.2
5. Hungary	49.9
6. Austria	49.8
7. Luxembourg	48.0

Country	Divorces Per 100 Marriages
8. New Zealand	47.1
9. Australia	46.0
10. Norway	39.7

DOCTOR DEARTH

Nations with the Fewest Physicians Per Capita

If you think the wait is long at your family doctor's office, look on the bright side—you could be #999 in line to see a doctor in Turkey, where there is only one doctor for every 1,000 people.

Whereas some countries have specialists in every conceivable branch of medicine, there are parts of the world where one physician takes care of an entire community. According to the Organisation for Economic Co-operation and Development, these are the nations with the fewest doctors in 2004:

Country	Doctors Per 1,000 People
1. Turkey	1.2
2. South Korea	1.3
3. Mexico	1.7
4. United Kingdom	1.8
5. Japan	1.9
6. Canada	2.1
7. Ireland	2.3
Poland	2.3
New Zealand	2.3
10. Australia	2.5

DOG DAYS, USA

Record High Temperatures in America

Ah, those lazy, hazy, crazy days of summer. Lemonade, warm breezes, brown grass, drought, and heat stroke. In the dead of winter when temperatures are below freezing, most of us look forward to summer. But sometimes Cole Porter was right: it's too darn hot.

The highest temperatures are typically in areas such as the desert where the soil is dry and humidity is low. It's no surprise, then, that

some of the highest temperatures on record occurred in Arizona and New Mexico. But North Dakota? Who'd have thought?

If you can't stand the heat, get out of the following states during the summer months. Here's the National Climatic Data Center's 2004 ranking of record highs in the United States:

State	Degrees Fahrenheit	Location
1. California	134	Greenland Ranch, July 10, 1913
2. Arizona	128	Lake Havasu City, June 29, 1994
3. Nevada	125	Laughlin, June 29, 1994
4. New Mexico	122	Waste Isolation Pilot Pit, June 27, 1994
5. Kansas	121	Alton, July 24, 1936
North Dakota	121	Steele, July 6, 1936
7. Arkansas	120	Ozark, August 10, 1936
8. Oklahoma	120	Tipton, June 27, 1994
South Dakota	120	Gannvalley, July 5, 1936
Texas	120	Seymour, August 12, 1936

DRINKING WATER SHORTAGES
Where's the ~~Beef~~ H$_2$O?

Few people in the world have endured more hardship in the last 20-odd years than the citizens of Afghanistan. Since the late 1970s, when the Soviets attempted to wrest control of the country, the Afghan people have experienced one disaster after another, from war to brutal repression at the hands of the Taliban. Although the country is now taking its first, tentative steps towards long-overdue political reform, Afghanistan's infrastructure has basically lain in ruins since the Soviet occupation. This is most glaringly apparent in the lack of precious drinking water. Some people have to go a mile or more to get some. According to the latest figures in a study jointly conducted by UNICEF and the World Health Organization, only 13% of

Need a drink of water? Here in Afghanistan, you'll need to go a piece or two down the road. Afghanis have the worst access to drinking water in the world.

Afghanistan's nearly 29 million people have ready access to drinking water.

Here are the 10 countries in the UNICEF/WHO study whose citizens have the least access to drinking water:

Country	Access to Drinking Water (% of Population)
1. Afghanistan	13
2. Ethiopia	22
3. Somalia	29
4. Cambodia	34
Chad	34
6. Papua New Guinea	39
7. Mozambique	42
8. Laos	43
9. Equatorial Guinea	44
10. Madagascar	45

DRIVERS AND DIPLOMACY
Worst Abuses of Diplomatic Immunity in Britain

For all the giant steps Libya has taken on the world stage, like paying $2.7 billion in compensation to the Lockerbie victims' families, the country's diplomats have a bad habit of ignoring traffic fines in the United Kingdom. According to the British Foreign Office, Libya's diplomats racked up an incredible £34,480 in 2003. At current exchange rates, that translates to just over $62,000! Talk about diplomatic immunity!

Here are the 10 countries whose diplomats accumulated the most unpaid traffic fines in the United Kingdom for 2003 according to the British Foreign Office:

Country	Unpaid Traffic Fines
1. Libya	£34,480
2. Saudi Arabia	£24,200
3. Nigeria	£16,460
4. Georgia	£15,850
5. China	£14,080
6. Kazakhstan	£13,670
7. Turkey	£10,410
8. Egypt	£10,930
9. Ghana	£9,650
10. Greece	£8,230

DRUG TRAFFIC MECCAS
Walgreens Doesn't Count

In the war on drugs, law enforcement officers around the world face cunning and heavily funded drug traffickers who seemingly multiply like cockroaches. For every cartel the DEA busts or drug lord whose financial assets are frozen, there are countless more operations flying under the legal radar. According to the latest findings in the *CIA World Factbook*, here is a ranking of the 10 countries with the most active drug-trade operations in the world:

1. PHILIPPINES
Filipino drug traffickers export locally grown marijuana and hashish to the East and the United States. This nation is also a major transit point for heroin and crystal methamphetamine.

2. GREECE
Drug-related money laundering is huge in Greece, which drug smugglers use as a gateway for bringing heroin and marijuana from the Middle East to the West.

3. CHILE
Much of the cocaine destined for the United States and Europe passes through Chile, where drug use is rising.

Road congestion is a problem here in the Philippines, but motor traffic takes a back seat to drug traffic. The Philippines is the number one nation in the world for illegal drug dealing.

4. THAILAND
Despite government crackdown efforts, Thailand continues to be a producer of opium, heroin, and marijuana. The country is also a transit point for heroin to Burma and Laos.

5. NIGERIA
A corrupt, indifferent government makes Nigeria a prime location for drug traffickers. Money-laundering continues unchecked in this African nation, the transit point for heroin and cocaine destined for Europe, East Asia, and North America.

6. SYRIA
A transit point for opiates and hashish destined for both the region and the West.

7. SINGAPORE
Stringent anti-drug laws fail to deter drug traffickers from using Singapore as a transit point for heroin from the infamous "Golden Triangle."

8. SWITZERLAND

Money-laundering is practically nonexistent here. However, Switzerland is a prime transit point and consumer of both South American cocaine and Asian heroin.

9. NAURU

All money-laundering operations welcome!

10. LEBANON

Although cultivation of marijuana and opium poppies has fallen in recent years, it's still strong enough to warrant Lebanon's inclusion in this list.

EARTHQUAKES, USA
The Days America Moved the Most

Well, it's still there. California, that is. In spite of dire predictions that California will fall into the Pacific Ocean any minute now, the golden state seems to be hanging in there pretty well.

In fact, compared to some countries, the United States has been lucky in terms of destructive earthquakes. The worst have occurred in Alaska, a sparsely populated state. Missouri has experienced a couple of scares, and although California hasn't been spared entirely, the quakes hitting the state haven't gone off the Richter scale.

Here's a look at the eight U.S. earthquakes that have spiked highest on the Richter scale, according to the U.S. Geological Society in 2003. Numbers 9 through 14 are tied at 7.9. Four of these took place in Alaska, one in Hawaii, and one in Fort Tejon, California, way back in 1857.

1. PRINCE WILLIAM SOUND, ALASKA, 1964: 9.2

While only 15 lives were lost in the actual earthquake, another 125 people died in the associated tsunami. Roughly $311 million was lost in property damage.

2. ANDREANOF ISLANDS, ALASKA, 1957: 9.1

The resulting tsunami caused much more damage than the original earthquake. More than 300 aftershocks were felt along the southern edge of the Aleutians.

3. RAT ISLANDS, ALASKA, 1965: 8.7
The earthquake produced only minor damage, but it spawned a tsunami that caused $10,000 in property damage.

4. EAST OF SHUMAGIN ISLANDS, ALASKA, 1938: 8.2
While this submarine quake registered high on the Richter scale, it hit a sparsely populated area and caused little damage.

5. NEW MADRID, MISSOURI, 1811: 8.1
Covering an extremely large area in Mississippi River Valley, this was one of the largest earthquakes in history. Since the area wasn't heavily populated, the quake did little damage. The aftershocks set off a series of five earthquakes in the general area within two months.

6. YAKUTAT BAY, ALASKA, 1899: 8.0
A series of major earthquakes struck the region, altering the course of glaciers in the area and creating a tsunami, an avalanche, and the release of icebergs.

ANDREANOF ISLANDS, ALASKA, 1986: 8.0
Only moderate damage resulted from this 8.0 earthquake near a small Alaskan island.

NEW MADRID, MISSOURI, 1812: 8.0
This is the fourth in the series of earthquakes that hit the Mississippi River Valley area in 1811–1812. It destroyed the town of New Madrid and damaged homes and chimneys in St. Louis.

EARTHQUAKES
World's Biggest Movers and Shakers

It's difficult to put the label of "worst" on an earthquake, since there are many factors in making an earthquake a bad one. In 1556 an earthquake claimed the lives of 830,000 people in Shansi, China, making it by far the deadliest earthquake on record, if not the strongest. China was the unfortunate site of several other earthquakes with fatalities ranging between 100,000 and 255,000.

In 1935 Charles F. Richter of the California Institute of Technology developed the Richter scale, a mathematical formula that ex-

presses earthquake magnitude in terms of whole numbers and decimal fractions. Seismologists now use the Richter scale to measure severity. Here is the U.S. Geological Survey's 2004 ranking of the world's worst earthquakes since 1900, based on where they fall on the Richter scale:

1. CHILE, 1960: 9.5
The strongest earthquake ever recorded, this one hit near the coast, killing 2,000 people and injuring another 3,000.

2. PRINCE WILLIAM SOUND, ALASKA, 1964: 9.2
This is the strongest quake to strike North America, claiming the lives of 125 people. Occurring 80 miles east of Anchorage, the subsequent seismic wave traveled 8,445 miles.

3. ANDREANOF ISLANDS, ALASKA, 1957: 9.1
The worst damage was done when the aftershock triggered a 15-meter tsunami that smashed into the coast and an 8-meter tsunami that washed away buildings. The 8-meter tsunami traveled all the way to Hawaii, where it destroyed 2 villages.

4. KAMCHATKA, 1952: 9.0
Here again, an earthquake generated a tsunami that caused almost $1 million in property damage on the Hawaiian Islands. Six cows were killed, but no human lives were lost.

5. INDIAN OCEAN, 2004: 9.0
A massive undersea earthquake off Sumatra generated a powerful tsunami that slammed into eleven Southeast Asian countries, killing an estimated 150,000 people. The total financial damage may eventually top $14 billion.

6. OFF THE COAST OF ECUADOR, 1906: 8.8
Severe shock waves created a tsunami that killed almost 1,500 people in Ecuador and Columbia. Shocks were felt as far north as San Francisco and as far west as Japan.

7. RAT ISLANDS, ALASKA, 1965: 8.7
A strong earthquake according to the Richter scale, but relatively mild in terms of damage, totaling only $10,000.

8. ASSAM—TIBET, 1950: 8.6
Rockslides resulting from this earthquake destroyed several villages and some forest area. Landslides accounted for 156 casualties.

Eight days later, the dike at Subansiri broke open, submerging several villages and killing 532 people.

9. KAMCHATKA, 1923: 8.5
This is the first of two major quakes to hit this area.

BANDA SEA, INDONESIA, 1938: 8.5
This earthquake was felt in the islands of Kai, Banda, New Guinea, and Australia.

EDUCATIONAL ATTAINMENT
Least-Educated Countries

Of the nearly 12 million people living in the African nation of Mali, just 15% are literate. Considering that children in this poor, desert country south of Algeria attend school on average of 2.1 years, such a dismal literacy rate isn't surprising. Sadly, the education rates in Mali are pretty much the norm for Sub-Saharan African countries, many of which have endured famine, drought, and horrific civil strife in the last

The children of Mali go to school an average of 2.1 years, making it the least-educated nation on earth.

few years. Here's UNESCO's 2002 ranking of least-educated countries:

1. Mali
2. Niger
3. Burkina Faso
4. Djibouti
5. Chad
6. Ethiopia
7. Democratic Republic of Congo
8. Eritrea
9. Burundi
10. Tanzania

ELBOW ROOM
Almost No Folks at All

You may think you'd like to get away from it all at times. Those who do, however, don't always enjoy the solitude. In Western Sahara, where the population density is 2.6 people per square mile, even the local pa-

Sick of crowds? These tourists practically packed the place here in Western Sahara, the nation with the "most elbow room": that is, the lowest population density on earth.

paya juice counter draws few on free-sample day. Though Hillary Clinton maintains "it takes a village," in the places listed below, not only are you sure not to find too many, you can also be sure it's easy to find a table at the best restaurants, even on Saturday night.

Here are the countries with the lowest population density according the International Database of the U.S. Census Bureau:

Country	People Per Square Mile
1. Western Sahara	2.6
2. Mongolia	4.6
3. Namibia	6.1
4. Australia	6.7
5. Botswana	6.7
6. Suriname	6.9
7. Iceland	7.4
8. Mauritania	7.5
9. Libya	8.3
10. Canada	8.4

EXPLOSIONS
Biggest Booms of All Time

On April 27, 1865, the Union riverboat *Sultana* was paddling up the Mississippi River carrying over 2,200 passengers when one of its massive boilers exploded. The ship was suddenly engulfed in flames, making escape nearly impossible. Those who didn't burn to death drowned in the Mississippi, not far from Memphis. All told, 1,547 people died, many of them Union soldiers just released from the Confederate prison Andersonville, in what is the worst explosion in American history, excluding mining, military, and terrorist-related explosions.

The Sultana tragedy ranks third on our list of all-time worst explosions in terms of fatalities:

Location	Source of Explosion	Date	Est. Fatalities
1. Lanchow, China	Arsenal	October 26, 1935	2,000
2. Halifax, Nova Scotia	Ammunition ship	December 6, 1917	1,635
3. Memphis, Tennessee	Ship boiler	April 27, 1865	1,547
4. Bombay, India	Ammunition ship	April 14, 1944	1,376
5. Cali, Columbia	Ammunition trucks	August 7, 1956	1,200
6. Salang Tunnel, Afghanistan	Oil tanker collision	November 2, 1982	1,100
7. Lagos, Nigeria	Military depot	January 27, 2002	1,000
8. Texas City, Texas	Ammonium nitrate on freighter	April 16, 1947	752
9. Oppau, Germany	Chemical plant	September 21, 1984	508
10. Uta, USSR	Liquid gas at railway	June 3, 1989	500

FAMINES

Worst Food Shortages of All Time

One of the saddest international news stories in recent years has been plight of the Sudanese people. In a country ravaged by civil war for nearly two decades, millions have been displaced or killed. Many of the deaths resulted from war-sponsored famine; both the Sudanese government and the rebel forces have destroyed crops or halted food shipments in their fight for control of the African nation. Despite international relief efforts and protests, such barbaric practices continue in Sudan. Although it's nearly impossible to ascertain the death toll from famine so far, millions remain a risk; in 1989 alone, 250,000 starved to death in southern Sudan.

Sadly, it's a mere trifle compared to other famines.

Whether driven by environmental or political causes, famines have long ravaged the global population. Here is a ranking of the 10 worst famines in history in terms of fatalities:

Country	Dates	Estimated Total Fatalities (Millions)
1. North China	1876–79	9–13
2. Soviet Union	1932–34	7
3. India	1876–79	5
4. India	1896–97	5
5. India	1769–70	3
6. China	1928–29	3
7. Soviet Union	1921–22	1.2–5
8. Bengal, India	1899–1900	1.25–3.25
9. India	1943–44	1.5
10. Ireland	1846–51	1

FLOODS
Worst Deluges of All Time

Legend has it that a little Dutch boy once saved his country from a massive flood by sticking his finger in a dike. Too bad he wasn't around in 1228, when a sea flood swept over the community of Friesland, Holland, killing over 100,000 people.

Today, flash floods are the cause of most flood-related deaths—and half of those are vehicle-related. Cars float when water reaches the chassis, so even a foot of water is enough to send a car off a washed-out road into deeper water. Not being airtight, cars can sink in a short time.

Dams collapsing and torrential rains from a hurricane are other leading causes of flooding. An amazing 90% of people who die in hurricanes drown.

Here's a look at some of the worst floods in history, ranked in terms of estimated fatalities:

1. CHINA, JULY–AUGUST 1931

A flooding Yangtze River left 3.7 million people dead as a result of drowning, disease, and starvation.

2. SOUTHEAST ASIA— DECEMBER 26, 2004

A 9.0 undersea earthquake in the Indian Ocean off Sumatra triggered devastating tsunamis that slammed into eleven Southeast Asian countries. Over 150,000 people perished.

3. FRIESLAND, HOLLAND, 1228

A sea flood left 100,000 drowned.

HANOI, NORTH VIETNAM, AUGUST 1971

Flooding in the Red River Delta killed 100,000.

4. YANGTZE RIVER, CHINA, AUGUST 5, 1975

Floods and famine killed 80,000 to 200,000 when 63 dams overflowed.

5. NORTHERN VENEZUELA, DECEMBER 15–16, 1999

Heavy rains, flooding, and mudslides killed between 5,000 and 20,000 people.

The Yangtze River in China is the source of three of the greatest floods in history. As pictured above, high ground is required for a river port to be viable on this mighty river.

6. CENTRAL AND NORTHEAST CHINA, SUMMER 1998
Heavy flooding of the Yangtze River killed more than 3,000 people and left 14 million homeless.

7. JOHNSTOWN, PENNSYLVANIA, MAY 31, 1889
The South Fork Dam collapsed, leaving more than 2,200 drowned in the flood.

89. ITALY, OCTOBER 9, 1963
The Vaiont Dam broke, killing 2,000.

ASIA, JUNE–AUGUST 2002
Annual monsoons caused flooding that took more than 2,000 lives in China, India, Nepal, and Bangladesh.

FOREIGN AID
Stingiest Nations on Earth

Don't go singing "Brother, Can You Spare a Dime?" and rattling your tin cup in some of the countries listed below—you might walk away empty-handed. Their record of economic aid is a bit on the low side, to say the least.

According to the *CIA World Factbook*, this list represents the net official development assistance from Organization for Economic Co-operation and Development (OECD) nations to developing countries and organizations. The figures reflect the per capita economic aid provided. Apparently, charity begins at home—and stays there in South Korea, Saudi Arabia, and Lesotho, each of which provided a whopping zero in financial aid to countries in need.

Country	Per Capita Aid Provided
1. South Korea	$0
Saudi Arabia	$0
Lesotho	$0
4. Italy	$17.24
5. United States	$23.76
6. New Zealand	$25.23
7. Portugal	$26.82
8. Spain	$33.07
9. Canada	$40.36
10. Australia	$45.30

FOREST FIRES, USA
Most Deadly Blazes on Record

By an exceptionally cruel twist of fate, two of the most catastrophic fires in American history began on the same day, just 240 miles apart. On October 8, 1871, legend has it that Mrs. O'Leary's cow kicked over a lantern, thereby starting the Great Chicago Fire. Whether or not a cow actually ignited this massive conflagration remains the source of endless speculation, but one thing is certain: the Great Chicago Fire decimated the Windy City. When the smoke finally cleared, 300 people were dead, 100,000 homeless, and 18,000 buildings destroyed, with property damage topping $200 million.

That same day, the worst forest fire in American history began in the tiny riverfront town of Peshtigo, Wisconsin. Strong winds whipped random fires into a wall of flame that engulfed the town and surrounding area; 1,500 people died and nearly four million acres of land burned, but it never generated the same media attention as the Chicago blaze. That said, the Great Peshtigo Fire of 1871 tops our list of the ten worst forest fires in American history in terms of overall fatalities:

Location	Date	Est. Fatalities
1. Peshtigo, Wisconsin	October 8–14, 1871	1,500+
2. Minnesota, Wisconsin	October 13–15, 1918	1,000
3. Minnesota	September 1, 1894	600
4. Idaho, Montana	August 10, 1910	85
5. Oregon, Washington	September 1902	38
6. Oakland-Berkeley, California	October 20–23, 1991	24
7. Southern California	October 25–29, 2003	24
8. Maine	October 25–27, 1947	16
9. South Canyon, Colorado	July 2–11, 1994	14
10. Mann Gulch, Montana	August 5, 1949	13

GARBAGE GALORE
The Trashiest Nations on Earth

Those Hostess cupcake wrappers can really add up. The Western nations of the world, where so much of their food comes in packages, are where you'll find the tallest trash heaps. It's no wonder that the United States leads in garbage with over 1,600 pounds produced by each person annually, which blows away that of the closest competitor, Norway, which still comes in at a beefy 1,184 pounds per person.

Could the obesity epidemic in the United States have anything to do with all those discarded Cheetos and Fritos bags? Maybe promoting the connection—fat equals trash—will help people to watch their intake. Or maybe we'll just get off our preaching pedestal and open up a bag of pretzels.

Here are the nations with the most garbage, and the poundage produced by one person annually, according to the Recycling Advocates:

Country	Annual Pounds of Garbage Per Person
1. United States	1,637
2. Norway	1,184
3. Netherlands	1,100
4. Germany	823
5. Sweden	662
6. France	572
7. Italy	548
8. Portugal	367

GENOCIDE IN THE MODERN AGE
The Worst 20th Century Ethnic Cleansings

Although mass killings based on ethnic hatreds have occurred since the dawn of civilization, the word genocide actually didn't exist until 1944. Raphael Lemkin, a Polish-born Jewish attorney, combined the Greek word "genos" (race) with the Latin "cide" (killing) in his monumental work *Axis Rule in Occupied Europe*. He then tirelessly lobbied the United Nations to adopt the term, which the General Assembly did in 1948. From the Nazi Holocaust to the ethnic cleansing in the Balkans

during the 1990s, the 20th century has borne witness to some genuinely nightmarish crimes against humanity. Here are the ten worst genocides of the 20th century with regard to estimated fatalities:

Genocide/Region	Dates	Estimated Fatalities
1. Stalin's forced famine/ Soviet Union	1932–33	7 million
2. Nazi Holocaust/Europe	1938–45	6 million
3. Pol Pot regime/Cambodia	1975–79	2 million
4. Armenian genocide/Turkey	1915–18	1.5 million
5. Ethnic and Political Purges/ Yugoslavia	1941–44	1 million
6. Rwanda (No name)	1994	800,000
7. Rape of Nanking/China	1937–38	300,000
8. Idi Amin regime/Uganda	1972–79	300,000
9. "Ethnic Clearing" Bosnia-Herzegovina	1992–95	200,000
10. Kurd genocide/Iraq	1988	50,000–100,000

GERMAN BOMB FATALITIES, WORLD WAR II
Most Deaths from Bombing Raids

Famous for the exquisitely crafted china bearing its name, the beautiful city of Dresden, Germany, was virtually obliterated by Allied bombers over the course of three successive nights in 1945. The bombing began the night of February 13, 1945, when 775 Royal Air Force planes dropped bombs on what was then known as the "Florence on the Elbe." Another 650 United States Army Air Force bombers continued the saturation bombing, which ignited a massive firestorm that destroyed 24,866 of the 28,410 homes in the inner city. More than 100,000 civilians died, many of them literally sucked into the firestorm.

This horrific attack, so memorably depicted by novelist Kurt Vonnegut in his novel *Slaughterhouse-Five*, heads the list of the 10 German cities heaviest hit by the RAF and USAAF bombers in World War II:

City	Estimated Fatalities
1. Dresden	100,000+
2. Hamburg	55,000
3. Berlin	49,000
4. Cologne	20,000
5. Magdeburg	15,000
6. Kassel	13,000
7. Darmstadt	12,300
8. Heilbronn	7,500
Essen	7,500
10. Dortmund	6,000

GLOOM AND DOOM

The Unhappiest Nations on Earth

Bobby McFerrin's hit single "Don't Worry, Be Happy" fell on deaf ears in the countries listed below, whose residents rank as the gloomiest on the planet, according to the World Values Survey, an international network of social scientists. Over a span of 16 years, the World Values Survey asked people in 50 countries the following question at three different times: "Taking all things together, would you say you are: very happy, quite happy, not very happy, or not at all happy?" Interestingly, the countries where a majority of the respondents expressed the greatest degree of unhappiness are former satellites of the now-defunct Soviet Union. It appears that the years of living under harsh, controlling Communist rule has taken a heavy emotional toll on the people of these Central European nations.

As for the United States, we placed 36th on the list—we're generally happier than the people in Bangladesh (30th), but could learn to look on the bright side from the Swedes (49th). Coming in last, or happiest, was tiny Iceland, where only 3% of those surveyed gave the thumbs-down with regard to the overall quality of their lives.

Here are the depressing results of the World Values Survey:

Sofia is the capital of Bulgaria, the nation where gloom and doom prevails most among all nations.

Country	Percentage Unhappy
1. Bulgaria	62%
2. Moldova	56%
3. Belarus	54%
4. Ukraine	52%
5. Russia	49%
6. Slovakia	48%
7. Lithuania	45%
8. Armenia	43%
9. Romania	38%
10. Latvia	37%

GOLF COURSES
Most Dangerous Links in the World

Do you have a fully paid-up insurance policy? You should if you're in Singapore playing a round. If uninsured, you might want to trade your spiked golf shoes for a sturdy pair of Wellingtons to protect your calves from cobra bites. In Compton, California, on the other hand, you might want to be accompanied on your rounds by a cordon of helmeted police. The Compton Par-3 Golf Course has violent gang fights when the Crips face off with the Bloods. At Elephant Hills Country Club in Victoria Falls, Zimbabwe, craters caused by mortar shells fired across the Zambezi River sometimes mark the fairways. Here are other golf courses you would do well to avoid if you're faint of heart. They are the ones for the fully insured, the suicidal, the insane, and, of course, the real men. In alphabetical order:

1. BEACHWOOD GOLF COURSE, NATAL, SOUTH AFRICA
A monkey attacked Mrs. Molly Whittaker after she made a successful bunker shot. Her caddy jumped in and chased the animal away.

2. LUNDIN LINKS, FIFE, SCOTLAND
Most people have a good day on the links while golfing here, but Harold Wallace had a bit of bad luck in 1950. He was hit by a train crossing the tracks on his way to the 5th green.

3. MACHRIE HOTEL GOLF COURSE, ISLAY, SCOTLAND
Played over sand dunes, virtually every drive and approach is blind.

4. PELHAM BAY AND SPLIT ROCK GOLF COURSES, BRONX, NEW YORK
The bodies that don't end up in the East River are dumped here apparently. In a recent 10-year period, 13 bodies were found.

5. PLANTATION GOLF AND COUNTRY CLUB, GRETNA, LOUISIANA
This is not a long course. In fact the entire 18 holes is on a 61-acre plat (less than half the normal size), making it necessary for players to squeeze against protective fencing while they wait for their turn.

6. SCHOLL CANYON GOLF COURSE, GLENDALE, CALIFORNIA
Built on a landfill, this course has

Playing a round at Lost City Golf Course in Sun City, South Africa, one of the world's most dangerous links? Then consider hiring a caddy with a large-caliber rifle to protect against the 15-foot crocodiles.

presented some unusual problems for golfers. Clubs hitting buried tires caused methane gas to arise from the divots. They are now pumping the gas to a local power company.

7. SINGAPORE ISLAND COUNTRY CLUB, SINGAPORE
Pro Jim Stewart encountered a 10-foot cobra in the 1982 Singa-pore Open. When he killed it, another emerged from its mouth.

8. LOST CITY GOLF COURSE, SUN CITY, SOUTH AFRICA
If you like a course with *real* hazards, this one is paradise. The course sports a stone pit fronting the 13th green that is filled with crocodiles, some 15 feet long.

GOLF GOPHERS
Where to Go for Golf? Not Around Here!

Broadway, the Yankees, and the Statue of Liberty come readily to mind when thinking of New York City. But golf? Not really. In fact, New

York City came in last in *Golf Digest*'s rankings of America's big cities in regard to the number and quality of municipal, private, and public golf courses for the estimated golfer population.

In all fairness to New Yorkers, there is at least one professional-quality golf course near the Big Apple: Shinnecock Hills Golf Club in Southampton. Founded in 1894, Shinnecock Hills Golf Club has hosted eight U.S. Championship tournaments. Its tall fescue grass and narrow fairways make this a particularly challenging course—just ask any of the players who competed in the 2004 U.S. Open here.

Here is a ranking of the metropolitan areas that comprise *Golf Digest*'s 2002 worst 10 for golfers in the United States:

1. New York, New York
2. Bergen, New Jersey
3. Charlotte, North Carolina
4. Philadelphia, Pennsylvania
5. San Francisco, California
6. Orange County, California
7. Oakland, California
8. Raleigh, North Carolina
9. Washington DC
10. San Jose, California

GROWING PAINS, USA
Worst Places in America to Raise Kids

Parents in Minnesota heaved a collective sigh of relief after reading this list in the *Kids Count 2004 Data Book*. The Land of 10,000 Lakes topped the list of the best states for raising children, based on a variety of factors ranging from infant mortality rates to the number of single-parent families. Other factors included teen birth rates, the number of children living in poverty, the high school dropout rate, and how many children live with unemployed parents.

Whereas Minnesota ranked number one, Mississippi crashed and burned into last place. Although rich in history and culture, Mississippi is sadly dirt-poor when it comes to maintaining a decent standard of living. In addition to being the worst state for raising children, Mississippi was recently judged both the least healthy *and* the least livable state in the nation.

Here are the 10 worst states for raising children according to the *Kids Count 2004 Data Book*:

1. Mississippi
2. Louisiana
3. New Mexico
4. Alabama
5. South Carolina

6. Arizona
7. Arkansas
8. Tennessee
9. West Virginia
10. North Carolina

GUN DEATHS

Nations with the Most Annual Firearm Deaths

Little South Africa wins the gold medal for gun deaths, whereas the United States ranks a measly fourth. For a country used to first places, the United States makes up for this disappointing fourth-place finish with the dubious honor of ranking first in overall crime, rapes, assaults, car thefts, and burglaries.

Surprisingly, violent crime statistics don't show any close correlation with national standards of living. For example, some of the poorest countries—Zimbabwe, Columbia, and Thailand—made the list of the nations with the most firearm deaths, but so did some of the most affluent, the United States and Germany. In South Africa, which leads all nations in death by firearms, the average man works only four and a half hours daily for lack of full-time jobs, and poverty abounds.

None of the trigger-happy countries listed below made it to the top of the list for agricultural growth, but one thing is clear. They all have a few bad apples.

1. SOUTH AFRICA: 31,918 ANNUAL FIREARM DEATHS
Advocates of the proposition that the death penalty deters murder could have a field day here. The death penalty was abolished in 1997.

2. COLOMBIA: 21,898 ANNUAL FIREARM DEATHS
Second in this category, Columbia is fighting the trend by doling out harsher punishments. The country is 1st in length of prison sentences.

3. THAILAND: 20,032 ANNUAL FIREARM DEATHS
They must be catching the culprits; Thailand also ranks 3rd in total citizens in prison.

4. UNITED STATES: 8,259 ANNUAL FIREARM DEATHS
Though a 4th-place finish hurts

America's national pride, justice reigns. The United States ranks 1st in the number of adults prosecuted, females prosecuted, and total prisoners.

5. MEXICO: 3,589 ANNUAL FIREARM DEATHS

First in manslaughter, guns must not be the clear weapons of choice for criminals in Mexico, which ranks only 5th in murder by firearms.

6. ZIMBABWE: 598 ANNUAL FIREARM DEATHS

A lowly 26th in terms of total crime, Zimbabwe jumps to 6th in murder with the use of a gun. Of the more cerebral crimes, the country is 10th in embezzlements.

7. GERMANY: 384 ANNUAL FIREARM DEATHS

Fraud is the number-one crime in Germany, which also ranks 1st internationally in this category. Second in total crime, Germany boasts the 3rd-most police officers.

HIV/AIDS
Highest Infection Rates

What was first erroneously called the "gay cancer" in the early 1980s has mushroomed into a global pandemic that afflicts the general population. One of the true scourges of the age, the HIV virus has taken an especially devastating toll on the people of Sub-Saharan Africa, wiping out entire generations and leaving millions of HIV-infected children orphans. Although scientists continue to fight the good fight against this ever-mutating foe, the most potent antiviral drug therapies are often prohibitively expensive. The good news (and yes, there is some good news) is that the major pharmaceutical companies bowed to public pressure and negotiated a deal with the United Nations to slash AIDS drug prices in the poor developing nations hit hardest by the disease. As a result, millions of people in the following list of countries are living longer and healthier lives. That said, the estimates listed below from the latest *CIA Factbook* show that AIDS is one of the worst plagues in recorded history:

Country	Number Living with HIV/AIDS (in Millions)
1. South Africa	5
2. India	4
3. Nigeria	3.5
4. Kenya	2.5
5. Zimbabwe	2.3
6. Ethiopia	2.1
7. Tanzania	1.5
8. Democratic Republic of Congo	1.3
9. Zambia	1.2
10. Mozambique	1.1

HEALTHCARE SPENDING
Two Band-Aids a Year, and That's It!

By a stunningly cruel twist of fate, the people of the world who most need quality healthcare on a regular basis are routinely deprived of it. If not for the intervention of international relief agencies, millions in these impoverished countries would probably go without medical care of any kind. Whereas an average of $4,271 is spent per person annually on health care in the United States—the highest in the world according to the World Bank—a measly $4.00 is spent per person in Ethiopia, a country long besieged by famine, drought, and violent civil warfare.

Here are the 10 countries where healthcare spending barely constitutes pocket change by American standards:

Country	Annual Spending Per Person
1. Ethiopia	$4.00
2. Niger	$5.00
Madagascar	$5.00
Burundi	$5.00
5. Laos	$6.00
6. Chad	$7.00
7. Indonesia	$8.00

Country	Annual Spending Per Person
Sierra Leone	$8.00
Mozambique	$8.00
10. Central African Republic	$9.00

HEAT-WAVE FATALITIES
Most Heat-Related Deaths, 1900 to Present

Global warming, anyone? In August of 2003 the worst heat wave in 150 years blanketed most of Europe, igniting forest fires, destroying crops, and causing thousands of deaths. In France alone, an estimated 14,000 people succumbed to the scorching temperatures. Of the deadliest heat waves to strike the globe since 1900, the United States has been particularly hit hard, most famously in the 1930s when the longest drought of the 20th century took hold. Although the Dust Bowl was a true blight on the land, estimated fatalities were surprisingly low, given the sheer length and magnitude of the environmental crisis.

Here are the worst heat waves since 1900, ranked by fatalities attributed to them:

Region	Length of Heat Wave	Year	Est. Fatalities
1. Europe	1 month	2003	14,000+
2. Central/eastern United States	Summer	1980	10,000
3. Central/eastern United States	Summer	1988	5,000–10,000
4. Southern India	1 month	2003	1,500
5. Los Angeles	8 days	1955	946
6. New York City	14 days	1972	891
7. Chicago	6 days	1995	739
8. Eastern United States	Summer	1999	502
9. Southern United States	Summer	1998	200
10. Southern United States	Spring–Summer	2000	140

HELL ON EARTH
Highest Recorded Temperatures

When you're hot, you're hot, especially at the locations listed below. How does it feel when the mercury hits 136 degrees Fahrenheit? Well . . . the experienced traveler knows it feels exactly like El Azizia, Libya, did back in 1922, when it actually happened there.

Here are the highest temperatures recorded in various areas according to the *Almanac of Science and Technology*:

Location	Date	Degrees Fahrenheit
1. World: El Azizia, Libya	Sept. 13, 1922	136
2. North America: Death Valley, CA	July 10, 1913	134
3. Asia: Tirat Tsvi, Israel	June 21, 1942	129
4. Australia: Cloncurry, Queensland	Jan. 16, 1889	128
5. Europe: Seville, Spain	Aug. 4, 1881	122
6. South America: Rivadavia, Argentina	Dec. 11, 1905	120
7. Canada: Midale and Yellow Grass, Saskatchewan	July 5, 1931	113
8. Oceania: Tuguegarao, Philippines	April 29, 1912	108
9. Antarctica: Vanda Station, Scott Coast	Jan. 5, 1974	59
10. South Pole	Dec. 27, 1978	7.5

HIGH SCHOOL DROPOUTS, USA
American States with the Most Quitters

For any teen thinking of dropping out of high school to work full time, think again: adjusted for inflation, the average hourly wage for workers without a high school diploma has dropped 24% since 1973. In dollars and cents, that means an average of $7,000 less than high school grads. Dropping out of high school virtually guarantees a one-way ticket to the poor house. Yet despite such grim statistics, there are nearly 1.5 million teen dropouts in the United States. According to the 2004 Current Population Survey, teenagers between 16 and 19 in Arizona, Nevada,

and Colorado lead the nation's dropout rate. The next highest rates belong to a group of southern states.

In spite of those troubling statistics, the United States ranks 14th worldwide in terms of the total years of schooling, with an average of 15.2 years of education. At the other end of the spectrum, Mali children average only 2.1 years of school.

The following states have a hard time keeping students in school:

State	Dropout Rate
1. Arizona	16%
2. Nevada	14%
3. Colorado	13%
4. Louisiana	12%
Florida	12%
New Mexico	12%
Kentucky	12%
Texas	12%
9. North Carolina	11%
Tennessee	11%
South Carolina	11%
Mississippi	11%
Alabama	11%
Oregon	11%
Alaska	11%
Idaho	11%

HIGHWAY BOTTLENECKS
America's Worst Traffic Jams

Do you feel like your trip to work or around town has gotten slower, busier, more congested? It's not your imagination. In a recent Associated Press poll, 55% of those surveyed said that they felt traffic had worsened in their area over the last five years. In fact, 30% said it was much worse.

Two-thirds of those polled said they allow more time when traveling due to traffic problems. Others reported avoiding major highways and

other popular roads during rush hour. The extra time spent by drivers during rush hour has tripled over the last two decades. And traffic chokepoints—where highways can't handle all the cars—has risen 40% over the past five years.

In 2004 the American Highway Users Alliance cited the following U.S. highways for having the worst bottlenecks. They are listed along with the number of vehicles they handle each day and the annual hours of delay:

City	Highway	Cars Per Day	Hours of Delay Per Year
1. Los Angeles	Ventura Freeway, U.S. 101 at I-405 interchange	318,000	27,144,000
2. Houston	I-610 at I-10 interchange	295,000	25,181,000
3. Chicago	I-90/94 at I-290, "Circle Interchange"	293,671	25,068,000
4. Phoenix	I-10 at State Roads 51/202, "Mini-Stack" interchange	280,800	22,805,000
5. Los Angeles	I-405 at I-10 interchange	296,000	22,792,000
6. Atlanta	I-75 at I-85 interchange	259,128	21,045,000
7. Washington DC	I-495 at I-270 interchange	243,425	19,429,000
8. Los Angeles	I-10 at I-5 interchange	318,500	18,606,000
9. Los Angeles	I-405 at I-605 interchange	318,000	18,606,000
10. Atlanta	I-285 at I-85, "Spaghetti Junction" interchange	266,000	17,072,000

City	Highway	Cars Per Day	Hours of Delay Per Year
11. Chicago	I-94 at I-90 interchange	260,403	16,713,000
12. Phoenix	I-17 at I-10, "the Stack" interchange to Cactus Road	208,000	16,310,000
13. Los Angeles	I-5 at State Roads-22/57, "Orange Crush" interchange	308,000	16,304,000
14. Providence, RI	I-95 at I-195 interchange	256,000	15,340,000
15. Washington DC	I-495 at I-95 interchange	185,125	15,035,000

HOME-RUN HELL

Most Difficult Ballparks to Hit a Homer

Poor ol' Casey at the bat. Going for the home run, the fabled slugger in Ernest L. Thayer's beloved poem strikes out, plunging all of Mudville into a deep sorrow. At certain major league venues, professional baseball players know Casey's pain firsthand. The center field fence is a long way from home plate in the following ballparks, where the game's power hitters struggle to knock 'em out of the park. Here are the 10 hardest major league ballparks to hit a home run, in terms of sheer distance:

Ballpark	Distance to Center Field Fence (in Feet)
1. Minute Maid Park, Houston	435
2. Comerica Park, Detroit	422
3. Fenway Park, Boston	420
4. Coors Field, Colorado	415
5. Pro Player Stadium, Florida	410

Ballpark	Distance to Center Field Fence (in Feet)
Shea Stadium, New York	410
Tropicana Field, Tampa Bay	410
8. Metrodome, Minnesota	408
Veterans Stadium, Philadelphia	408
Yankee Stadium, New York	408

HORNIEST GUYS ON EARTH?
Lowest Female-to-Male Ratios

World's horniest men? In Qatar, the nation with the lowest ratio of women to men, they very likely are.

Romantic lore tells us there's a woman out there for every man. Try telling that to the guys in Qatar who can't get a date. It's no wonder: there are 2.36 males for every female in Qatar. (Ladies of Qatar, be cautious and check out the toilet seat's position before you have a seat in a public restroom.)

Below are the countries with the worst ratio—that is, if you're a guy—of men to women in the 15–64 age group, according to the *CIA World Factbook*. (But if you're a women in any of 10 nations below, *rejoice!*)

Country	Males Per Female
1. Qatar	2.36
2. Kuwait	1.77
3. Samoa	1.68
4. United Arab Emirates	1.65

Country	Males Per Female
5. Oman	1.51
6. Bahrain	1.42
7. Saudi Arabia	1.37
8. Mayotte	1.20
9. Palau	1.19
Greenland	1.19

HOSPITAL BEDS
Lowest Patient Capacities

Confirmed hypochondriacs wouldn't fare too well in Turkey. Not only are doctors scarce, with one physician for every 1,000 patients, but hospital beds, too. Only Mexico has fewer hospital beds, with an alarming average of 1.1 beds per 1,000 people.

The United States, on the other hand, ranks among the top 20 nations with the most doctors. So there must be hospital beds, galore, right? Nope. Chalk it up to the rise in outpatient surgery over the last few years.

Here, according to the Organisation for Economic Co-operation and Development, is the 2004 ranking of countries with the fewest hospital beds per 1,000 people:

Country	Beds Per 1,000 People
1. Mexico	1.1
2. Turkey	2.6
3. United States	3.6
4. Sweden	3.7
5. Canada	3.9
6. Portugal	4.0
7. United Kingdom	4.1
Spain	4.1
9. Denmark	4.5
10. Greece	4.9

INCOME DISPARITY
Countries with the Most Unequal Income Distribution

"The rich get richer and the poor get poorer." That's pretty much the case everywhere, but in some countries the economic gap between the rich and the poor has become a chasm.

Statistics from the World Development Indicators show the Gini index, which measures income inequality within a country. A score of 0 would indicate perfect equality, with 100 reflecting absolute inequality. The "lowest 20%" category shows what percentage of income that country's poor receive, while the "highest 20%" reflects the percentage garnered by the wealthiest citizens.

For those who are wondering, the United States rates 40.8 on the Gini index, with the poorest 20% of its population receiving 5.2% of the income and the richest 20% receiving 46.4%. Sorry, no magic advice as to how to become part of that upper group.

Here are the countries with the greatest income disparity and their scores, according to the World Development Indicators:

Country	Gini Index	Lowest 20%	Highest 20%
1. Sierra Leone	62.9	1.1	63.4
2. Central African Republic	61.3	2.0	65.0
3. Swaziland	60.9	2.7	64.4
4. Brazil	60.7	2.2	64.1
5. Nicaragua	60.3	2.3	63.6
6. South Africa	59.3	2.9	64.8
7. Paraguay	57.7	1.9	60.7
8. Colombia	57.1	3.0	60.9
9. Chile	56.7	3.3	61.0
10. Honduras	56.3	2.2	59.4

COMMERCIAL DISASTERS
Deadliest Commercial Accidents

One of the most horrifying and tragic industrial accidents occurred in Bhopal, Madhya Pradesh, India, where industrial giant Union Carbide had a pesticide plant. During the early morning hours of December 3,

1984, a tank containing toxic methyl isocyanate leaked into the atmosphere, killing upwards of 5,000 people. Perhaps as many as 50,000 other people may be partially or totally disabled because of their exposure to this chemical.

The gas leak at Bhopal heads the list of the 10 all-time worst commercial disasters in terms of immediate fatalities:

Location	Date	Type Of Disaster	Fatalities
1. Bhopal, India	December 3, 1984	Gas leak	5,000+
2. Oppau, Germany	September 21, 1921	Chemical explosion	561
3. Brussels, Belgium	May 22, 1967	Retail business fire	322
4. Guadalajara, Mexico	April 22, 1992	Gas leak/explosions	230
5. Sao Paulo, Brazil	February 1, 1974	Office building fire	189
6. North Sea	July 6, 1988	Oil rig explosion/ fire	173
7. New York, New York	March 25, 1911	Factory fire	145
8. Eddystone, Pennsylvania	April 10, 1917	Munitions explosion	133
9. Cleveland, Ohio	October 20, 1944	Gas tank explosion	131
10. Caracas, Venezuela	December 19–21, 1982	Fuel tank fire	129

INFANT MORTALITY
Most Infant Deaths

Contrary to their vulnerable appearance, infants are generally resilient little critters. They have a natural immunity at birth. And if fortune shines upon them, they're born to loving and protective parents who tend to their every need. Even in countries that have few doctors and no insurance, moms will usually do whatever it takes to save a sick

With luck, this African child will make it past age one. Nine of the ten nations with the worst infant mortality rates are on the African continent, where Angola tops the list for infant deaths: almost 20% of children there die before their first birthday.

child. So when infants are dying at a rate of 120 to 200 per 1,000, you know the health situation in that country is dire.

From the *CIA World Factbook*, here is a 2003 ranking of nations with the highest infant mortality rate per 1,000 births:

Country	Infant Mortality Per 1,000 Births
1. Angola	191.66
2. Afghanistan	144.76
3. Sierra Leone	144.38
4. Mozambique	138.55
5. Liberia	130.21
6. Guinea	127.08
7. Niger	122.23
8. Somalia	122.15
9. Malawi	119.96
10. Mali	119.63

INFLATION RATES
Greatest Annual Price Increases

Remember when a candy bar used to cost a nickel? How about penny candy? Careful—you're showing your age! The good news is that you're probably earning a lot more than you—or your parents—did back when candy was so cheap.

Of course, the candy inflation didn't happen overnight; it took place over quite a long period of time. The price of a Hershey Bar this year is still pretty close to what it was last year.

When economists analyze inflation rates, they compare the change in consumer prices with the previous year's prices. And some countries seem to be hit a lot harder than others. Here is a 2003 ranking of countries with the highest rate of inflation according to *The CIA World Factbook*:

Fortunately for this youthful produce vendor in Zimbabwe, things sell fast here; the inflation rate, the world's highest, is 134.5%.

Country	Annual Inflation Rate
1. Zimbabwe	134.5%
2. Angola	106%
3. Iraq	70%
4. Burma	53.7%
5. Turkey	45.2%
6. Belarus	42.8%
7. Argentina	41%
8. Venezuela	31.2%
9. Malawi	27.4%
10. Uzbekistan	26%

INTERNATIONAL CRISES
The Most Overlooked Catastrophes

While most of the world's attention is focused on the strife in the Middle East, specifically Iraq, many international crises get comparatively overlooked—20, to be precise. Yet according to United Nations secretary general Kofi Annan, these 20 crises affect over 45 million people in Africa, Asia, and Central Europe. Occasionally, Chechnya's fight for independence from Russia will grab the headlines; most recently, Chechen rebels held Russian schoolchildren hostage in a siege that ended in disaster. But for many people enduring famine, poverty, and civil war in these ravaged countries, their stories fail to generate the attention they so desperately need and deserve.

Here are the 20 international crises Annan deems most overlooked as of 2004, in alphabetical order:

Country/Region	Crisis
1. Angola	Postwar poverty, refugees
2. Burundi	Civil war
3. Central African Republic	Postwar poverty, political instability
4. Chechnya	War
5. Congo, Democratic Republic	War
6. Eritrea	Food shortage, drought
7. Great Lakes region (Africa)	Conflict, refugees, AIDS
8. Guinea	Refugees, poverty
9. Liberia	Postwar poverty
10. North Korea	Famine
11. Sierra Leone	Postwar poverty
12. Somalia	Failed state
13. Southern Africa	AIDS, poverty
14. Sudan	Civil war
15. Tajikistan	Postwar poverty
16. Tanzania	Refugees
17. Uganda	Refugees, drought, conflict
18. West Bank/Gaza	Conflict, economic devastation
19. West Africa	Conflict, refugees
20. Zimbabwe	Economic devastation

JOURNALISTS IN JEOPARDY
Most Dangerous Beats for the Press

In some parts of the world, the sword is far mightier than the pen. Each year, scores of journalists are attacked, kidnapped, or murdered in countries ravaged by political strife. Although some, like the late *New York Times* reporter Daniel Pearl, fall prey to terrorists, many reporters court serious retribution from oppressive regimes like China, which maintains a virtual stranglehold on all media to squelch criticism of government policy. As an unfortunate result, China has been the world's leading jailer of journalists for the past five years straight.

On World Press Freedom Day in May of 2003, the international press organization the Committee to Protect Journalists (CPJ) issued their annual list of the worst places in the world to be a journalist. Here is their ranking of 10 countries where reporting the news could prove hazardous to your health:

1. IRAQ

Scores of journalists have been killed in action since the U.S. forces invaded the country to topple Saddam Hussein in 2002. Others have perished at the hands of Iraqi insurgents, who often target foreign journalists. Many Arab and Iraqi journalists have also been detained and interrogated by U.S.-led forces.

2. CUBA

No lover of the free press, Cuban dictator Fidel Castro cracked down on Cuba's independent journalists in 2003. That year, 29 reporters were arrested and sentenced to long jail terms for voicing opposition to Castro's iron rule. Both physical and psycho-logical torture is the norm for these reporters in maximum-security facilities.

3. ZIMBABWE

In addition to shutting down the country's only independent daily newspaper, the government made it a criminal offense to report the news without a government-approved license. The last foreign reporter was deported in 2003 after being deemed an "undesirable inhabitant."

4. TURKMENISTAN

Because the self-appointed "president for life" Saparmurat Niyazov controls all of Turkmenistan's media, independent journalism exists only underground. In 2003

Niyazov's goons arrested and tortured a Turkmenistan freelance stringer for Radio Free Europe/Radio Liberty. For two days, he was beaten and repeatedly injected with an unknown substance.

5. BANGLADESH

Over the last decade, at least 7 journalists have been murdered and dozens more attacked in Bangladesh, which CPJ cites as the most dangerous country in Asia for journalists. Journalists investigating corruption regularly incur the violent wrath of thugs, especially in the rural areas outside the capital city of Dhaka.

6. CHINA

Twenty years of slow, steady media reform nearly fell by the wayside when President Hu Jintao and Premier Wen Jiabao took office in 2002. Under their rule, journalists are routinely imprisoned and news blackouts imposed on anything that might reflect negatively on their regime.

7. ERITREA

In September of 2001 President Isaias Afwelki banned the country's private press and sent many reporters he deemed dangerous to top-secret prisons in this tiny African country bordering the Red Sea. Afwelki and his corrupt officials regularly accuse independent journalists of committing espionage and "endangering national unity."

8. HAITI

During the two months of violence preceding the ouster of Haitian president Jean-Bertrand Aristide in February 2004, native and foreign journalists faced continuous harassment. A Spanish television correspondent was killed and a cameraman seriously wounded. Gangs also burned several of the country's radio stations to the ground.

9. WEST BANK/GAZA STRIP

In a region where violence is a horrible constant, journalists run the risk of getting caught in the crossfire between Israelis and Palestinians; 3 reporters have been killed since 2003. Palestinian journalists are especially at risk for attack by Israeli troops.

10. RUSSIA

Under Russian President Vladimir Putin's policy of "managed democracy," the Kremlin has employed everything from lawsuits to hostile corporate takeovers to keep

a tight rein on the independent media. Attacks on journalists outside metropolitan areas are common and rarely prosecuted. Two editors of a rural independent newspaper were stabbed to death for publishing an exposé on organized crime.

KIDNAPPINGS
Body Snatcher Havens

In the classic novel *One Hundred Years of Solitude*, Nobel Prize–winning writer Gabriel Garcia Marquez celebrates the lush, almost surreal beauty of his native Colombia. Yet for most people, mention Colombia and they'll talk about the country's powerful drug cartels, violent political upheaval, and omnipresent threat of kidnapping, usually at the hands of leftist guerrilla groups. In 1999, for example, an average of 8.3 people were snatched daily in this country of 42 million. Although foreign executives and wealthy locals have long been primary targets, these leftist groups are now equal-opportunity kidnappers who regularly go after Colombia's middle class.

At least the kidnappers don't behead you here in Colombia like they do elsewhere. The South American nation leads the world in kidnappings.

Not only does Colombia top the list of countries with the highest kidnapping rates, it's also number one worldwide in terms of murders per capita. Needless to say, these alarming statistics are conspicuously missing from the country's tourist brochures! Sightseeing with a bodyguard or two is strongly advised.

Here are the countries with the world's highest kidnapping rates, according to a seven-year study by the Hiscox Group, a British insurance company specializing in "unusual" problems or risks. These sta-

tistics have been culled from cases containing the most substantive information.

Country	Number of Reported Kidnappings*, 1992–1999
1. Colombia	5,181
2. Mexico	1,269
3. Brazil	515
4. Philippines	492
5. Former Soviet Union	250**
6. Venezuela	109
7. India	76
8. Ecuador	66
9. Nigeria	34
10. South Africa	11

*Only 10% or so of all kidnapping cases are reported to authorities.
**The former Soviet Union comprises the Russian Federation and the 14 fully independent republics of Armenia, Azerbaijan, Belarus, Estonia, Georgia, Kazakhstan, Kyrgyzstan, Latvia, Lithuania, Moldova, Tajikistan, Turkmenistan, Ukraine, and Uzbekistan

KILLING JOBS
Highest Execution Rates

Remember Michael Fay, the American teenager who got caned in Singapore for spray-painting a car in 1994? There was a huge international outcry about the severity of the punishment; even President Clinton intervened on Fay's behalf, calling the sentence "excessive." But in Singapore, where the government bans all chewing gum except for medical uses, leniency and mercy are in short supply in the legal system. For example, the laws against drug trafficking are particularly draconian. If you're over 18 and caught with more than 15 grams of heroin, you'll be executed by hanging.

Since 1991 Singapore has executed approximately 400 people, most of them on drug charges. Given that this tiny city-state has a population hovering just around 4 million, it appears that Singapore has the highest execution rate in the world relative to its population. In a

Singapore is where many Texans would feel right at home. Like the Lone Star State does in America, this Asian city-state knocks 'em dead in the killing department, too. Singapore has the world's highest execution rate.

study of international capital punishment rates in the years 1994–1999, the office of the United Nations Secretary General concluded that Singapore had an average rate of 13.57 executions per one million people. Singapore tops the list of the seven countries named in the United Nations report.

In terms of the overall number of executions for the same period, China came in first, followed by Iran, Saudi Arabia, the United States, Nigeria, and Singapore.

Here are the seven countries with the highest average execution rates per one million people:

Country	Executions Per Million People
1. Singapore	13.57
2. Saudi Arabia	4.65

Country	Executions Per Million People
3. Belarus	3.20
4. Sierra Leone	2.84
5. Kyrgyzstan	2.80
6. Jordan	2.12
7. China	2.01

LETHARGIC EUROPEANS
Laziest People on the Continent

In 2003 a group calling itself the Association of Friends of the Siesta formed in Portugal to promote the health benefits of naps after lunch. Apparently their campaign succeeded beyond their wildest expectations. According to a recent study conducted by scientists at Spain's University of Navarra, the Portuguese are the most sedentary people in the European Union by a wide margin. Nearly 88% of Portugal's 10.5 million citizens spend a great deal of their time sitting or sleeping; exercise is practically unheard of, despite frequent warnings about how inactivity can lead to obesity, diabetes, and heart disease.

To determine the activity levels of people in the European Union's 15 countries, the scientists surveyed approximately 1,000 citizens of each country about exercise and weight. If a person spent less than 10% of their free time exercising or doing some other form of strenuous activity, he was deemed sedentary. Of the 15 countries in the European Union, Sweden boasts the most active citizens, since only 43.3% lead inactive lives.

Here are the 10 countries with the laziest people in the European Union:

Country	Percent of Population Sedentary
1. Portugal	87.8%
2. Belgium	71.7%
3. Spain	71.0%
4. Germany	71.0%
5. Greece	70.0%
6. Italy	69.3%
7. France	68.5%

Country	Percent of Population Sedentary
8. Netherlands	62.0%
9. Denmark	61.4%
10. Great Britain	59.4%

LIBRARY BOOKS

Fewest Volumes in Libraries

Can you imagine life without a "shhh" and a quietening glare from the pinched-face librarian? Where else but the public library could we hide in the dusty stacks to pore over the juicy parts of novels our parents had forbidden us to read? Yet the very things many of us take for granted—summer reading lists, the bookmobile, story hour—are practically unheard of in other parts of the world. According to a 2003 UNESCO study, the following countries have the fewest library books in the world:

Country	Number of Library Books
1. Rwanda	1,197
2. Gambia	2,000
3. Burma	4,800
4. Benin	7,000
5. Andorra	8,000
6. Sao Tome and Principe	8,636
7. Bangladesh	14,000
8. Togo	19,000
9. Sierra Leone	20,000
10. Mali	60,315

LIFE EXPECTANCY

Nations with the Lowest Longevity Rates

Most 30-somethings are shocked the first time someone calls them ma'am or sir. Teenagers, on the other hand, pretty much consider anyone over 30 to be way over the hill, especially a parent or a teacher.

But it isn't like that in every country. In some nations, 35 years old is, well, elderly. Most of these are third-world countries, where nutrition is

unheard of, food is scarce, health care is hard to get, and hard work is the norm.

Here is the *CIA World Factbook* 2003 ranking of countries with the lowest life expectancies:

Country	Life Expectancy (years)
1. Mozambique	31.3
2. Botswana	32.3
3. Zambia	35.2
4. Lesotho	36
5. Angola	37
6. Malawi	38
7. Zimbabwe	39
8. Rwanda	39.3
9. Swaziland	39.5
10. Ethiopia	41.2

LITERACY RATES
World's Worst Readers

No wonder some call it the "three R's"—they can't spell. Reading, writing, and arithmetic aren't a priority everywhere, especially in some of the least-developed countries. Naturally, books are neither available nor priorities in the following countries with the lowest literacy rates in 2003, according to the United Nations:

Country	Literacy Rate
1. Niger	17.6%
2. Burkina Faso	26.6%
3. Sierra Leone	31.4%
4. Guinea	35.9%
5. Afghanistan	36%
6. Somalia	37.8%
7. Gambia	40.1%
8. Senegal	40.2%
9. Iraq	40.4%
10. Benin	40.9%

And Back Home in ~~Amereca~~ America

Marian the librarian from *The Music Man* would hate these cities. So would your 10th grade English teacher. They're the least-literate cities in America, according to a 2004 poll by the University of Wisconsin–Whitewater. In descending order:

1. El Paso, Texas
2. Hialeah, Florida
3. Corpus Christi, Texas
4. Santa Ana, California
5. San Antonio, Texas
6. Anaheim, California
7. Long Beach, California
8. Arlington, Texas
9. Fresno, California
10. Garland, Texas

LIVABILITY CONDITIONS
Least-Livable American States

So much for the South rising again! A 2004 study by Morgan Quitno Press ranked the 50 states in 44 categories, such as crime, poverty rate, household income, and education level. When the rankings were tallied, the Yankees had prevailed, with tiny New Hampshire topping the list as the nation's most livable state. In fact, almost all of the states that once constituted the Confederacy landed in the bottom of the rankings.

You can bet that nobody in Mississippi was whistling Dixie after glancing at the list. The home state of Elvis Presley and William Faulkner was named the least livable state of all.

1. Mississippi
2. Louisiana
3. South Carolina
4. Alabama
5. Tennessee
6. North Carolina
7. Arkansas
8. West Virginia
9. Kentucky
10. New Mexico

LOOKING FOR LOVE
Worst Places to Find a Date

So you're back on the market, looking to find Mr. or Miss Right. Where do you start? Ask friends who are married or have a steady and you'll get the proverbial mixed bag of ideas, most of which sound

pretty lame to the single person asking for the advice. Still, going to a church social or volunteering sounds a lot better than hanging out at your local meat market/singles bar with "Desperate and Dateless" branded on your forehead.

In 2004 the writers and advice columnists at the Web sites msn.com and match.com compiled a list of the very worst places to meet a prospective date. Staying home on a Friday night sounds a lot better than any of the following options. In no particular order:

1. A LOW-LIFE BAR

A nice campus bar or local pub is one thing, but if the bartender, clientele, or bathrooms are questionable, get out fast.

2. THE "MILITARY HISTORY" SECTION OF A BOOKSTORE

With all the book and magazine sections you can prowl at the bookstore, why set yourself up to meet someone who can plot each battle of the Civil War move for move?

3. ANYWHERE NEAR A PUBLIC RESTROOM

People lurking near the bathrooms probably aren't anyone you'd want to bring home to mother.

4. THE WAITING ROOM OF YOUR SHRINK'S OFFICE

Okay, so you have something in common. Is this the kind of thing you *want* to have in common? And will your issues come back to haunt you?

5. ON A WEB SITE CALLED "I'MGOINGTOSTALKYOU.COM"

Only if restraining orders sound like fun.

6. A FUNERAL

They say it's good to meet someone through someone you know —or knew—but it'll be hard to shake the cloud of death.

7. THE POLICE STATION

Don't even think about it. No matter why you're there. No matter why the other person is there. It's not going to work out.

8. BEHIND A DUMPSTER IN THE ALLEY

How many *Law & Order* episodes have begun in this exact location? And you know what happens next, so keep away.

9. WORK

Maybe if it's a huge company and you work on different floors—or in different states.

10. WRIGLEY FIELD

The Cubs haven't won a World Series since 1908. Who's to say any date you meet here won't be jinxed, too?

MINING DISASTERS
Worst Mother Lodes of Death

According to the United States Mine Rescue Association, mining accidents are classified as disasters if there are five or more fatalities. Such disasters are a comparative rarity nowadays, what with strict safety regulations and technological advances. Tragically, these improvements are often implemented in the wake of disaster. In 1907 over 362 miners died in the Monongah, West Virginia, coal mine explosion—the worst mining disaster in the nation's history. Due to

A mine disaster at ground level is the proverbial "tip of the iceberg," subterranean style. The real devastation lies deep below as it did at Honkeiko, China, where 1,549 died in 1942, the worst death toll from a mining disaster on record.

the public outcry over Monongah, Congress created the Bureau of Mines.

The Monongah disaster ranks ninth in the rankings of the 10 all-time worst mining disasters, in terms of fatalities:

Mine Location	Date	Fatalities
1. Honkeiko, China	April 26, 1942	1,549
2. Courrieres, France	March 10, 1906	1,060
3. Omuta, Japan	November 9, 1963	447
4. Senghenydd, United Kingdom	October 14, 1913	439
5. Coalbrook, South Africa	January 21, 1960	437
6. Wankie, Rhodesia	June 6, 1972	427
7. Bihar, India	May 28, 1965	375
8. Dhanbad, India	December 27, 1975	372
9. Monongah, West Virginia	December 6, 1907	362
10. Barnsley, United Kingdom	December 12, 1866	361

MOVIE-SHORT
Countries with the Fewest Cinemas

Known as the Land of the Midnight Sun, the tiny island country of Iceland (population: 250,000) is also the Land of the Midnight Movie. According to a 2003 UNESCO Institute for Statistics survey, Iceland boasts the most cinemas per capita, along with the United States and Japan. When you're living in a country of active volcanoes, regular earthquakes, and encroaching glaciers, what better way to unwind than spending Friday night at the Reykjavik multiplex?

But if you live in one of the countries below, you may want to settle in with a novel or take up knitting. The cinemas here are few and far between. In fact, Suriname has only one.

Country	Number of Cinemas
1. Suriname	1
2. Oman	2
3. Benin	3
San Marino	3
5. Bermuda	4
6. Nicaragua	10
7. Kenya	20
8. Luxembourg	21
9. Zimbabwe	22
10. Libya	27

MOVIE PRODUCTION
One-Film Wonders

Back in the 1930s, when Hollywood was the known as the Dream Factory, many starry-eyed hopefuls took the song "You Oughta Be in Pictures" to heart and went to Tinsel Town seeking fame and fortune. Only a select few ever saw their name in lights, but with dozens of films being shot at any one time, there was always a chance, albeit a slim one, to get discovered.

Today, with film production down, it's even harder for wanna-be actors to get their shot at Hollywood glory. That said, your chances of becoming a big screen icon are still a lot better in the glamour capital than in any of the following countries, where film production is virtually nonexistent. According to the Internet Movie Database in 2003, each of these countries has produced just one film to date:

1. Afghanistan
2. Albania
3. Bangladesh
4. Bhutan
5. Dominican Republic
6. Ecuador
7. Guinea
8. Honduras
9. Iraq
10. Kuwait
11. Lithuania
12. Macau
13. Mongolia
14. Mozambique
15. Nepal
16. North Korea
17. Sudan
18. United Arab Emirates
19. Vietnam

NOVEL APPROACH
Nations Where Teens Read the Fewest Novels

When Scholastic Publications unveiled J. K. Rowling's *Harry Potter and the Order of the Phoenix* in the summer of 2003, many wondered if young readers weaned on Game Boy and MTV had the attention span to wade through the 870-page epic. That was before kids snapped it up and read the mammoth fifth installment in the best-selling series cover to cover. Who said kids don't read as much nowadays?

The Organisation for Economic Co-operation and Development, that's who. In a 2004 survey of teen reading habits worldwide, the organization found that teens in the following countries read novels only sporadically, if that. No specific reasons were cited for the teens' literary apathy. The dismal percentage of 15-year-olds reading novels is listed for each country:

Japanese teens study hard, and play hard, but they don't read much fiction. Teens there read fewer novels than in any nation. What that says about the Nipponese youth culture is anyone's guess.

Country	Percentage of Teens Reading Novels
1. Japan	3.0%
2. Finland	12.1%
3. Belgium	12.5%
4. Norway	13.4%
5. South Korea	14.0%
6. Iceland	15.1%
7. Denmark	16.3%
8. France	16.6%
9. Portugal	19.5%
10. Italy	19.9%

OIL SPILLS

All-Time Worst Petroleum Accidents

In 1989 Alaska's Prince William Sound was awash in 11 million gallons of crude oil after the tanker *Exxon Valdez* collided with a reef. Over

Unknown Iraqi casualty: this oil-soaked bird was the result of the 1991 Persian Gulf War when Iraqi forces released hundreds of millions of gallons of crude oil into the Persian Gulf, causing the largest oil spill in history.

1,500 miles of once-pristine shoreline virtually turned black and wildlife perished in countless numbers. A three-year clean-up followed, but some of the damage to the coastline is irreparable.

While the *Exxon Valdez* is the worst oil spill in the U.S. history, it pales in comparison to the havoc wreaked by Saddam Hussein's forces, who flooded the Persian Gulf with hundreds of millions of gallons in crude oil during the first Gulf War. Their act of environmental terrorism tops the list of the all-time worst oil spills:

1. PERSIAN GULF, 1991, 240–460 MILLION GALLONS

Iraqi forces released hundreds of millions of gallons of crude oil into the Persian Gulf.

2. GULF OF MEXICO, 1979, 140 MILLION GALLONS

An exploratory well blew out, sending 140 million gallons of crude oil into the Gulf of Mexico.

3. UZBEKISTAN, 1992, 88 MILLION GALLONS

An oil well in Uzbekistan's Fergana Valley exploded in March of 1992.

4. NORTH SEA, 1977, 81 MILLION GALLONS

An oil well in the Ekofisk oil field exploded in April of 1977.

5. PERSIAN GULF, 1983, 80 MILLION GALLONS

The Nowruz Field platform had a massive spill in February of 1983.

6. SOUTH AFRICA, 1983, 78 MILLION GALLONS

The Spanish oil tanker *Castillo de Bellver* went up in flames in the waters near Cape Town.

7. FRANCE, 1978, 68 MILLION GALLONS

The supertanker *Amoco Cadiz* wrecked off France's Brittany Coast, which sustained serious environmental damage from the resulting oil spill.

8. TOBAGO, 1979, 46 MILLION GALLONS

The tankers *Atlantic Express* and *Aegean Captain* collided in the Caribbean. The *Aegean Captain* leaked *another* 41 million gallons of crude oil while being towed away.

9. NEWFOUNDLAND, 1988, 43 MILLION GALLONS

The tanker *Odyssey* spilled 43

million gallons of crude oil in November of 1983.

10. ITALY, 1991, 42 MILLION GALLONS

The tanker *Haven* spilled this amount of crude oil while at port in Genoa, Italy.

OLYMPIC DISGRACEFULS, SUMMER GAMES
All-Time Lowest Medal Counts

While the same athletic powerhouses duke it out for the most gold medals every four years, there are a few more modest nations that are happy to earn even one medal. Any medal. Ever.

Gymnastics training may require expensive equipment and sponsorship. Basketball success requires a bunch of pros with enough free time to make the trip. But everybody should be able to run, right? Maybe not. Whether it's the climate, the interest, or the talent, some countries seem to have a harder time of it than others.

The following countries have earned the fewest medals of all time at the Summer Olympics—one each:

1. Bermuda
2. Saint Kitts and Nevis
3. Cote d'Ivoire
4. Kuwait
5. Tonga
6. Senegal
7. Ecuador
8. Netherlands Antilles
9. Guyana
10. Dominican Republic
11. Niger
12. Burkina Faso
13. Kyrgyzstan
14. Barbados
15. Iraq
16. Macedonia, Republic of
17. Vietnam
18. Singapore
19. Zimbabwe
20. Virgin Islands
21. Sri Lanka
22. Djibouti

OLYMPIC DISGRACEFULS, WINTER GAMES
All-Time Lowest Medal Counts

Who better to earn the most Winter Olympic medals than Norway? A Scandinavian winter wonderland if there ever was one. Is it the snow

advantage that gives the northern countries an edge over their sweltering counterparts? If that's the case, then how do you explain Denmark's poor showing in the Winter games? Too much Hamlet-style brooding, not enough skiing, skating, and sledding? Whatever the reason, the not-so-great Danes were medal-less until the 1998 games in Nagano when the Danish women's team took the silver medal in curling.

Denmark tops the list of the 12 nations with the all-time fewest medals at the Winter Olympics:

Country	Number of Medals
1. Denmark	1
Romania	1
Uzbekistan	1
New Zealand	1
5. North Korea	2
Luxembourg	2
7. Slovenia	3
Estonia	3
Ukraine	3
10. Spain	4
Croatia	4
Australia	4

PARTY SCHOOLS
Toga! Toga! Toga!

When the *Princeton Review* reveals its college rankings each year, university presidents, admissions counselors, and students rush to find out where they rank. Everyone wants to be the best academically. Or the best value. Or best school of its size. But not many people—except the students—are anxious to be ranked as the Number One Party School.

The ranking is determined by a 70-question survey answered by 110,000 students on campuses across the country. The top party school is determined by questions related to the amount of alcohol consumed, drug use, amount of time spent studying, and the popularity of fraternities and sororities. All the things parents don't want to hear when forking over big bucks to pay the kids' college tuition.

Here's the *Princeton Review*'s 2004 ranking of the nation's biggest

party schools. Read through the list, but take it with a grain of salt—
followed by a double shot of tequila.

1. State University of New York at Albany
2. Washington and Lee University
3. University of Wisconsin–Madison
4. West Virginia University
5. Ohio University–Athens
6. Florida State University
7. University of Texas at Austin
8. University of Georgia
9. University of Colorado at Boulder
10. University of Mississippi

PAUPER'S PAY
Where a Dollar a Day Is the Pay of the Day

Back in 1950s, parents could buy two hours of peace and quiet, i.e.,
babysitting, for a dollar. Today, it's almost cheaper to have another kid
than hire a babysitter!

It's been decades since Americans earned four quarters for their day's
work. So it may be hard to imagine that workers in some countries are
still bringing home a mere dollar a day.

The following countries are ranked by the percentage of the popula-
tion making less than $1 a day according to 2001 World Bank statistics.
In these countries, which are mostly located in Sub-Saharan Africa, a
penny for your thoughts isn't too far from the truth:

Country	Percentage Making Less Than $1 a Day
1. Mali	72.8%
2. Nigeria	70.2%
3. Central African Republic	66.6%
4. Zambia	63.6%
5. Niger	61.4%
6. Burkina Faso	61.2%
7. Gambia	59.3%
8. Sierra Leone	57.0%
9. Madagascar	49.1%
10. Ghana	44.8%

PETROLEUM PRICES
Most Expensive Nations to Buy Gasoline

With the average price per gallon for regular unleaded gasoline hovering around the $2 mark in the United States, Americans are shedding tears and dollars to "fill 'er up" at the pump. Of course, that's not too bad compared to what they're paying in the UK for petrol. According to AirInc for *CNNMoney*, British drivers were paying the U.S. equivalent of $5.64 per gallon as of mid-2004. If prices continue to rise in the UK, many Brits won't keep their famous "stiff upper lip" for long.

At the other end of the gasoline price spectrum, motorists in Venezuela pay approximately 14 cents a gallon. We'd guess a free window wash is out of the question at that unbelievably low rate.

Here are the 10 countries with the highest gasoline prices in mid-2004, in U.S. dollars:

Country	Price Per Gallon
1. United Kingdom	$5.64
2. Hong Kong	$5.62
3. Germany	$5.29
4. Denmark	$5.08
5. Norway	$5.07
6. Italy	$4.86
7. Turkey	$4.85
8. Portugal	$4.80
9. South Korea	$4.71
10. Switzerland	$4.56

PHONE CHARGES
Most Expensive Local Telephone Calls

"ET phone home." The little extraterrestrial finally succeeded in reaching his family somewhere out there in the cosmos. Good thing it was a long-distance call, however, because local calls in some parts of the world would have been just too expensive for the alien paying in Reese's Pieces candy.

No wonder people walk around with cell phones stuck to their ears—the rates are just plain better than a lot of landline services. Even the competition of more than one server isn't enough to put the United States among the top-20 cheapest phone call charges. There may be unrest in the Middle East, but if you live there, a penny will buy you three minutes chat time with your friends. Vietnam is also a bargain at two cents for three minutes. But in Ecuador? You practically need a second mortgage to call your mom.

From nationmaster.com, 2001, here is a list of the most expensive places to make a local phone call:

Country	Price Per 3 Minutes
1. Ecuador	60 cents
2. Central African Republic	48 cents
3. Faroe Islands	40 cents
4. Azerbaijan	29 cents
5. New Caledonia	27 cents
Greenland	27 cents
7. French Polynesia	25 cents
8. Vanuatu	21 cents
9. Djibouti	20 cents
10. United Kingdom	17 cents

PO' FOLKS

Brother, Can You Spare a Billion?

Although rich in natural resources like copper, cobalt, and zinc, the African nation of Zambia is deeply mired in poverty. According to recent estimates in the *CIA World Factbook*, a staggering 86% of the country's 10,462,436 citizens live at or below the poverty line. With the unemployment rate hovering at 50%, the Zambians eke out a subsistence-level existence that most Americans can't or won't imagine.

Worldwide, as the rich get richer, the poor get poorer, particularly in Sub-Saharan Africa, which is home to a majority of the world's 10 poorest economies:

Country	Percentage of Population Below Poverty Line
1. Zambia	86%
2. Chad	80%
Haiti	80%
Moldova	80%
Liberia	80%
6. Guatemala	75%
7. Madagascar	71%
8. Bolivia	70%
Suriname	70%
Zimbabwe	70%

POPULATION DENSITY

Want a Little Privacy? Sorry!

Some places in the world might seem a bit cozier than others. A place as geographically large as China can hold a gigantic population, but

Hate crowds? Get out of town. This one, Monaco, has the highest population density in the world.

Monaco is so small that the relatively few folks living there must feel like they're bumping into each other every time they turn around. ("Oh, excuse me, Prince Rainier, sorry about your toes. I'll try not to step on them again.")

Here is a ranking of the countries with the most people per square mile according to the International Database of the U.S. Census Bureau:

Country	People Per Square Mile
1. Monaco	42,861
2. Singapore	16,279
3. Vatican City	5,362
4. Malta	3,253
5. Maldives	2,930
6. Bahrain	2,640
7. Bangladesh	2,542
8. Barbados	1,672
9. Taiwan	1,638
10. Nauru	1,580

PRISONERS
The "Land of the Free" Has the Lion's Share

Back in the days when the Soviet Union was regarded as "The Evil Empire," many Americans perceived the Communist stronghold to be the national equivalent of a sprawling gulag, where the oppressed and downtrodden citizens lived with the constant threat of being carted off to a Siberian work camp. But with the dissolution of the Soviet Union into 15 separate countries in the early 1990s, the good ol' U.S. of A. is now the country with most prisoners relative to population in the world by a sizable margin. In light of the findings in a 2003 study conducted by the International Centre for Prison Studies, maybe our national motto should be revised to "Life, liberty, and the pursuit of felons!"

Here are the 10 countries where many citizens view the world from behind bars:

Life, liberty, and jail. The United States leads in all three categories. America, "land of the free," has more prisoners per capita than any other nation.

Country	Prisoners Per 100,000 People
1. United States	715
2. Russia	584
3. Belarus	554
4. Palau	523
5. Belize	459
6. Suriname	437
7. Dominica	420
8. Ukraine	416
9. Bahamas	410
10. South Africa	402

REBEL ROUSERS
Countries That Experienced Secession Attempts

Archie Bunker was so vocal when he told television audiences all over the world they could "love it [their country] or leave it," the whole world must have taken note.

Here is an alphabetical list of 10 countries that experienced attempts to break away by rebel republics or regions, which are shown in parentheses:

1. China (Tibet)
2. Cyprus (Turkish Federated State of Cyprus)
3. Denmark (Faroe Islands)
4. France (Corsica, the Bretons, the Alsatians)
5. India (East Punjab, Kashmir)
6. Nigeria (Biafra)
7. Papua New Guinea (Bougainville)
8. Russia (Chechnya, Abkhazian, South Ossetia)
9. Sri Lanka (Tamil Elam)
10. Yemen (Democratic Republic of Yemen)

REEFER MADNESS
The Most Pot Heads

In New Zealand, with close to a quarter of its population having engaged in marijuana smoking, it's not surprising that the movie makers

In New Zealand nearly one quarter of the population has tried reefers, making the former British colony the most pot-smoking nation in the world.

found all those extras to convincingly portray walking trees when film-ing *Lord of the Rings* there. And hey man, those jumping kangaroos look really far-out in second place Australia, too. And you knew the United States would be "high" on the list as well—it comes in third.

The list below is a ranking of countries with the greatest percentage of its population that has used marijuana, according to the Organization for Economic Cooperation and Development's Social Cohesion Survey:

Country	Percentage Having Used Marijuana
1. New Zealand	22.23%
2. Australia	17.93%
3. United States	12.3%
4. United Kingdom	9%
5. Switzerland	8.5%
6. Ireland	7.91%
7. Spain	7.58%
8. Canada	7.41%
9. Netherlands	5.24%
10. Belgium	5.01%

REFUGEES

From Whence They Come, and Come, and Come

Civil strife and repressive governments around the world force hundreds of thousands to flee their homelands annually. Consigned to makeshift camps where most basic amenities are luxuries, these displaced popula-tions often find themselves living in permanent limbo, dependent on the aid and services of international relief agencies.

Each year, the United Nations Refugee Agency publishes a lengthy report on the state of the world's refugees and the countries and eth-nic groups most affected. Although Afghanistan has over three times the number of refugees than Sudan, the number of Sudanese refugees fleeing their war-torn country has jumped nearly 20%—the second largest increase after Liberia, whose annual refugee numbers have swollen by 28%.

Here are the 10 countries that are the points of origin for the biggest

refugee populations in the world according to the latest findings of the United Nations Refugee Agency:

Country	Number of Refugees	Annual Change
1. Afghanistan	2,136,000	−14.9%
2. Sudan	606,200	+19.3%
3. Burundi	531,600	−7.5%
4. Democratic Republic of Congo	453,400	+6.7%
5. Palestinians	427,800	−0.2%
6. Somalia	402,200	−6.9%
7. Iraq	368,400	−12.7%
8. Vietnam	363,200	−2.8%
9. Liberia	353,300	+28.2%
10. Angola	323,600	−24.6%

ROOMMATES
Most People Per Room, by Nations

If you're one of those people who needs space, a little togetherness goes a long way. But in Pakistan, where on average three people squeeze into a room, privacy is a luxury. Living in such cramped quarters can be a breeding ground for contempt, especially if your roommates don't share your standards of cleanliness or etiquette. Maybe these kind of intimate living arrangements would be great in the Arctic, where snuggling to keep warm is a necessity. Unfortunately, the most crowded countries in the world are also among the warmest, according to the United Nations Centre for Human Settlements in a 2001 survey. The following 10 countries have the highest average number of people per room:

Country	People Per Room
1. Pakistan	3
2. India	2.7
3. Nicaragua	2.6
4. Sri Lanka	2.2

Country	People Per Room
Honduras	2.2
6. Lesotho	2.1
Azerbaijan	2.1
8. Peru	2
Syria	2
10. Kuwait	1.7

SHARK ATTACKS
Where the Fish Are Really Biting

Ah, nothing like leaving the 9-to-5 grind behind to hit the beach, catch some rays, surf the waves—and get nibbled on by a hungry shark. While it's extremely rare—you're 100 times more likely to be bitten by another *person* than by a shark—these consummate ocean predators occasionally snack on swimmers.

So where are you are most at risk for shark attack in the world? According to the statisticians at the International Shark Attack File, the

Must be Florida, the number one place in the world for hungry sharks . . . and shark attacks on humans.

142

waters off Florida. From 1990 to 2003, there were 746 recorded shark attacks on humans worldwide. Of this number, a whopping 311 occurred off Florida beaches. Whether it's the water temperature, number of swimmers, or proximity to Disney World, sharks seem to flock to the Sunshine State like seniors with Mahjong sets. Only 3 of the 311 attacks resulted in death, but that's scant consolation to the 308 shark attack victims who lost limbs or live with terrible scars from their ordeal. In terms of fatalities, Australia tops the list with 14.

Here are the 10 places in the world with the highest incidence of shark attacks for the past 13 years:

Location	Number of Attacks	Fatalities
1. Florida	311	3
2. South Africa	63	8
3. Brazil	57	12
4. Australia	51	14
5. Hawaii	49	3
6. California	30	1
7. New Zealand	16	0
8. Reunion Island★	9	7
9. Hong Kong	6	6
10. Japan	4	3

★Reunion Island is a small, popular tourist destination in the Indian Ocean.

Note: 151 more attacks were attributed to unspecified other regions.

SPORTS TOWNS
Worst Cities in North America for Athletic Competition

You're sitting there in the stands, dressed head to toe in the home team colors, cheering yourself hoarse—and you're utterly alone. Is this some kind of sports-fan nightmare? Not if you're living in any of the cities that *The Sporting News* named the absolute worst for sports in North America.

The magazine's editors created the list by looking at wide range of criteria. They started off with almost 400 cities, each of which meets the minimum requirement of at least being home to one of the following: an NCAA Division I basketball team, a Class A minor league base-

ball team, or a training camp for a baseball or NFL team. Other factors meeting the requirements include the city hosting a bowl game, PGA tournament, or Triple Crown race. Once on the list, the cities are ranked based on a 12-month snapshot that looks at season records, play-off berths, tournament bids, or bowl appearances. Overall atmosphere and stadium or arena quality are also factors, along with marquee athletes. And here's where you come in: towns are judged by attendance and fan fervor at sporting events.

The cities that made the following list don't have much to cheer about. They are the 2004 10 worst cities for sports. In descending order:

1. Saint John, New Brunswick, Canada
2. St. John's, Newfoundland, Canada
3. Winnipeg, Manitoba, Canada
4. Springfield, Massachusetts
5. Hershey, Pennsylvania
6. Grand Rapids, Michigan
7. Myrtle Beach, South Carolina
8. Rockford, Illinois
9. Kannapolis, North Carolina
10. Augusta, New Jersey

STRESSFUL CITIES
America's Most Migraine-Inducing Communities

Your babysitter cancels and you're late for work. A deadline is looming, traffic is backed up for an hour, you're out of milk, *and* your in-laws are coming for a week. All this before lunch—and the bar across the street from work doesn't open for another hour.

Cheer up, it could be worse—your in-laws could stay *two* weeks— and you could live in any of the following cities, which are most stress-ful cities in America. The 2004 *Sperling's Best Places* survey ranked communities in nine categories: unemployment rate, violent crime, commute time, suicide rate, mental health, divorce rate, property crime, alcohol consumption, and cloudy days.

There's not much of a silver lining for these communities. They topped the ranks of most stressful cities for their size:

Most Stressful Large Cities:
1. Tacoma, Washington
2. Miami, Florida
3. New Orleans, Louisiana
4. Las Vegas, Nevada
5. New York, New York
6. Portland, Oregon;
 Vancouver, Washington
7. Mobile, Alabama
8. Stockton/Lodi, California
9. Detroit, Michigan
10. Dallas, Texas

Most Stressful Midsize Cities
1. Galveston/Texas City, Texas
2. Flint, Michigan
3. Fort Pierce/Port St. Lucie,
 Florida
4. Bremerton, Washington
5. Beaumont/Port Arthur, Texas

6. Lakeland/Winter Haven,
 Florida
7. Daytona Beach, Florida
8. Modesto, California
9. Brazoria, Texas
10. Shreveport/Bossier City,
 Louisiana

Most Stressful Small Cities
1. Yuba City, California
2. Gadsden, Alabama
3. Sherman/Denison,
 Texas
4. Anniston, Alabama
5. Pueblo, Colorado
6. Jackson, Michigan
7. Pine Bluff, Arkansas
8. Redding, California
9. Kenosha, Wisconsin
10. Danville, Virginia

STRUCTURAL FIRES
Worst Fire Damage, 1900 to Present

Thirty-two years after the Great Chicago Fire burned 18,000 buildings and killed 300 people, the Windy City was hit by another fiery tragedy. On December 30, 1903, as nearly 2,000 audience members gathered in the new, purportedly fireproof Iroquois Theater to watch the holiday show "Mr. Blue Beard, Jr.", one of the theater's heavy velvet curtains burst into flames. Ill-equipped to snuff the fire before it spread, the Iroquois Theater employees and performers joined the stampede for the exits, many of which were locked or opened inward. Although the Chicago fire department extinguished the blaze a half hour after it ignited, over 600 died in the Iroquois Theater fire. Excluding mine explosions, firestorms caused by military action, and the 9/11 attacks on the World Trade Center, here are the ten deadliest structural fires from 1900 to present:

Structure	Location	Date	Fatalities
1. Iroquois Theater	Chicago, Illinois	1903	602
2. Coconut Grove Nightclub	Boston, Massachusetts	1940	491
3. Supermarket	Asuncion, Paraguay	2004	464
4. Movie Theater	Abadan, Iran	1978	400
5. Circus	Niteroi, Brazil	1961	323
6. L'Innovation department store	Brussels, Belgium	1967	322
7. Ohio State Penitentiary	Columbus, Ohio	1930	320
8. Shopping Center	Luoyang, China	2000	309
9. Bank Building	Sao Paulo, Brazil	1974	189
10. Subway	Daegu, South Korea	2003	189

SWEAT-TOWN USA
America's Sweatiest Cities

While perspiration may not be a topic of polite conversation, the makers of Old Spice actually conducted a survey in 2004 to determine the sweatiest cities in the United States. Mechanics of the research are mercifully not included. Top-rated El Paso's average resident produces 1.09 liters of sweat per hour during a typical summer day. In fact, Old Spice has determined that the people of El Paso sweat enough in four hours to fill an Olympic-size swimming pool. Perhaps that's just a little too much information.

The sweatiest U.S. cities are listed below ranked in descending order.

1. El Paso, Texas
2. Greenville, South Carolina
3. Phoenix, Arizona
4. Corpus Christi, Texas
5. New Orleans, Louisiana
6. Houston, Texas
7. Miami, Florida
8. West Palm Beach, Florida
9. Fort Myers, Florida
10. Las Vegas, Nevada

TAXATION
Don't Work Here, If You Can Help It

Will Rogers said it well: "The only difference between death and taxes is that death doesn't get worse every time Congress meets." Years after his death, Americans now pay 19.4% of their earnings to Uncle Sam, according to the Organization of Economic Development (OECD). But that's chump change relative to the rest of the world.

In a 2001 study of its 30-member countries on four continents, the OED determined the countries where single-income families of four pay the highest percentage of gross earnings, including any social security contributions, to the government. Compared to the Turks and the Swedes, taxpayers in the United States got off fairly easily, coming in 24th out of 30 in the rankings.

Here are the top 10 countries, ranked by percentage of gross earnings taxed:

The Grand Bazaar in Istanbul no longer packs 'em in like it used to. Turkey, the nation with the highest income taxes in the world, has suffered economically like almost no other nation because of them.

Country	Percentage of Gross Earnings Taxed
1. Turkey	43.2%
2. Sweden	41.4%
3. Belgium	40.2%
4. France	39.4%
5. Hungary	38.9%
6. Finland	38.8%
7. Poland	38.0%
8. Greece	36.1%
9. Italy	35.6%
10. Germany	32.6%

TEACHER SALARIES
Lowest Earnings for Primary School Teachers

Inspired by serving in what is often referred to as "the noblest profession," many go into teaching, visions of *To Sir, With Love* and *Goodbye, Mr. Chips* in their heads, only to confront the exhausting reality of molding young minds in this era of rampant attention deficit disorder, overcrowded classrooms, and absent parents. For the amount of time they devote to the classroom, teachers often get the short end of the stick, financially speaking. Then again, no one goes into teaching to become rich; the rewards are of more intellectual and emotional nature. That said, if any profession needs to be better compensated, it's teaching, particularly on the primary school level.

According to a UNESCO-sponsored study of 22 countries, here are the countries with the lowest average starting salary for primary school teachers. Salaries are listed in equivalent U.S. dollars.

Country	Starting Salary
1. Hungary	$5,763
2. Czech Republic	$6,806
3. Turkey	$9,116
4. Mexico	$10,465
5. New Zealand	$16,678

Country	Starting Salary
6. Finland	$18,110
7. Sweden	$18,581
8. Portugal	$18,751
9. Italy	$19,188
10. Greece	$19,327

TREE BARREN
Least-Forested Countries

Looking for soft instrumental music in the background while you stroll down a picturesque forest path amid the lush trees and gently rustling leaves? There are a few countries in which you won't get much satisfaction.

Here are the nations with the least amount of forested land as a proportion of total land area, according to the Food and Agriculture Organization of the United Nations:

A tree grows in Brooklyn, but almost never here in Oman, the nation with the fewest trees. (What's a dog to do here?)

Country	Percentage of Forested Land
1. Oman	0.0%
2. Egypt	0.1%
Qatar	0.1%
4. Libya	0.2%
5. Iceland	0.3%
Mauritania	0.3%
Kuwait	0.3%
Djibouti	0.3%
9. Lesotho	0.5%
10. Western Sahara	0.6%

WEATHER DISASTERS
Worst Meteorological Calamities of the 20th Century

The 20th century endured Mother Nature at her most ferocious. After studying the world's weather records back to 1900, a team of U.S. scientists and climatologists put together a list of the very worst weather disasters of the last century. To determine their rankings, the members of the National Oceanic and Atmospheric Administration assessed each event in terms of economic impact, death toll, and meteorological uniqueness, according to Cynthia Long, a staff writer for the Web site DisasterRelief.org.

Tragically, the 21st century has barely begun, and already we've experienced one of the all-time worst weather disasters. In December 2004, massive tsunamis tore into eleven southeast Asian countries, killing over 150,000 and causing billions of dollars worth of damages.

Here are NOAA's findings of the 10 worst weather disasters of the 20th century, ranked in terms of fatalities:

Country/Region	Weather Event	Date	Est. Fatalities
1. China	Drought/famine	1907	24,000,000
2. Ukraine/Volga Region of USSR	Drought	1921–22	250,000 to 5,000,000
3. China	Yangtze River flood	1931	3,700,000
4. India	Drought	1900	250,000 to 3,000,000

Country/Region	Weather Event	Date	Est. Fatalities
5. India	Drought	1965–67	1,500,000
6. Africa	Drought	1972–75	600,000
7. Bangladesh	Cyclone	1970	300,000 to 500,000
8. Bangladesh	Cyclone	1991	138,000
9. Vietnam	Flooding	1971	100,000
10. Central America	Hurricane Mitch	1998	11,000

WELLNESS QUOTIENT, USA
Least-Healthy American States

Boasting the same name as the mighty river, Mississippi had the misfortune to be voted least-livable state and least-healthy state all in the same year. There's probably a connection—and it has nothing at all to do with Old Man River.

Healthy food production didn't seem to influence the judges. All the oranges—and vitamin C—in the world weren't enough to keep Florida from making the least-healthy list. Ditto with those healthy Georgia peaches.

A 2004 Morgan Quitno Press survey considered 21 factors, including affordability of health care, access to health providers, and the general health of each state's population. Many of the least-healthy states are from the Deep South, but Nevada couldn't beat the odds against it. The state came in 6th.

1. Mississippi
2. New Mexico
3. Louisiana
4. Alabama
5. South Carolina
6. Nevada
7. Delaware
8. Texas
9. Georgia
10. Florida

WORLD WAR I CASUALTIES
The "War to End All Wars," Huh?

Ninety years ago the "Great War" effectively began in Bosnia, when Gavrilo Princip shot and killed Archduke Franz Ferdinand and his wife

in the streets of Sarajevo. The conflict soon spread from the volatile Balkans throughout Europe and the Middle East. By the time World War I ended in 1918, millions had perished. Of all the countries embroiled in the conflict, Russia sustained the heaviest casualties: just over nine million Russian soldiers were killed, wounded, taken prisoner, or reported MIA.

Here are the 10 countries with the highest casualties in World War I:

Country	Total Casualties
1. Russia	9,150,000
2. Germany	7,142,558
3. Austria-Hungary	7,020,000
4. France	6,160,800
5. Great Britain	3,190,235
6. Italy	2,197,000
7. Turkey	975,000
8. Romania	535,706
9. Serbia	331,106
10. United States	320,518

3

Things

ACADEMIC ALIBIS
Best True-Life Excuses for Not Turning in Homework

It's the oldest homework excuse in the book: "My dog ate it." Some kids may have actually tried using that old chestnut with a straight face. But if they're going to blow off homework, kids should cut Rover some slack and dream up a more creative excuse—the more outlandish the better. For instance: "I made a paper airplane out of it and it got hijacked." Hmmm. How about the one where aliens borrowed it to learn about the human mind? Or the one where the lights went out and the homework had to be burned to light the way to the fuse box?

Following is a list of real excuses compiled by one teacher, which we ranked from most to least dubious. The only one missing here is probably the most obvious of all: "Homework? What homework?"

1. My homework was used to clean the dirty bottom of a baby.

2. I got my head caught in the power window of the car.

3. My car exploded and it burned up.

4. It was so cold last night that we had to burn all of the pencils for heat.

5. My homework blew over into the neighbor's pool and got all wet.

6. My brother and I got into a fight and he burned it on the stove.

7. I had to have my baby.

8. I got married over the weekend.

9. There's a virus in my printer.

10. It's at home—with my mind.

ACADEMY AWARD EMBARRASSMENTS
The Poorest Behavior at the Oscars . . . but Great TV!

For the past fifty-odd years, film fans around the world have clustered around television sets to watch the annual endurance test better known as the Academy Awards. Regularly clocking in at three or more hours, these bloated celebrations of Hollywood's best occasionally produce a

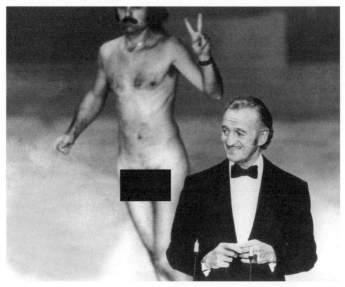

A streaker, naked as pup, dashed across the stage behind host David Niven at the 1974 Academy Awards in one of the 10 most embarrassing moments in Academy Award history.

genuinely exciting or touching moment. Who can forget Cuba Gooding Jr.'s exuberant break dancing during his acceptance speech for 1996's Best Supporting Actor? Or a sadly frail John Wayne, making one of his last public appearances before dying, to present 1978's Best Picture winner?

Of course, for every golden moment, there's a corresponding gaffe or mind-boggling lapse in taste that's the television equivalent of a three-car pileup. And no, we don't just mean Cher's tacky wardrobe. Here are 10 of the most embarrassing moments in the broadcast history of the Academy Awards, in chronological order, according to the Web site Oscarworld.net and the writers of this book:

1. 1959 TELECAST: THE SHOW MUST GO ON . . . NOW!

In 1959 the show actually ran short by 20 minutes. Confronted with dead air, NBC ordered show host Jerry Lewis to improvise. His schtick was so unfunny that NBC took pity on viewers and cut away to a feature on pistols.

2. 1973 TELECAST: DUVALL'S GIGGLE-FIT

While reading Shelley Winters's name as a nominee for Best Supporting Actress, Robert Duvall got a sudden attack of the giggles for no apparent reason. He apologized, but not before the cameras cut away to show a very bewildered Winters staring daggers at the actor.

3. 1973 TELECAST: BRANDO'S SNUB

When Marlon Brando's name was announced as Best Actor for *The Godfather*, the actor was MIA. In his stead, a Native American actress calling herself Sacheen Littlefeather took the stage to announce that Brando would refuse the honor because of Hollywood's shoddy portrayal of Native Americans.

4. 1974 TELECAST: THE STREAKER

A streaker making the V-sign for victory dashed across the stage behind host David Niven. Once the shock subsided, Niven recovered his composure and delivered one of the funniest lines in the show's history: "Well, ladies and gentlemen, that was bound to happen. But isn't it fascinating to think that the only laugh that man will probably ever get in his life was when he stripped off to show his shortcomings."

5. 1978 TELECAST: REDGRAVE'S SPEECH

Picketed by Jewish groups for her support of the PLO, Vanessa Redgrave threw gasoline on the fire in her acceptance speech for Best Supporting Actress when she referred to the protesters as "Zionist hoodlums."

6. 1986 TELECAST: OPENING NUMBER

In a truly bizarre moment, Telly Savalas, Pat Morita, and Dom DeLuise performed "Fugue for Tinhorns" in the ceremony's opening number. Their performance was closer to the Three Stooges than the Three Tenors.

7. 1989 TELECAST: LOW MOMENT FOR ROB LOWE

Rob Lowe humiliated himself by singing a duet of "Proud Mary" with Snow White in the opening number of the 1989 Academy Awards telecast. The legal eagles at Disney were not amused.

8. 1992 TELECAST: DEMME'S SPEECH

Accepting the Oscar for Best Director, Jonathan Demme rambled, paused and said "Um" so many times that it got to be ridiculous.

9. 1995 TELECAST: STUPID HOST TRICKS

Visibly uncomfortable, David Letterman seemed way out of his element as the host of the 1995 telecast. Most of his jokes fell flat with a resounding thud, like the "Uma/Oprah" bit that he milked in desperation. At another point, he dragged Tom Hanks onstage to assist in a "Stupid Pet Tricks" segment that left the crowd cold.

10. 1998 TELECAST: DANCING PRIVATE RYAN

Tap and flamenco dancers performed interpretative dances to excerpts from the five scores nominated for Best Dramatic Score. Savion Glover's tap dance to the score for *Saving Private Ryan* was criticized as especially inappropriate.

ACADEMY AWARD–WINNING SNUBS
Best Movies Never *Nominated*

Since the first Academy Awards ceremony was held in 1928 at Holly-wood's Roosevelt Hotel, some of the greatest films ever made have been conspicuously overlooked by the Academy voters, who've been known to reward popularity over quality. How else to explain *Titanic* winning Best Picture over the far superior *LA Confidential*? Or *How Green Was My Valley*, a fine, traditional piece of entertainment, taking the prize over Orson Welles's landmark *Citizen Kane*?

At least both *LA Confidential* and *Citizen Kane* were nominated for Best Picture, which is more than can be said for the following classics. As ranked by the Web site E! Online, here are the 10 best movies never nominated for the Academy's most coveted statuette, from the most egregious oversight to the least:

1. *REAR WINDOW*, 1954
A perennial Oscar bridesmaid, Al-fred Hitchcock made some of his greatest films in the 1950s. This nail-biter starring Jimmy Stewart and Grace Kelly is pure cinema magic, but the Academy thought otherwise and bypassed it com-pletely. At least the eventual win-ner, *On the Waterfront*, is a classic in its own right.

2. *SINGIN' IN THE RAIN*, 1952
Few movies are as purely pleasur-able and charming as this Gene Kelly masterwork, which most critics regard as the all-time best musical. Not only did the Acad-emy ignore it, the members named Cecil B. DeMille's mediocre *The Greatest Show on Earth* Best Picture!

3. *CITY LIGHTS*, 1930–31
Charlie Chaplin's last entirely silent film is a beautiful and poignant vehicle for Chaplin's beloved creation, The Little Tramp. Talkies ruled that year, however, and the turgid western drama *Cimarron* won Best Picture.

4. *THE SEARCHERS*, 1956
Arguably John Ford and John Wayne's greatest collaboration, this influential western didn't make the Oscar grade. The cameo-laden *Around the World in 80 Days* won Best Picture.

5. *SOME LIKE IT HOT*, 1959
Usually, the Academy recognized the brilliance of writer/director Billy Wilder. In 1959 the Acad-emy voters lost their sense of hu-

Acclaimed by critics, but not the Academy, the brilliant Hitchcock thriller Rear Window, *starring Jimmy Stewart and Grace Kelly, ranks as the number-one most egregious snub in Oscar history.*

mor and went for the lumbering epic *Ben-Hur* instead of this deliriously funny farce.

6. *DO THE RIGHT THING*, 1989

Spike Lee's stunning meditation on violence and racism may have been a bit too controversial for Academy voters, who opted for the excellent but exceedingly safe period film, *Driving Miss Daisy*.

7. *METROPOLIS*, 1927–28

Fritz Lang's futuristic drama is a provocative wonder to behold nearly 80 years after its release. At the first Academy Awards, the

members went the patriotic route and gave the Best Picture trophy to the rousing WWI film *Wings*.

8. *THE AFRICAN QUEEN*, 1951

Bogie and Hepburn make an irresistible team in this witty and exciting romantic drama beloved by audiences and critics. Although Bogie took home the Oscar, *The African Queen* wasn't one of the nominees for the prize that went to *An American in Paris*.

9. *RAN*, 1985

Japanese filmmaker Akira Kurosawa transformed Shakespeare's

King Lear into a magnificent story of feudal Japan. The Academy members were feeling colonial and went with *Out of Africa*.

10. *BREAKFAST AT TIFFANY'S*, 1961
The incandescent Audrey Hepburn is at her best in this sophisti-

cated and bittersweet adaptation of Truman Capote's novella. Both she and the film were ignored. The eventual winner is almost equally beloved: *West Side Story*.

AIRCRAFT CROWDED
Airlines with the Highest Rates for Bumping Passengers

The skies aren't so friendly these days for airline travel. In the summer of 2003, flights were fuller than ever, with an average of 80% of all seats filled. The good news? On overbooked flights, attendants usually ask for volunteers to give up their seats and compensate them with free travel vouchers. In fact, sometimes passengers battle each other for the opportunity. But when no one is willing or able to wait for another flight, the airline will bump someone involuntarily—usually the last person to arrive at the gate.

While U.S. airlines seem to be the worst offenders (possibly due to the higher number of flights scheduled), international carriers pull the same tricks in a different language. According to bumptracker.com, Air Canada, Aero Mexico, Scandinavian Airlines, and Lufthansa have the highest bump rate among non-American airlines.

So if you're flying one of the American carriers below with the highest bump rates according to a 2004 Department of Transportation survey, be sure to get to the gate with plenty of time to spare.

Airline	Percentage Passengers Bumped
1. Atlantic Southeast	7.86%
2. AirTran	1.45%
3. Delta	1.30%
4. Continental	1.06%
5. Southwest	1.02%
6. ATA	0.89%
7. Alaska	0.81%

Airline	Percentage Passengers Bumped
8. Northwest	0.70%
9. United	0.65%
10. America West	0.40%

AIRPLANE CRASHES
The Deadliest Plane Crashes in Aviation History

Although the odds of dying in a plane crash are slim, fatalities have always been a part of aviation. In fact, the first person to die in an aviation accident was a passenger of Orville Wright. While the chances of dying in a car crash are 1 in 247, your lifetime odds of being killed in an airplane crash are only 1 in 4,023 according to the National Safety Council. And in the unlikely event of a crash, the chances of surviving are as high as 80%.

International Airline Carrier Crashes

Here are the 10 worst international airline carrier disasters, ranked by fatalities:

1. AUGUST 12, 1985, JAPAN
A Japan Air Lines Boeing 747 crashed into a mountain, killing 520 of the 524 aboard. This is the highest death toll involving a single plane in aviation history.

2. NOVEMBER 12, 1996, NEW DELHI, INDIA
349 people died when a Saudi Arabian Airlines 747 collided in the air with a charter cargo flight outside New Delhi, India.

3. MARCH 3, 1974, PARIS
A Turkish Airline DC-10 jumbo jet crashed in the forest soon after takeoff, killing all of the 346 passengers and crew aboard.

4. JUNE 23, 1985, ATLANTIC OCEAN
A Sikh terrorist bomb is thought to be the cause of the explosion that killed 329 passengers aboard an Air India 747.

5. JULY 3, 1988, PERSIAN GULF
The U.S. Navy cruiser Vincennes shot down an Iran Airbus carrying 290 passengers after mistaking it for an enemy jet fighter.

6. FEBRUARY 19, 2003, SHAHDAD, IRAN

An Iranian military airplane, an Ilyushin Il-76MD, crashed in the Sirach Mountains. All 276 aboard were killed.

7. AUGUST 30, 1983, ISLAND OF SAKHALIN OFF SIBERIA

A Korean Air Lines Boeing 747 was shot down by a Soviet fighter after it veered off course into Soviet airspace, killing all 269 aboard.

8. APRIL 26, 1994, NAGOYA, JAPAN

264 of the 271 passengers on China Airlines Airbus A-300 died when the plane crash-landed and exploded on the tarmac.

9. JULY 11, 1991, JEDDAH, SAUDI ARABIA

A Nigeria Airways DC-8 exploded and crashed, killing 261.

10. NOVEMBER 28, 1979, MT. EREBUS, ANTARCTICA

An Air New Zealand DC-8 crashed into Antarctica's Mt. Erebus, killing all 257 aboard.

Domestic Airline Carrier Crashes

Here are the 10 worst domestic airline carrier disasters, ranked by fatalities:

1. MARCH 27, 1977, SANTA CRUZ DE TENERIFE, CANARY ISLANDS

A Pan Am 747 carrying 249 passengers and a KLM 747 with 394 passengers collided on the runway, killing 582 people. This is the highest death toll for any aviation disaster to date.

2. MAY 25, 1979, CHICAGO

An engine failure on an American Airlines DC-10 sent it crashing to the ground seconds after takeoff. It killed 272 people aboard and 3 on the ground.

3. DECEMBER 21, 1988, LOCKERBIE, SCOTLAND

A bomb planted by Libyan terrorists exploded aboard a Pan American World Airways B747, killing all 259 aboard. Eleven people died on the ground.

4. NOVEMBER 12, 2001, QUEENS, NEW YORK

An American Airlines Airbus A-300 crashed into a residential area shortly after taking off from JFK Airport, killing 260 passengers and 5 people on the ground.

5. DECEMBER 12, 1985, GANDER, NEWFOUNDLAND

256 American soldiers going home for Christmas aboard a chartered Arrow DC-8 were killed when the plane crashed on take-off.

6. JULY 17, 1996, LONG ISLAND, NEW YORK

A TWA Boeing 747-100 exploded over the Atlantic Ocean while en route to Paris. All 230 passengers were killed.

7. DECEMBER 20, 1995, BUGA, COLOMBIA

An American Airlines B757 crashed into Mt. San Jose upon descent into Cali, Colombia. 155 of the 159 passengers died, along with 8 members of the flight crew.

8. AUGUST 16, 1987, ROMULUS, MICHIGAN

A Northwest Airlines MD82 crashed shortly after take-off. 154 of the 155 people aboard died. Two more people on the ground were killed.

9. JULY 9, 1982, KENNER, LOUISIANA

Shortly after take-off from New Orleans during a intense storm, a Pan American World Airways B727 crashed into a suburban neighborhood, killing all 144 aboard and 8 people on the ground.

10. SEPTEMBER 25, 1978, SAN DIEGO, CALIFORNIA

A Cessna collided in midair with a Pacific Southwest Airlines plane. 144 died, including 7 people on the ground.

AIRSHIP DISASTERS
Beautiful, Bloated, and Deadly

Before airplanes were perfected as passenger vehicles, great hope was placed on airships, which are inflated, lighter-than-air "bags" capable of taking passengers aloft. They proved to be one of the most dangerous modes of mass transit of all time.

In the late 1930s, Germany's Zeppelin Company launched what they billed as the grandest airship ever built: the *Hindenburg*, which measured 804 feet long and 135 feet wide. On May 6, 1937, with 97 people aboard, the *Hindenburg* arrived in Lakehurst, New Jersey, on what would be its first and last transatlantic voyage. As onlookers watched in horror,

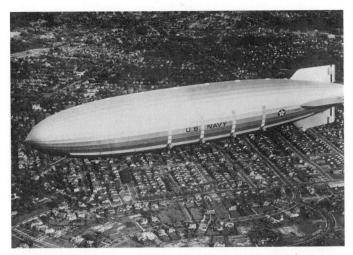

The USS Akron, *a "state of the art" airship, crashed at sea in 1933, four years before the* Hindenburg *calamity that killed 36 people. The crash of the* Akron, *in which 73 people died, was the worst airship disaster of all time.*

the airship filled with 7,063,000 cubic feet of hydrogen suddenly exploded in flames. In just under a minute, thirty-five people aboard the Hindenburg died; another person on the ground was also killed, bringing the death toll to 36.

Although the *Hindenburg* airship disaster has been referred to as the "*Titanic* of the sky," it ranks only fifth on the list of the 10 all-time worst airship disasters in terms of deaths.

Airship	Date	Type of Disaster	Deaths
1. *USS Akron*	April 3, 1933	Crashed into sea	73
2. *Dixmude*	Dec. 21, 1923	Struck by lightning	52
3. *R101*	Oct. 5, 1930	Crashed into hillside	50
4. *R38*	Aug. 24, 1921	Broke in two	44
5. *Hindenburg*	May 6, 1937	Exploded at mooring	36
6. *Roma*	Feb. 21, 1922	Crashed to earth	34
7. *LZ18*	Oct. 17, 1913	Crashed to earth	28

Airship	Date	Type of Disaster	Deaths
8. *SL9*	March 30, 1917	Struck by lightning	23
9. *L10*	Sept. 3, 1915	Struck by lightning	19
10. *L1*	Sept. 9, 1913	Crashed into sea	14
11. *Shenandoah*	Sept. 3, 1925	Broke up in storm	14

ALCOHOLIC "PUNCH"
Most Hangover-Inducing Drinks

Before a bout with your favorite bottle of hooch that leaves you hugging the porcelain stool in the bathroom all night, you might consider consulting the list below. According to the writers at rocknroll.force9.co.uk, the following list reflects, in order, the worst eight hangover-inducing alcoholic beverages. According to this Web site, the darker the color of the alcohol, the more potential is there for a wicked morning after.

Brandy is the number one most hangover-inducing alcoholic beverage.

1. Brandy
2. Red wine
3. Rum
4. Whiskey
5. Beer
6. White wine
7. Gin
8. Vodka

ANIMAL LETHARGY
The Laziest Animals

Ah, the stressful life of the domestic cat. Every day is a nerve-fraying struggle for our feline companions to find just the right spot to collapse in an exhausted heap and sleep hours on end. If they do in fact lead

nine lives, they probably spend most of the time napping, dreaming of mice to torture and owners to ignore.

While the average cat sleeps upwards of 13 hours a day, kitty is by no means the world's laziest animal. And contrary to the widely held belief by many women, neither are men on chore days! Nor is the sloth, who "moves"—just barely—through the world's rain forests as if in a perpetual daze, like he's just awakened from a three-day bender. The world's laziest animal is the Quantas Airlines mascot, the koala bear, who logs 22 hours a day asleep. The Australian marsupial heads the list of animals who sleep most of the day away:

Cute, cuddly and lazy, the koala bear is the most lethargic beast in the animal kingdom, sleeping 22 hours daily.

Animal	Hours Asleep Per Day
1. Koala bear	22
2. Sloth	20
3. Armadillo	19
Opossum	19
5. Lemur	16
6. Hamster	14
Squirrel	14
8. Cat	13
Pig	13
10. Spiny anteater	12

AUTOMOBILE MILEAGE
The Greediest Gas Guzzlers

Every year, the U.S. Department of Energy and the Environmental Protection Agency release the *Fuel Economy Guide*, which ranks cars, trucks, and sports utility vehicles in terms of gas mileage. In the 2004 edition, the Honda Insight tops the rankings as the most fuel efficient car on the road. A hybrid vehicle, the two-seat, manual transmission Insight gets an average of 60 miles per gallon in the city—on the highway, the rate increases to an incredible 66 mpg!

Way at the other end of the fuel efficiency spectrum lies the ultra-snazzy Lamborghini L-147 Murcielago. This plush two-seater with manual transmission burns through gas like a flash fire, averaging only 9 mpg in the city, 13 mpg on the highway. That said, anyone who's driving one of these babies probably isn't hunting pennies to fill 'er up at the pump.

From two-seaters to midsize station wagons, here are the U.S. Government's picks for 2004's eight biggest gas guzzlers:

Car Size	Model	Mpg City/Highway
1. Two seater	Lamborghini L-147 Murcielago	9/13
2. Minicompact	Aston Martin V12 Vanquish	12/19
3. Subcompact	Maserati Coupe Cambiocorsa GT	11/17
4. Compact	Bentley Continental GT	11/18
5. Midsize	Bentley Arnage	10/14
6. Large	Bentley Arnage LWB	10/14
7. Small station wagon	Audi S4 Avant 4WD	15/21
8. Midsize station wagon	Mercedes-Benz E500 4matic Wagon	16/22

AUTOMOBILE REPAIRS
The Most Expensive Cars to Fix

It only makes sense—the more it costs to make a car, the more it will cost to repair. Need a new headlight? Don't pull out a ten-dollar bill, or even a fifty. Try $500 for the new high-intensity headlights.

Here is a look at the most expensive cars to repair in each car class, based on five-year repair costs, according to a report from Edmunds.com:

Car Type	Model	5-Year Repair Cost
1. Luxury convertible	Porsche 911	$2,067
2. Mid-range convertible	BMW Z4	$1,156
3. Luxury coupe	Porsche 911	$2,067
4. Mid-range coupe	Mercedes-Benz C-Class	$1,328
5. Minivan	Oldsmobile Silhouette	$869
6. Luxury SUV	Porsche Cayenne	$2,067
7. Midrange SUV	Land Rover Freelander	$1,897
8. Luxury sedan	Jaguar XJR	$1,937
9. Mid-range sedan	Jaguar X-Type	$1,897
10. Luxury wagon	Audi S4	$1,668

AUTOMOBILES MOST STOLEN
Favorite Makes and Models of America's Best Car Thieves

Joy-riding kids will steal any car with the keys inside, but beware of enterprising car thieves. These are the guys who make their money by selling the stolen parts. The target is usually a popular vehicle, making the parts easier to sell and harder to trace. Cars are still more popular with thieves than SUVS. But the latter is gaining in popularity with the Mitsubishi Montero, the Chevrolet Tahoe, and the Jeep Cherokee heading the list of SUVs stolen. The Chevy Silverado is the favorite truck among thieves.

Police reports show that car thieves tend to steal cars that are most popular in their region of the country. In Texas the most stolen vehicle in 2003 was the 1994 Chevrolet C1500 4X2 pickup. California cons prefer imports. And if you think color doesn't matter, you're wrong.

White cars are stolen most often, followed by red, blue, black, and then green.

Here is a list of the ten vehicles most-often stolen in the United States, as reported to the National Insurance Crime Bureau (NICB) in 2003 by law enforcement agencies:

1. Toyota Camry (1989)
2. Honda Accord (1994)
3. Honda Civic (2000)
4. Chevrolet full-size pickup (1992)
5. Ford F-Series pickup (1997)
6. Jeep Cherokee/Grand Cherokee (1993)
7. Oldsmobile Cutlass (1986)
8. Dodge Caravan (1994)
9. Ford Taurus (1996)
10. Toyota Corolla (2001)

BAD IDEAS
The Most Absurd Brainstorms of the 20th Century

The late, unlamented U.S. President Herbert Hoover called Prohibition "a noble experiment." But according to the nearly quarter of a million readers who voted in a *very* informal *Time Magazine* poll in 2000, the 18th Amendment is clearly the worst idea of the entire 20th century. Finally repealed in 1933—because no one wanted to face the Depression without a good stiff drink—the 18th Amendment heads this mostly tongue-in-cheek list of 100 colossal errors in judgment like the leisure suit, strip malls, and Milli Vanilli's Grammy.

Here are the top 25 vote-getters on *Time*'s cringe-inducing list:

1. Prohibition
2. The Y2K bug
3. Geraldo Rivera opens Al Capone's vault
4. Telemarketing
5. *The Jerry Springer Show*
6. O.J. Simpson tries on the glove
7. Spandex in plus sizes
8. The designated hitter rule
9. Driftnet fishing
10. Beeping watches
11. DDT
12. The Ugandan space program
13. Personal watercraft
14. The Dalkon Shield
15. The Red Sox sell Babe Ruth to the Yankees
16. Michael Jackson marries Lisa Marie Presley
17. The Treaty of Versailles

18. The *Titanic* (the ship, not the movie)
19. Breast implants
20. Psychic hotlines
21. Barney the dinosaur
22. New Coke
23. Spray-on hair
24. Thong underwear for men
25. Attacking Israel on Yom Kippur

BARGAINS TO BEWARE
Most Hazardous Thrift-Store Goods

It's a common phenomenon: caviar tastes on a "mac and cheese" budget. Anyone who takes a walk though the mall or picks up a magazine is deluged with expensive designer products. But who can afford them all?

Enter the thrift shop. Goodwill and Salvation Army stores have an almost cult following. And newer, more upscale thrift shops are popping up that carry only designer brands, in everything from evening gowns to diaper bags.

With clothes, the biggest worry is whether the outfit is a perfect fit. But when it comes to buying other products from the local resale shop, you need to be

Old-style hair dryers, like many of the new cheap ones, don't adequately protect users from electrocution, making them among the most dangerous bargains to beware.

more discriminating. Some products, especially those for infants and children, can be dangerous because they don't meet today's safety standards.

From a 2000 Consumer Product Safety Commission survey, here is an alphabetical list of the most hazardous products commonly found in thrift stores:

1. Battery-powered vehicles that catch fire
2. Cedar chests
3. Cribs that don't meet current safety standards
4. Drawstrings on children's outerwear
5. Hairdryers that can cause electrocution
6. Halogen torchiere floor lamps
7. Lawn darts
8. Older playpens
9. Recalled car seat carriers
10. Recalled toy basketball nets

BASEBALL IN THE BASEMENT
Teams That Lost the Most Fans

"If people don't wanna go to the ball game, how you gonna stop 'em?"—Yogi Berra. Perhaps when the inveterate orator of mangled English posed the question, he didn't know that attendance at major league games would be up 11.4% between 2003 and 2004, making it the best attendance in six years.

Some things just packed in the fans: the world champion Marlins's attendance increased by an average of 10,000 people per game, or 70%, since they won the 2003 Series. Other teams have die-hard fans that fill the park no matter how many games they lose (can you say Chicago Cubs?).

But there are some ball clubs that just can't even give away tickets. The teams below are those with the biggest drop in attendance in 2004:

1. Montreal Expos: −25%, dropped from 12,191 to 9,197

2. Toronto Blue Jays: −11%, dropped from 22,603 to 20,127

3. Pittsburgh Pirates: −10%, dropped from 21,660 to 19,570

4. Seattle Mariners: −8%, dropped from 38,350 to 35,103

5. Minnesota Twins: −6%, dropped from 22,201 to 20,944

6. Arizona Diamondbacks: −2%, dropped from 33,562 to 32,810

7. New York Mets: −2%, dropped from 29,543 to 28,945

8. Kansas City Royals: −1%, dropped from 22,809 to 22,600

BOOK TITLES
The Most Improbably Named Books

Whoever said you can't judge a book by its cover obviously never tried to launch a title in today's crowded literary marketplace. With countless books lining the shelves at bookstores worldwide, it's tougher than ever to stand out from the pack. An eye-catching cover and snappy title are practically required—except, that is, if you're writing for more of a niche audience. Even so, the following, actual book titles are truly among the oddest.

In the late 1970s, the Diagram Group started giving out an annual award at the Frankfurt Book Fair for the most improbable title. Here are 10 of our favorites chosen from the winners and runners-up, in alphabetical order:

1. *Do It Yourself Brain Surgery and Other Home Skills*

2. *Entertaining with Insects: The Original Guide to Insect Cookery*

3. *Natural Bust Enlargement with Total Mind Power: How to Use the Other 90 Percent of Your Mind to Increase the Size of Your Breasts*

4. *New Guinea Tapeworms and Jewish Grandmothers*

5. *Nuclear War Fun Book*

6. *Proceedings of the Second International Workshop on Nude Mice*

7. *Sex after Death*

8. *The Water of Life—A Treatise on Urine Therapy*

9. *Where Do Babies Come From and How to Keep Them There*

10. *Wife Battering: A Systems Theory Approach*

BOOKS CHALLENGED
Most-Oft-Censored Titles

In 1920, the United States Government imposed a 15-year ban on the publication of James Joyce's masterpiece *Ulysses*, which was labeled "obscene." Other classics such as *Candide* and the bawdy satire *Fanny Hill* also kept the morality watchdogs busy for years; first published in

1749, *Fanny Hill* was finally cleared of obscenity charges by the U.S. Supreme Court in 1966.

Although actual book banning has virtually disappeared in today's more liberal climate, parents and religious groups still regularly *challenge* schools and public libraries to remove certain titles, which they deem "unsuitable" for children and adolescents. According to the American Library Association's Office for Intellectual Freedom, the mega-selling *Harry Potter* series has come under particular fire from religious fundamentalists, who condemn the books for glorifying wizardry and witchcraft.

Here is a list of the books most-often challenged in 2003, in no particular order:

1. *Alice* series by Phyllis Reynolds Naylor: offensive language and unsuited to the age group

2. *Harry Potter* series by J. K. Rowling: depiction of wizardry and magic

3. *Of Mice and Men* by John Steinbeck: offensive language

4. *Arming America: The Origins of a National Gun Culture* by Michael Bellesiles: inaccuracy

5. *Fallen Angels* by Walter Dean Myers: racism, offensive language, sexual content, drugs, and violence

6. *Go Ask Alice* by Anonymous: drugs

7. *It's Perfectly Normal* by Robie Harris: homosexuality, sexual content, nudity, and sex education

8. *We All Fall Down* by Robert Cormier: offensive language and sexual content

9. *King & King* by Linda de Haan: homosexuality

10. *Bridge to Terabithia* by Katherine Paterson: offensive language and occult/satanism

BROADWAY MUSICAL FLOPS

Worst Song-and-Dance Shows to Ever Hit the Great White Way

Everything's *not* coming up roses for Rosie O'Donnell these days. After losing her crown as the Queen of Nice in a nasty legal brawl with her former magazine publishers, O'Donnell lost her shirt, pants, and shoes as the sole investor in the expensive Broadway musical flop, *Taboo*. The critically panned $10 million rock musical import from London, starring rock-and-roll has-been Boy George, closed after three barely attended months. Strangely enough, the prospect of watching self-destructive club kids sing and dance between injections of heroin and cross-dressing didn't strike a chord with tourists, who are Broadway's bread and butter these days.

Taboo is merely the latest in a recent series of high-cost, low-return Broadway musicals that debut in a frenzy of buzz, only to die a very public, very humiliating, and very expensive death once the bad word hits the streets. Here are 10 mega-budgeted Broadway musicals that

It flopped like a pancake. Legs Diamond, *a 1988 Broadway show, one of the 10 biggest eggs ever laid on the Great White Way.*

sank faster than the Titanic, which inspired a Tony-winning musical that actually cost more than the ill-fated ocean liner itself!

In alphabetical order:

1. *ANNIE 2: MISS HANNIGAN'S REVENGE*

The producers bet their bottom dollars—all 7 million of them—that fans would love this 1990 musical sequel to the 1978 hit. *Annie 2: Miss Hannigan's Revenge* closed on the road.

2. *ASPECTS OF LOVE*

One of Andrew Lloyd Webber's few flops, *Aspects of Love* lost $8 million in its 1991 Broadway incarnation after a successful run in London.

3. *BIG*

What sounded like a "can't miss" proposition—a musical, family-friendly version of the 1988 Tom Hanks movie—missed in a big way to the tune of $10 million when it opened and rapidly closed on Broadway in 1996.

4. *THE CAPEMAN*

Some big names—rock legend Paul Simon, Nobel Prize–winning poet Derek Walcott, avant-garde choreographer Mark Morris—conspired, er, collaborated on this $11 million musical flop based on a real-life 1959 gang killing.

5. *CARRIE*

This $8 million musical based on the Stephen King novel closed after just 5 performances amidst a chorus of ear-splitting boos. According to cast member Betty Buckley, the opening night audience cheered when the mortified actors fled the stage at the show's climax.

6. *DANCE OF THE VAMPIRES*

In 2002 critics and audiences drove a stake through the heart of this $14 million pop operetta, based on the 1967 horror comedy *The Fearless Vampire Killers* by Roman Polanski.

7. *A DOLL'S LIFE*

This $4 million musical sequel to Ibsen's *A Doll's House* closed after 5 performances in 1982.

8. *LEGS DIAMOND*

The late Peter Allen co-wrote the book and starred in this legendary disaster about a Depression-era gangster. The $5 million production closed after 8 weeks in 1988.

9. *RAGS*
This 1986 $5.5 million musical about immigrants circa 1910 lasted just 4 performances.

10. *TABOO*
If ever a show was aptly named, it would be *Taboo.* Faded androgy-nous icon Boy George wrote the score and played a supporting role in this $10 million flop, based on his clubbing days in 1980s-era London.

CANDY CALORIES
Candy Bars with the Highest Fat Content

Looking for Mr. Goodbar? The bearer of that famous name in candies is good, all right, but not if you want to look like Mr. Universe or Julia Roberts.

Chew on this: chocolate is the number-one food that women crave—and for many good reasons. It is a high-energy food containing potassium, magnesium, calcium, and vitamins A, B_1, B_2, D, and E. It works as an antidepressant and stress reliever, releasing endorphins that elevate your mood and relieve pain. And chocolate contains antioxidants that protect against heart disease and cancer.

A recent study of 8,000 male Harvard graduates showed that choco-holics actually live longer than abstainers. But if you want to grow old lean, check out this list and keep your intake of the candies on the list to a minimum:

Candy	Grams of Fat	Calories
1. Mr. Goodbar	16.3	264
2. Mounds	14.1	258
3. Snickers	14	273
4. Reese's Peanut Butter Cup	13.7	232
5. O'Henry Bar	13.2	263
6. Peanut M&Ms	12.3	243
7. Reese's Pieces	11.6	203
8. Almond Joy	11.5	234
9. Kit Kat	11.4	217
10. Krackle	10.9	210

CANINE COPS
Most Ineffective Watchdog Breeds

Contrary to popular belief, size doesn't matter when it comes to watch dogs. In fact, getting a big dog to defend home and hearth is one of the most common mistakes that people make, according to Petrix.com, a Web site that ranks the best and worst watchdogs. Take a St. Bernard, for instance. He's the linebacker of the canine world, leading the pack in terms of bulk. But intimidating? Not unless excessive slobbering strikes fear in the heart of a burglar preparing to go to work.

It's those little dogs—the ones with a Napoleon complex—that are the real terrors. They growl, they bark, they bare their teeth. That's canine-speak for "don't mess with me—or my family."

Here's a look at some of the most laid-back dogs, in alphabetical order. Great pets? You bet! But these amiable pooches would hardly even bark at a gang of thieves rattling their burglar tools at them.

1. Basset hound
2. Blood hound
3. Bulldog
4. Clumber spaniel
5. Irish wolfhound
6. Newfoundland
7. Old English sheepdog
8. Pug
9. Saint Bernard
10. Scottish deerhound

CANINE INTELLIGENCE
The Dumbest Dogs

Who cares if your dog hides under the bed during a storm, as long as he wags his tail and licks your face when you come home? But if you want a smart dog, there are certain breeds that rank highest among dog trainers. The smart breeds like border collies, poodles, German shepherds, and golden retrievers obey a command 97% of the time and understand new words with less than five repetitions.

Dog trainer and psychology professor Stanley Coren polled 100 dog obedience judges for their opinions of the intelligence of specific breeds. The list gives a good indication of the relative intelligence of the recognized breeds, which Coren states is really a measure of how

easy they are to train. But pedigreed dogs are bred for specific traits, and sometimes intelligence is not one of them. Below is a ranking of the 10 dumbest breeds according to Coren's poll. If you're looking for dogs any dumber, you're barking up the wrong tree.

1. Afghan hound
2. Basenji
3. Bulldog
4. Chow chow
5. Borzoi
6. Bloodhound
7. Pekinese
8. Mastiff
 Beagle
9. Bassett hound
10. Shih tzu

World's dumbest dog, the Afghan Hound.

CAR CALLS
Weirdest Names for Automobile Models

A rose by any other name might smell as sweet, but a car with a weird name? Just try to give off that James Dean–style cool while tooling around in your brand-spanking-new Honda Life Dunk. Huh? Is this some car designer's sick joke?

Sadly, no. For every Mustang or Jaguar, there's a car on the market with an unfortunate moniker that defies belief. We've all heard the story of how the Chevy Nova was a poor seller in Mexico. Who wants a car that "no va" (doesn't go)? And who can forget the legendary, much-maligned Edsel from yesteryear?

From a 2004 *Forbes* magazine article, here's an alphabetical list of the worst and weirdest car names. If you were a 16-year-boy trying to im-

press the girls, would you be caught dead behind the wheel of an Isuzu GIGA 20 Light Dump?

1. Daihatsu Naked	7. Rickman Space Ranger
2. Honda Life Dunk	8. Rinspeed X-Dream
3. Isuzu GIGA 20 Light Dump	9. Suzuki Cappucino
4. Mazda Bongo	10. Toyota Deliboy
5. Mitsubishi Delica Space Gear	11. Volkswagen Thing
6. Nissan Prairie Joy	12. Volugrafo Bimbo

CAREERS, LEAST ADMIRED
Would You Buy a Used Car from This Individual?

Used car salesmen may have ditched those loud plaid sport coats of an earlier (uglier) era, but that hasn't upped their standing in a national poll of the most-admired professions. Whether they're selling a Lamborghini or a lemon, car salespeople are regarded by a sizable majority of Americans as the professional equivalent of bottom feeders.

In contrast, nursing is regarded as the most admirable career; that profession has topped the poll four of the last five years. Doctors, veterinarians, and pharmacists didn't lag too far behind, but chiropractors apparently need some image adjustments—they came in 11th in the ranking of least admired careers, according to a 2003 *Los Angeles Times* article.

1. Car salespeople	7. Business executives
2. HMO managers	8. Senators
3. Insurance salespeople	9. Journalists
4. Stockbrokers	10. Governors
5. Lawyers	11. Chiropractors
6. Congressmen	12. Bankers

CHURCH BULLETINS
The Most Ungodly Bloopers

It's no wonder that with all the tasks on their "to do" lists, church secretaries often have little time to proof the bulletins for errors. And we

don't just mean typos or the occasional misspelling. We're talking full-on, laugh-out-loud bloopers.

The Vancouver English Centre put together this list of true church bulletin bloopers, which we ranked in terms of humor. Feel free to laugh—just as long as you're not in church.

1. Don't let worry kill you—let the church help.

2. Thursday night—potluck supper. Prayer and medication to follow.

3. Remember in prayer the many who are sick of our church and community.

4. The rosebud on the altar this morning is to announce the birth of David Alan Belzer, the sin of Rev. and Mrs. Julius Belzer.

5. Tuesday at 4:00 p.m. there will be an ice cream social. All ladies giving milk will please come early.

6. Thursday at 5:00 p.m. there will be a meeting of the Little Mothers Club. All ladies wishing to be "Little Mothers" will meet with the pastor in his study.

7. This being Easter Sunday, we will ask Mrs. Lewis to come forward and lay an egg on the alter.

8. Next Sunday a special collection will be taken to defray the cost of the new carpet. All those wishing to do something on the new carpet will come forward and do so.

9. A bean supper will be held on Tuesday evening in the church hall. Music will follow.

10. At the evening service tonight, the sermon topic will be "What is Hell?". Come early and listen to our choir practice.

COLLEGIATE ATHLETIC SCANDALS
Higher Learning?

Known as "The General," University of Indiana basketball coach Bobby Knight achieved infamy for his nasty temper and violent outbursts on the court. Throwing chairs, punching or choking players, ver-

bally assaulting officials—Knight's boorish antics finally caught up with him in 2000 when he was fired for his umpteenth offense.

Knight's courtside behavior was often reprehensible. But in recent years the antics have moved off the court (or field or ice) to affect entire programs. Coaches are caught partying indiscriminately. They provide illegal perks for recruits. And term papers for players.

Emulating these fine role models, the athletes are getting in on the act. Why should they toe the line when coaches and boosters keep erasing it? In 2004 *USA Today* researched the phenomena. Here's a look at some of the college athletic antics they reported on, in alphabetical order:

1. ALABAMA FOOTBALL: FROM TOPLESS TO JOBLESS

Mike Price served as head coach for just 4 months when one reckless night on the town cost him his job. In Florida for a school-sponsored golf outing, Price spent $200 at a topless bar before dropping another $1,000 on room service for himself and a woman guest.

2. BAYLOR: MURDER AND MAYHEM

In a saga reminiscent of prime-time TV, Baylor basketball player Patrick Dennehy was found shot to death. His former teammate and roommate Carlton Dotson was arrested and tried for the murder. The fallout was tremendous: head basketball coach Dave Bliss was fired under allegations of major program violations, and the school was placed on 3 years' probation.

3. FRESNO STATE: MORE THAN A TUTOR

Most colleges offer tutors and academic assistance to help their athletes succeed. But former statistician Stephen Mintz went one step further for 3 basketball players at Fresno State. He wrote and sold 17 homework assignments to players. An investigation revealed evidence of academic frauds as well as recruiting and eligibility violations. The school is under a 4-year probation and voluntarily cut 3 scholarships from their program.

4. GEORGIA: NOT MAKING THE GRADE

When a former Georgia basketball player accused assistant coach Jim Harrick Jr. of academic fraud and other NCAA violations, school officials discovered that Harrick had awarded credits to players who didn't attend his class

in basketball strategy. He also paid hotel and phone bills for players. Both Harrick and his father, head coach Jim Harrick Sr., were suspended. Harrick Jr. was later fired, while his father resigned.

5. IOWA STATE: A PICTURE'S WORTH A THOUSAND WORDS

Photogenic or not, Iowa basketball coach Larry Eustachy must have been dismayed to see his picture splashed all over the Internet. Especially since the photo showed him partying and drinking with college students after an away game. Clearly caught in the act, Eustachy admitted to an alcohol problem and asked for a second chance, but school officials fired him.

6. ST. BONAVENTURE: WELDERS NOT ADMITTED

An ineligible player caused St. Bonaventure to forfeit 6 games, miss post-season play, and face a 3-year probation. The Atlantic 10 Conference discovered that center Jamil Terrell violated NCAA guidelines when he transferred from a junior college with only a welding certificate, rather than an associates degree. School president Robert Wickenheiser admitted that he facilitated the admission and resigned his post. Athletic Director Gothard Lane and head coach Jan van Breda Kolff were both dismissed. St. Bonaventure board chairman William Swan was hit hard by the turn of events and committed suicide a few months later.

7. WASHINGTON: BETTING IT ALL

The NCAA frowns on gambling by coaches, even if it's not related to the sport they coach. University of Washington football coach Rick Neuheisel was fired for gambling on college basketball tournaments over the previous 2 years. It was later determined that football recruits were taken on improper boat rides, and replacement coach Keith Gilbertson also dabbled in betting.

COMPANIES THAT CAN'T
Firms Most in Need of a Makeover

Remember when flying was considered glamorous and exciting? Those days have gone the way of the three-martini business lunch. Today, airline passengers complain loud and long about the inedible food, cavalier service, and cramped leg room on many carriers. Squeezed into coach

on an overbooked flight is like the 21st century equivalent of crossing the Atlantic in steerage. In business, where image is everything, negative buzz from disgruntled passengers has certainly contributed to the rash of airlines filing for bankruptcy. In fact, three of *Fortune* magazine's 10 least-admired companies in America are commercial airline carriers: TWA, Northwest, and Continental.

Here is *Fortune*'s ranking of the 10 companies most in need of corporate makeovers:

1. *Brooke Group*, tobacco
2. *Trans World Airlines*, airlines
3. *Leslie Fay*, apparel
4. *Gitano Group*, apparel
5. *Northwest Airlines*, airlines
6. *Crystal Brands*, apparel
7. *Southern Pacific Transportation*, railroads
8. *Stone Container*, forest and paper products
9. *Continental Airlines Holdings*, airlines
10. *Glendale Federal Bank*, savings institutions

COMPUTER VIRUSES
The Nastiest Strains to Come Over the Net

In Greek mythology, curiosity got the better of Pandora, who ignored warnings and opened a sealed box containing plagues that soon overran the earth. Computer viruses and worms are the hi-tech equivalent of Pandora's Box. Lurking in e-mails and attached files, they're unleashed with click of a computer mouse to wreak untold havoc on users' hard drives, files, and e-mail.

In the past few years, computer viruses and worms have become increasingly destructive, spreading through cyberspace like virtual wildfire and causing billions of dollars in damage.

Here's a look at some of the worst viruses and worms to date, as ranked by *PC World* in 2002:

1. LOVELETTER VIRUS, 2000
There wasn't much love for this virus that affected millions of computers. Causing more damage than any other virus to date, it spread through e-mail, Internet chat rooms, and shared files bearing the subject line "ILOVEYOU."

2. KLEZ WORM, 2001

The Klez worm is a chameleon of the virus world. Sometimes it acts like a worm and sometimes like a Trojan horse, but it spreads like a virus. It attacks through open networks and e-mail. Sometimes it disguises itself as a worm-removal tool. And beware—it is still in circulation today.

3. MELISSA VIRUS, 1999

The first virus that was able to jump from one computer to another, Melissa spread when a user opened e-mail with an infected attachment. Using Microsoft Outlook, the virus was sent to the first 50 names in the user's address book. It was especially tricky because the e-mail seemed to come from someone the users knew, so they felt comfortable opening the document. And on it went.

4. MAGISTR VIRUS, 2001

One of the most complex viruses out there, Magistr spread though infected e-mail attachments. It wasn't as widespread as some viruses, but it was very destructive to those it did hit. One lovely feature of the Magistr is that it had an anti-debugging device, making it hard to detect and destroy.

5. EXPLORER WORM, 1999

Like the Melissa virus, Explorer spread via e-mails that seemed to come from someone the user knew. It deleted Word, Excel, and PowerPoint files at random and altered other files. Instead of gathering names form the user's address book, this worm sent automatic replies to senders of incoming mail using the same subject line. Who wouldn't open that?

6. ANNA KOURNIKOVA WORM, 2001

Tennis star Anna Kournikova is known for her beauty, but the same cannot be said for her worm namesake. It traveled with a photo attachment that users found hard to resist opening. No photo appeared, but the worm invaded and sent itself out to addresses found in the user's address book. Fortunately, no data was lost with this one.

7. NIMDA VIRUS, 2001

This worm burrowed into systems, modifying web documents and files, then creating copies of itself. It attacked tens of thousands of servers and hundreds of thousands of PCs. The Nimda worm also infected shared hard drives on networks, as well as users brows-

ing Web pages that were sponsored by infected users.

8. BENJAMIN WORM, 2002

No boring e-mail stuff for Benjamin—this worm hit those using Kazaa, a popular file-sharing program. It appeared as movie and music files, infecting users who tried to download media but got the imposter instead.

9. CODE RED WORM, 2001

Corporate networks were hardest hit with this worm. Hundreds of thousands of computers were infected when Code Red got through the Internet Information Server (IIS) software. It went on to scan the Internet for vulnerable systems to infect and continue the progression.

10. SIRCAM VIRUS, 2001

The virus isn't old, but tended to prey on systems that were slightly older. It hit computers running Windows 95, 98, and ME. Subject lines were friendly, begging the user to open the attachment. "Hi, How are you?" it would ask. If the user opened the attachment, it sent out random files to other users. Files were also sometimes deleted and the user's hard drive filled with gibberish.

CONSUMER FRAUD

Most Consumer Complaints

Got a spare $200 lying around? Because that's the average loss victims of Internet fraud reported for 2003, according to the latest statistics of the Federal Trade Commission. Although scam artists and identity thieves continue to use the tried-and-true methods to prey upon consumers, like phony telemarketing offers and direct mail, the Internet has proven a gold mine for hi-tech crooks. In fact, nearly 55% of *all* fraud complaints the FTC received in 2003 were Internet-related.

Each year, the FTC reviews and categorizes all consumer fraud complaints logged into the agency's Consumer Sentinel database. Over 900 agencies across the United States, Canada, and Australia currently contribute data to Consumer Sentinel. These agencies range from the FBI and the U.S. Postal Inspection Service to the Better Business Bureau.

Here are the FTC's top 10 categories for consumer fraud, ranked by the highest percentage of consumer complaints for 2003:

Category	Percentage of Total Complaints
1. Internet auctions	15%
2. Shop-at-home/ catalog sales	9%
3. Internet services and computer complaints	6%
4. Prizes, sweepstakes, and lotteries	5%
5. Foreign money offers	4%
6. Advance fee loans and credit protection	4%
7. Telephone services	3%
8. Business opportunities and work-at-home plans	2%
9. Magazine buyers clubs	1%
10. Office supplies and services	1%

CORPORATE FRAUD
The Pros of Cons

How do you uncover a sophisticated con job, one employing all the resources to potentially beat just about any rap: the legal eagles, the creative accountants, the friends in high places?

The Feds have one way. Under the False Claims Act, firms that have cheated the government can be fined big time, and whistle-blowers who report them may be eligible to receive a portion of these not-so-inconsequential amounts.

Here are the biggest fines levied against companies that got caught with their pants a couple of miles below their ankles, and the fines they had to pay, according to Taxpayers Against Fraud. Listed in order of the size of the fine:

1. $731,400,000: HCA—THE HEALTHCARE COMPANY, DEC. 2000
The largest for-profit hospital chain in the United States got caught billing for lab tests that weren't medically necessary and not ordered by physicians, among other things.

Dressed as Darth Vader and a patient, these protesters are demonstrating against HCA—The Healthcare Company, a firm involved in some of the biggest corporate scandals on record.

2. $631,000,000: HCA, JUNE 2003

This time they submitted false claims to Medicare and other federal health programs.

3. $559,483,560: TAP (TAKEDA-ABBOTT PHARMACEUTICALS) OCT. 2001

They were fined for fraudulently pricing and marketing Lupron, a drug used to treat prostate cancer.

4. $400,000,000: ABBOTT LABS, JULY 2003

The firm defrauded Medicare and Medicaid with their products that supply food for patients who can't eat normally (by mouth).

5. $385,000,000: FRESENIUS MEDICAL CARE OF NORTH AMERICA, JAN. 2000

This producer of kidney dialysis products and services was found to be faking blood testing claims, among other violations.

6. $325,000,000: SMITHKLINE BEECHAM LABS (GLAXOSMITHKLINE), MARCH 1997

False claims are more common than you may think, as this firm was fined for fraudulent lab tests paid by the government.

7. $324,200,000: NATIONAL MEDICAL ENTERPRISES, JULY 1994

Fraudulent claims for Medicare and Medicaid reimbursement were made by psychiatric and substance-abuse hospitals.

8. $292,969,482: SCHERING-PLOUGH, JULY, 2004

The drug firm was fined for its pricing of Claritin sold to Medicaid.

9. $266,127,844: ASTRAZENECA INTERNATIONAL, JUNE 2003

They committed fraud in regard to pricing and marketing of Zoladex, a drug that is used to treat prostate cancer.

10. $257,200,000: BAYER CORP., APRIL 2003

The firm was fined for relabeling products and selling them at an artificially low rate in order to avoid paying additional rebates to the government.

DOCTOR DUPES

Most Common Reasons Patients Lie to Physicians

Going to the doctor is fraught with fear and loathing for some people, who shut down simply at the thought of hearing two simple words: "Cough, please." At their most neurotic, certain patients even risk their health by lying to their physicians. Irrational? Heck yes, but inexplicable? Not according to the findings in a WebMD survey.

Here are the 10 most common reasons why patients routinely lie to doctors:

Reasons for Lying	Percentage of Lies
1. Don't want to be judged.	50%
2. The truth was too embarrassing.	31%
3. Didn't think the doctor would understand.	21%
4. Thought it's none of their doctor's business.	9%
5. To get a particular drug or treatment.	6%
6. So they would not get medications.	2%
7. Didn't want a lecture.	2%
8. Didn't think the lie was important.	1%
9. Disagreed with their doctor.	1%
10. Didn't want the truth to appear on their records or be available to their insurance companies.	1%

DOG-GONE DANGEROUS

The Most Menacing Breeds

Many pet owners consider their dogs to be part of the family, but insurance companies don't seem to share the sentiment. In fact, some insurance companies are starting to blacklist certain breeds of dog. Canines with the reputation of being dangerous are raising liability issues. As a

result, more insurers are declining to write policies for homeowners who have a blacklisted breed. Suddenly, man's best friend is public enemy #1.

According to the Centers for Disease Control (CDC), dog bites are responsible for 4.9 million injuries each year; 800,000 of these require medical care. Seventeen people will die this year from dog attacks.

Children are the most common victims of dog bites. Not surprisingly, 40% of all bites occur in the victim's own home and another 30% happen at the home of a friend or neighbor.

The *Cincinnati Enquirer* compiled this 2001 ranking of breeds that have been blacklisted by insurance companies or considered dangerous as a breed. In descending order:

1. Rottweiler
2. Pit bull
3. Chow
4. Doberman pinscher
5. German shepherd
6. Jack Russell terrier
7. American Staffordshire terrier
8. Great Dane
9. Presa Canario
10. Boxer

DRIVING DEFECTIVE
The Biggest Lemons on Four Wheels

Millions of radio listeners tune into Car Talk each week to hear brothers Tom and Ray Magliozzi answer maintenance questions from the average, albeit clueless, car owner. In an effort to name the worst cars ever made, Tom and Ray asked listeners and readers of their syndicated newspaper column to vote in 2000. There was no ballot, just mailbags of surprisingly vehement opinions from disgruntled drivers. The following 10 lemons were the top vote-getters as the worst cars of the second millennium:

1. YUGO

The winner by a landslide. There isn't enough space to list all the complaints owners had about this misbegotten car. Although it wasn't around for long, the Yugo will long be remembered. Knobs came off, radios fell out, and there were gaps that made the windows leak.

Did the owner get frustrated and try to drown his Yugo? Who'd blame him—the Yugo ranks as the biggest lemon on four wheels.

2. CHEVY VEGA

Slow and built of inferior materials, this car was even ridiculed by its owners. One said it seemed as though the car was built of compressed rust.

3. FORD PINTO

Available in atrocious colors such as baby-poop orange, this car was found to blow up on rear impact. They even had their own bumper sticker: "Hit Me and We Blow Up Together!"

4. AMC GREMLIN

As if ugliness wasn't enough, this car had serious quality and safety issues, but some former owners still have a fondness for this little car.

5. CHEVY CHEVETTE

One driver called this car "an engine surrounded by drywall." Ouch.

6. RENAULT LECAR

Even worse than the Dauphine, this Renault was made of poor materials, causing one owner to swear that she thought the metal body was made of Reynolds aluminum foil.

7. DODGE ASPEN/PLYMOUTH VOLARE

Carburetor problems caused this car to stall frequently. It was an ego-destroyer. Even the theme song was embarrassing: "Volare!"

8. CADILLAC CIMARRON

Nothing "Cadillac" about this car. It drove like a cheaper car, yet was priced like a luxury car. The Cimarron did nothing for Cadillac except soil its good name.

9. RENAULT DAUPHINE

In this case, inexpensive really does mean cheap. It was half the price of a VW, which was one of the cheapest cars around. One owner said hers was totaled when a bicyclist ran into the side.

10. VOLKSWAGEN BUS

Mechanically unsound. It had no heat in the winter and blew around in the wind. But it was a hip van in its time, adorned with giant flower-power stickers. Many a baby boomer has warm memories of this car.

DRUG ADDICTION
What's Easiest to Get Hooked On?

You've tried the patch, chewed your way through several packs of that special nicotine gum, even gone cold turkey to the horror of your friends and family, but you still can't kick that nasty cigarette habit. Like the estimated 1.25 *billion* smokers on the planet, you crave that daily nicotine fix, despite the acknowledged health risks to yourself and to others via secondhand smoke. Is it any wonder that a panel of medical experts polled by *In Health* magazine named nicotine the most addictive drug in the world?

To determine the most addictive drugs, the experts based their rankings on two criteria: (1) the comparative ease of getting addicted, and (2) the difficulty of quitting. On a scale of 1 to 100, here are the 10 most addictive drugs in common use:

Drug	Rating
1. Nicotine	100.00
2. Methamphetamine, smoked	98.53

The nicotine in ordinary store-bought cigarettes makes them the number-one most addictive of all drug habits, more than crack (ranked 3rd) and heroin (ranked 9th).

Drug	Rating
3. Crack	97.66
4. Methamphetamine, injected	94.09
5. Valium	85.68
6. Quaalude	83.38
7. Seconal	82.11
8. Alcohol	81.85
9. Heroin	81.80
10. Amphetamine, taken orally	81.09

EMERGENCY CALLS, COMEDIC
The Wackiest 911 Calls

Police and emergency-call dispatchers save a lot of lives over the course of a year. They also get a lot of laughs.

Some callers have a legitimate problem—but they don't have a way with words. Others, like the man who called to report a woman mowing her lawn in a thong bikini, don't quite comprehend the purpose of a 911 call.

Whether it's a real emergency or something wacky, more than 200 million 911 calls are made each year. And countries all over the world have their own phone emergency system in place. In the United Kingdom the number to call is 999. In France it's simply 17. Denmark callers use 000. The number is not quite so catchy for Brazilians—dial 2815051. Maybe that explains why the call volume is a little lower.

Here are some of the strangest recorded emergency calls, ranked in ascending order of weirdness and plain stupidity:

1. Caller: "I'd like to make a unanimous complaint, so don't use my name."

2. Caller: "He's not breathing!"
Call-taker: "Can you get the phone close to him?"
Caller: "WHY? You want to hear he's not breathing, too?"

3. Call-taker: "We'll need a description of him."
Caller: "He's a lawyer."

4. Complaint about a stolen mailbox:
Call-taker: "What is your address?"
Caller: "It's gone."

5. Caller: "I heard what sounded like gunshots coming from the brown house on the corner."
Call-taker: "Do you have an address?"
Caller: "No, I'm wearing a blouse and slacks, why?"

6. Call-taker: "Does she have any weapons?"
Caller: "Well, she has real long fingernails."

7. Caller: "Can my woman refuse to let me shower with her?"

8. Caller: "I'm having trouble breathing. I'm all out of breath . . . I think I'm going to pass out."
Call-taker: "Sir, an ambulance is on the way. Are you an asthmatic?"
Caller: "No."
Call-taker: "What were you doing before you started having trouble breathing?"
Caller: "Running from the police."

9. Caller: "If I start losing my memory, how will I know?"

10. Caller: "There's a guy at the pool. He's got his privates stuck in the pump line . . . He's been in there for three hours . . . It's got to be shriveled up like hell."

EPIDEMICS PROPORTIONS
Deadliest Scourges That Infected America

Modern medicine can cure a great deal these days—except for the common cold, of course. But when our ancestors settled this country, epidemics claimed more lives than anything else. Fast and deadly, these illnesses spread like wildfire, taking an enormous toll on communities.

Over the years, medicine has improved; vaccines were created to eliminate many of the worst illnesses. Sanitary conditions also improved, which helped to restrict the spread of germs.

Nowadays what can't be cured can often be contained, so that others are not as likely to contract the disease. Now if only we could find that cure for the common cold . . .

Here's a look at the worst epidemics that have plagued the United States, ranked by number of reported cases or deaths (whichever number is larger):

1. AIDS, 1981–2001
AIDS made its first appearance in 1981, and by December 2001, 816,149 cases had been reported to the Centers for Disease Control. Deaths totaled 467,910.

2. SPANISH INFLUENZA, 1918
A nationwide outbreak of Spanish influenza killed over 500,000 people. This was the worst single epidemic in the United States.

3. POLIO, 1952
Killing 3,300 people, polio reached an amazing 57,628 cases, becoming the worst polio outbreak since 1916.

4. POLIO, 1916
The nation's first polio epidemic struck. More than 7,000 deaths occurred and 27,363 cases were reported.

5. POLIO, 1949
Polio claimed the lives of 2,720 from 42,173 cases reported.

6. YELLOW FEVER, 1878
Yellow fever spread throughout the lower Mississippi Valley, killing over 13,000.

7. YELLOW FEVER, 1853
Yellow fever killed 7,790 people in New Orleans.

8. CHOLERA, 1848
Twelve years after the first outbreak, cholera was still deadly in New York City, claiming the lives of more than 5,000 people.

9. CHOLERA, 1832
Cholera took the lives of 4,340 people in New Orleans.

10. YELLOW FEVER, 1793
Yellow fever claimed the lives of more than 4,000 residents in Philadelphia.

11. YELLOW FEVER, 1867
Yellow fever was still around, taking the lives of 3,093 people in New Orleans.

12. CHOLERA, 1832
More than 3,000 people were killed when a cholera epidemic hit New York City.

"FAN-TASTROPHIES"

Most Catastrophic Fan Disasters at Sports Competitions

When the Boston Red Sox finally broke the Curse of the Bambino to win the 2004 World Series, rabid fans took to the streets for a riotous celebration. The party came to a tragic end, however, with the accidental death of a young woman in the melee.

Sporting events bring out the best and worst in us. At professional baseball and hockey games, players get into skirmishes all the time. And fan pandemonium after big football games is the norm. But then football is a violent sport—so who'd expect the fans to behave with decorum?

Now soccer—that's a different story entirely. Civilized. A game of skill, the world over. So who'd ever guess that soccer would turn out to be the most violent sport of all—for the spectators, that is.

Here's a look at some of the worst sports disasters, ranked by the number of fatalities; all except one involved soccer games. (Bullfights are looking safer by the minute, aren't they?)

1. LIMA, PERU, MAY 24, 1964
Worst soccer disaster on record, with 500 injured and 300 killed, all over an unpopular referee ruling.

2. MOSCOW, OCTOBER 20, 1982
340 died, crushed to death in an open staircase.

3. ACCRA, GHANA, MAY 2001
120 killed in soccer stampede.

4. SHEFFIELD, ENGLAND, APRIL 15, 1989
In Britain's worst soccer disaster, a barrier collapsed, killing 96.

5. GUATEMALA CITY, OCTOBER 16, 1996
84 killed, 147 injured in soccer stampede.

6. LE MANS, FRANCE, JUNE 11, 1955
Grand Prix race car plunged into the grandstand, killing 82 spectators.

7. KATHMANDU, NEPAL, MARCH 12, 1988
Hailstorm and locked door led to stampede and 80 deaths at soccer game.

8. GLASGOW, SCOTLAND, JANUARY 2, 1971
Crush caused by fan confusion killed 66 at soccer game.

9. BRADFORD, ENGLAND, MAY 11, 1985
Fire broke out, killing 56 and injuring 200 at soccer game.

10. BRUSSELS, BELGIUM, MAY 29, 1985
400 injured and 39 killed when restraining wall collapsed at soccer stadium.

FAST FOOD FAT
Most Fattening Temptations on Franchise Row

You've heard the saying, "That which doesn't kill us, makes us stronger." When it comes to fast food, a calorie-conscious rewrite is in order: "That which doesn't kill us immediately, makes us fatter!" A lot fatter, as obesity rates nationwide continue rising, due in large part to Americans' weakness for fast food.

That fast food is high in calories won't surprise anyone, but you may not have realized just how high it really is. The figures below represent the highest calorie item at each of the fast food places listed, according to fatcalories.com. Trust us, Subway's pitchman Jarrod the former fatty didn't drop the pounds on a "diet" of the company's double meat meatball subs, which tips the calorie scale at a mammoth 1,560 calories per sandwich!

Food	Calories
1. Subway's Double Meat Meatball sub	1,560
2. Hardee's two-third lb. Bacon Cheese Thickburger	1,340
3. McDonald's Triple Thick Shake	1,150
4. Burger King's Double Whopper w/cheese	1,070
5. Arby's Chicken Fingers Combo	1,050
6. Blimpie's Cheese Trio Sub	980
7. Wendy's Triple Burger with everything	940
8. Taco Bell's Taco Salad w/salsa	790
9. KFC's Chunky Chicken pot pie	770
10. Pizza Hut's Meat Lover's P'zone	680

FAST FOOD FLOPS
Worst Drive-Thru Disasters

Backed by a showy marketing campaign, fast-food giant McDonald's proudly unveiled its latest creation, the Arch Deluxe, to universal derision in 1997. Misconceived from the word go, this tasteless appeal to supposedly more cultivated palates is now considered the all-time biggest fast food flop. And that's saying something, when you consider some of the other unappetizing product launches over the years that even hungry stray dogs wouldn't bother with. McDonald's weathered the uproar and quickly pulled the Arch Deluxe from store menus.

Here is an alphabetical listing of fast food flops that never should have made it out of the companies' test kitchens, as reported by *USA Today* in 2003:

1. ARBY'S LOADED FRENCH FRIES, LAUNCH DATE UNKNOWN
Smothered with cheddar cheese, bacon bits, and sour cream, these fries got soggy and so did sales.

2. ARCH DELUXE, 1997
McDonald's tried to appeal to sophisticated taste buds with this burger topped with brown mustard, ketchup, and peppered bacon on a sesame potato roll. Yuck!

3. TACO BELL BORDER LITES, 1996
This line of healthier food from south of the border should have stayed there.

4. BURGER KING'S FRENCH FRIES, 1998

In their biggest product launch ever, BK introduced a new, crispier french fry, coated with potato starch to retain heat and maintain crunch. The taste was terrible and the idea turned out to a whopper of a flop.

5. JACK IN THE BOX CHILI DOG BURGER, LAUNCH DATE UNKNOWN

Designed for the big eater, this sandwich combined a burger with a hot dog and topped them with chili and cheese. The concoction never made it out of the test stage.

6. KFC SKIN-FREE CRISPY CHICKEN, 1991

The texture of this new treat was so strange that it just wasn't finger-lickin' good enough.

7. MCDLT, 1985

This burger, packaged in a large, unwieldy Styrofoam container, kept the hot parts hot and the cold parts cold—and nobody very happy.

8. MCLEAN DELUXE, 1996

With half the fat of a quarter-pounder, this sandwich was targeted to health-conscious diners. In place of fat, McDonald's added seaweed derivative to the meat, and the taste just didn't catch on.

9. TACO BELL PIZZA, LAUNCH DATE UNKNOWN

Mexican toppings on pizza crust made for a heavy, slightly soggy meal. Leave the pie to Pizza Hut.

FILM FLOPS
The Decade's Biggest Box-Office Bombs

According to the latest estimates of the Motion Picture Association of America, it costs approximately $150 million to produce, market, and distribute the *average* studio film. With so much money on the line, studio executives monitor opening weekend box office receipts hourly to determine whether they should uncork the champagne or begin scanning the want ads.

Sometimes, the riskiest of ventures pay off both critically and commercially, like *The Lord of the Rings* trilogy. Yet for every crowd-pleasing

Disney animated this sci-fi version of Treasure Island, *named it* Treasure Planet, *released it in 2002, and watched it flop like a flapjack. Profit-wise, the uncharacteristic Disney bomb was the number-one biggest flop of the last decade.*

smash, there's a big fat flop like *Gigli* (2003) or Disney's *Treasure Planet* (2002), which sent shock waves through the corporate headquarters of the happiest place on earth.

Over the last decade or so, there have been almost too many expensive box office bombs to list. From 2004 alone, *The Alamo, Alexander,* and *The Stepford Wives* spring to mind. Since figures for 2004 movies are not yet complete, those films are not included on the list.

Here are some of the biggest box office bombs of the last decade, ranked by their monetary losses—the difference between their budgets and their box office grosses:

1. *TREASURE PLANET* (2002), $102 MILLION
This animated Disney movie was a sci-fi version of the classic novel *Treasure Island.*

2. *THE ADVENTURES OF PLUTO NASH* (2002), $96 MILLION
Spectacularly unfunny sci-fi comedy starring Eddie Murphy.

3. *TOWN & COUNTRY* (2001),
$83 MILLION
An impressive cast (Warren Beatty, Goldie Hawn, Diane Keaton, Garry Shandling) couldn't make a middle-aged sex romp look fun.

4. *CUTTHROAT ISLAND* (1995),
$81 MILLION
Geena Davis didn't swash any buckles in this costly dud of a pirate movie.

5. *THE POSTMAN* (1997),
$62 MILLION
Audiences marked this Kevin Costner flick "return to sender."

6. *THE FOUR FEATHERS* (2003),
$62 MILLION
Lavish remake of 1939 adventure classic was DOA at the box office.

7. *OSMOSIS JONES* (2001),
$62 MILLION
Bill Murray starred in a mish-mash of live action and animation.

8. *SOLDIER* (1998),
$60 MILLION
Audiences stayed away from this outer-space version of *Shane*.

9. *RED PLANET* (2000),
$58 MILLION
The producers saw red when this expensive sci-fi flick flopped.

10. *WILD WILD WEST* (1999),
$56 MILLION
Despite Will Smith's appeal, this western/sci-fi/comedy still lost money.

FIRST-DATE FOUL-UPS
Most Common Faux Pas Daters Make

Your mother told you what *not* to do on the first date, but how about what you *should* do? Check your hair 10 times in the mirror, try on countless outfits, and gag a few times from all the breath mints you've swallowed.

According to Brenda Ross, who provides dating advice at dating-class.com, the following guidelines should be required reading before going out on that all-important first date. They're ranked from smallest to biggest first-date faux pas:

1. Don't wear something you don't feel drop-dead gorgeous in.

2. Don't wear colored contacts.

3. Don't mention your last boyfriend/girlfriend 600 times.

4. Don't talk about yourself too much.

5. Don't talk wistfully about how many children you'd like to have.

6. If it's a blind date, don't compare yourself to anyone famous, looks-wise.

7. Don't check out other people.

8. Don't drink too much.

9. Don't assume that he/she will automatically grab for the check.

10. Don't jump into the sack!

FOOD ALLERGIES
Deadliest Common Food Allergies

Eggs are among the most common food allergies, along with seven other regular menu items most people consume.

Nutritionists and doctors commonly refer to the following foods as the "big eight" of allergies because they can cause immediate hypersensitive reactions, especially in children. Symptoms run the gamut from the comparatively benign—hives, wheezing, mild gastrointestinal distress—to life threatening. At their most severe, food allergies can cause anaphylaxis. While it's extremely rare, anaphylaxis occurs when several reactions occur simultaneously. A person develops hives, his throat swells, and he experiences difficulty breathing. Unless treated immediately with a shot of epinephrine to open the patient's airway and blood vessels, anaphylaxis can prove fatal.

Here are the eight most-potentially dangerous food allergies, in alphabetical order:

1. Eggs
2. Fish
3. Milk
4. Peanuts

5. Shellfish
6. Soy
7. Tree nuts
8. Wheat

FOODS THAT FLOPPED

The Biggest Commercial Failures at the Grocery Store

From Hamburger Helper to Cup-a-Soup, convenience foods have become a staple in many homes, where the days of the home-cooked meal from scratch have gone the way of leisurely, sit-down dinners around the kitchen table.

Chalk it up partially to television, which in turn inspired the creation of the TV dinner. Big guys fill up on Hungry Man dinners while dieters become losers with Lean Cuisine. But for every new, improved convenience food item that hits the shelves, an equal number hits the trash can.

Here is an alphabetical list of convenience food fiascos from CNN/Money:

1. CRYSTAL PEPSI
Pepsi should always be brown—no exceptions.

2. GARLIC CAKE
This misnamed hors d'oeuvre left a bad taste in consumer's mouths, probably because it never said on the package what it really was.

3. GERBER'S SINGLES FOR ADULT CONSUMERS
Those little jars just scream messy, smeary, and tasteless—and adults had a hard time digging in.

4. HEINZ FUNKY FRIES
Even chocoholics couldn't buy this flavor on a fry. And blue ones? Not unless you're a Smurf.

5. NORWOODS EGG COFFEE
The best part of waking up has nothing to do with a coffee like this.

6. SCRAMBLED EGG PUSH-UPS AND MACARONI AND CHEESE PUSH-UPS
Fast or not, buyers couldn't get used to eating mush from a push-up.

7. TO-FITNESS TOFU PASTA
Yuck.

8. UNCLE BEN'S RICE WITH CALCIUM
Got rice? Americans don't eat enough rice to replace that white milk mustache with a grainy version.

FOOTBALL, "PROFESSIONAL?"
All-Time Worst NFL Teams

When asked why the Cincinnati Bengals were having such an awful season in 1997, coach Bruce Coslet put it bluntly: "We can't run. We can't pass. We can't stop the run. We can't stop the pass. We can't kick. Other than that, we're just not a very good football team right now."

What Coslet said about the Bengals applies to the following NFL teams, which the Page 2 writers on ESPN's Web site ranked as the all-time worst:

1. 1976 TAMPA BAY BUCCANEERS
The Buccaneers not only averaged less than 9 points per game, they were shut out 5 times. Stats: 0–14

2. 1990 NEW ENGLAND PATRIOTS
The Patriots got stuck with the NFL's worst offense and second-worst defense for 1990. Stats: 1–15

3. 1973 HOUSTON OILERS
The Oilers scored only 199 points all season and gave up a whopping 447 points. Stats: 1–13

4. 1971 BUFFALO BILLS
1971 was an ugly year for the Bills, who bottomed out with the NFL's worst offense and defense. Stats: 1–13

5. 1981 BALTIMORE COLTS
Colts coach Mike McCormick got the ax at the end of the team's miserable season in which they gave up 533 points, an NFL record. Stats: 2–14

6. 1991 BALTIMORE COLTS
The Colts entered the NFL Hall of Shame by setting records for the fewest points (143) and fewest

touchdowns (14) in a season. Stats: 1-15

7. 1952 DALLAS TEXANS
Moving to Dallas from New York didn't help the team's game; they didn't kick a single field goal the entire season. Stats: 1-11

8. 1980 NEW ORLEANS SAINTS
The 1980 season was so bad, diehard fans took to calling the team the "Ain'ts." Stats: 1-15

9. 2001 CAROLINA PANTHERS
15 straight losses cost the Panthers head coach George Seifert his job. Stats: 1-15

10. 1934 CINCINNATI REDS
Way back in the early days of the NFL, the Cincinnati Reds football team endured a demoralizing season, wherein the team scored only one touchdown in nine games. Stats: 0-8

GLOBAL EPIDEMICS
10 Deadly Plagues

Lately, it seems every time you open a newspaper or log onto the Internet, there's a story about the outbreak of some exotic and deadly disease on the verge of ravaging the globe. AIDS, Ebola, SARS—the list of medical horrors grows, confirming the worst fears of hypochondriacs worldwide that we've opened a Pandora's box of virulent diseases, resistant to traditional forms of treatment.

With the grim exception of AIDS, most of the headline-generating diseases have thankfully not developed into full-blown pandemics like the devastating plagues of the past, the Black Death or the Spanish influenza, each of which killed millions around the globe.

Here are 10 of the all-time worst epidemics that swept through populations like the hooded figure of Death with his scythe, ranked according to the estimated number of total casualties:

1. SPANISH INFLUENZA, 1918–1919
Thought to have originated in Spain, hence the name, the "Spanish Flu" or "La Grippe" is widely considered the deadliest pandemic in history. Over 18 months, it reached nearly every corner of the globe and killed anywhere from 25 to 40 million people.

The lucky ones in the Spanish influenza outbreak (1918–1919) wound up in the hospital. An estimated 25–40 million people died. Assuming the higher figure, the pandemic was the deadliest in history, greater than AIDS, which is estimated to have killed 20–27 million people so far.

2. AIDS, 1981–

According to the latest estimates, an estimated 27 million people worldwide have succumbed to AIDS, which has particularly ravaged Sub-Saharan Africa and parts of Asia.

3. THE BUBONIC PLAGUE, 1348–1352

In the 14th century, bubonic plague spread from Asia to Europe. Over the next 6 years, the Black Death took the lives of approximately 20 million people—a quarter of Europe's population.

4. THE BUBONIC PLAGUE, 1855–1894

The Black Death resurfaced with a deadly vengeance in India and China in 1855. By the time it ran its fatal course in 1894, 12 million people were dead.

5. THE ANTONINE PLAGUE, AD 165–180

During the reign of Marcus Aurelius, smallpox swept through the Roman Empire. Twenty million were infected; 5 million died, including Marcus Aurelius.

6. MEXICAN MEASLES, LATE 1600S

Along with necklaces and firewater, the European explorers to the New World often brought surprise gifts for the native people: highly infectious diseases like measles, which wiped out nearly 2 million Mexican Indians who lacked immunity to the disease.

7. CHOLERA, 1852–1860

Since the 18th century, there have been seven cholera pandemics. In the third pandemic of 1852–1860, over a million Russians died from cholera.

8. HONG KONG FLU, 1968–1969

700,000 died from an especially deadly form of the influenza virus that devastated Asia over a 2-year period.

9. THE PLAGUE OF JUSTINIAN, AD 541

The first recorded incidence of the bubonic plague occurred during the tumultuous reign of the Roman Emperor Justinian. Spreading from Egypt to the Eastern regions of the Mediterranean, the plague killed nearly 250,000 people—10,000 a day in Constantinople.

10. SMALLPOX, MID–1500S

Another legacy of the European explorers, smallpox hit Mexico hard, killing at least 150,000 in the 1530s, including the Mexican emperor.

GOLDEN FLEECE AWARDS
Worst Uses of Public Funds

Famous for his frugality, Wisconsin Democratic Senator William Proxmire was the taxpayer's watchdog during his 32 years on Capitol Hill. In March of 1975 he created the Golden Fleece Award, which he awarded monthly to the federal government's most "wasteful, ridiculous or ironic use of the taxpayers' money" for the next 13 years. Although he bestowed this dubious honor on federally funded projects with a healthy dose of sarcasm, Proxmire was genuinely troubled by the amount of money spent on everything from studying the body measurements of flight attendants ($57,800) to buying a designer doormat for the Department of the Navy ($792).

Although the Golden Fleece Award was briefly discontinued upon Proxmire's retirement in 1989, the non-partisan group Taxpayers for Com-

mon Sense revived it in 2000 due to overwhelming public demand—and the ongoing waste of taxpayer money. Here are the 10 most outrageous Golden Fleece Awards from Proxmire's tenure, 1975 to 1988, in descending order of wastefulness, as ranked by Taxpayers for Common Sense:

1. DRINKING LIKE FISH
In 1975 the National Institute on Alcohol Abuse and Alcoholism spent millions on a study to determine if drunken fish are more prone to aggression than sober fish.

2. CHINA COMES TO THE MIDWEST
In 1981 The Economic Development Administration of the Commerce Department spent $20,000 to build an 800-foot limestone replica of China's Great Wall in Bedford, Indiana.

3. BUYING SAUCE FOR DUMMIES
Also in 1981, the Department of the Army spent $6,000 on a 17-page instruction book on the best way to buy Worcestershire sauce.

4. MONEY DOWN THE DRAIN
In 1980 the Environmental Protection Agency spent approximately $1 million to $1.2 million to turn a Trenton, New Jersey, sewer into a historic monument.

5. REMOTE CONTROL 101
In 1978 the U.S. Office of Education spent $219,592 to develop a curriculum for teaching college students to watch television.

6. GAME, SET, CHEAT!
In 1977 the National Endowment for the Humanities used a $25,000 grant to explore the high incidence of cheating, lying, and screaming on Virginia tennis courts.

7. NATIONAL SECURITY?
In 1974 The Department of the Navy used 64 planes to fly 1,334 officers to Las Vegas for a reunion of the Tailhook Association.

8. THIS YEAR'S EDSEL
In 1978 the Law Enforcement Assistance Administration spent $2 million to develop a high-tech police patrol car that would have cost $49,078 each. The gadget-laden prototype was never finished.

9. HOOPS MEDICINE
Between 1981 and 1984 the Health Care Financing Administration for Medicaid paid an estimated $40 to $80 million to psychiatrists for meeting with patients at basketball games.

10. SURF'S UP! TAXPAYERS DOWN

In 1981 the Department of Commerce gave the City and County of Honolulu $28,600 to determine how they could establish another surf-friendly beach for $250,000.

GOLF INJURIES

Most Common Causes of Golf Injuries

Maybe your golf buddy knows someone whose cousin's friend was attacked by a wild animal on the golf course. Or someone who reached into the hole to retrieve his ball and got stung by a scorpion. But those freak accidents really aren't par for the course, so to speak.

It's no fun playing with a bad sport, but aside from Happy Gilmore in the movie of the same name, most of us don't have to fear attack by our fellow golfers. So what injuries do golfers truly need to watch out for on the links?

From *The Best and Worst of Golf* (2002), here's a list of things that cause the most common golfer injuries, ranked in order. And be sure to keep a lid on that golf gambling—you may survive, but your wallet can sure take a beating.

1. GOLF BALLS
Flying golf balls can easily hit other golfers—hard. Players have been killed by errant balls hitting their head. Lesser problems are concussions and broken bones or sprains.

2. GOLF CLUBS
Wild swings can result in flying clubs that could injure another player. And don't get too close to a golfer during his backswing or follow-through.

3. HEAT STROKE
It can get hot out there. Golfers should drink fluids and hit the shade whenever possible.

3. LIGHTNING
Those sirens are sounded for a reason. When lightning has been sighted, it's time to get off the course. Stay away from trees, open spaces, hills, water hazards, and never hold a club in the air.

4. GOLF CARTS
Carts can shoot forward, tip over,

and do funny things when in reverse.

5. SUNBURN

Golfers tend to forget that they are in the sun longer than most sunbathers. Don't forget the sunscreen.

6. PLANTS

The woods can be prime places to run into poison ivy and poison oak.

7. TREES

These aren't dangerous by themselves, of course, but golfers should be careful with golf shots near trees. Balls can ricochet off the trunk and hit someone. The force of a club hitting a tree can stun or injure a player. And watch out for those evergreens—playing a ball too close to the prickly branches can be a danger to eyes.

HEADLINE HILARIOUS

The Silliest Newspaper Headlines

Critics regularly assail *The New York Post* as a glorified tabloid, but whatever you may think of the newspaper's journalistic failings, its editors sure have a way with eye-catching headlines. Remember "Headless Body in Topless Bar"?

Whether they're gaffes or tongue-in-cheek parodies, silly headlines provide ample fodder for comedians like Jay Leno, who has a weekly feature on *The Tonight Show* showcasing such gems as "Diaper Market Bottoms Out" or "Is There a Ring of Debris Around Uranus?"

Here is a ranking of the silliest newspaper headlines in recent years in descending order:

1. "Iraqi Head Seeks Arms"

2. "Miners Refuse to Work after Death"

3. "Red Tape Holds Up New Bridges"

4. "Killer Sentenced to Die for Second Time in 10 Years"

5. "Kids Make Nutritious Snacks"

6. "Two Sisters Reunited After 18 Years at Checkout Counter"

7. "Blind Woman Gets New Kidney from Dad She Hasn't Seen in Years"

8. "Patient at Death's Door—Doctors Pull Him Through"

9. "Something Went Wrong in Jet Crash, Expert Says"

10. "Drunk Gets Nine Months in Violin Case"

11. "Hospitals are Sued by 7 Foot Doctors"

12. "If Strike Isn't Settled Quickly, It May Last a While"

13. "Cold Wave Linked to Temperatures"

HEALTHY AND HARMFUL
Most Unwholesome "Health Foods"

Americans are fatter than ever, thanks to an artery-clogging diet of junk food and an increasingly sedentary lifestyle. With obesity now a bona-fide health crisis, people are gradually turning to healthier alternatives to satisfy their cravings. Glazed doughnuts are taboo and ice cream sales are down. A great many TV commercials for food or restaurants advertise low-fat or low-carb options. But are these "healthy snacks" really all that much better for us than a couple of piping hot Krispy Kremes, washed down with a pint of hot chocolate?

MSN Diet and Fitness took a look at some of the most popular "healthy" snacks of 2004—and the reasons why they aren't really all that good for us. Here they are, in alphabetical order:

1. BAGELS

These may not be sugary snacks, but the refined flour is a simple carbohydrate. And one bagel is equal to about six slices of white bread.

2. BEEF JERKY

The salt in beef jerky is not only bad for your health, but results in water retention that will inhibit weight loss.

3. FRUIT

OK, so fruit is truly good. No hidden calories in raw fruit. But watch for chemicals and pesticides by washing everything thoroughly. Also beware of the

Beware of snack bars, among the most unhealthy of treats.

calories in the heavy syrups in canned fruits.

4. FRUIT JUICE

Check the label. Is "high fructose corn syrup" listed before or after the apple or grape juice? Sugar, or some long-name variation, is usually a key ingredient in these best-selling drinks.

5. MUFFINS

Go for the doughnut. Muffins are loaded with margarine or oil that makes them moist but adds be-

tween 600 and 900 calories to your diet.

6. POPCORN

Popcorn is a great source of fiber, but pop it in oil and then douse it in butter, margarine, or "golden flavor" and you've added an un-healthy amount of calories and fat.

7. PRETZELS

Another simple carbohydrate, there is little fiber in pretzels, and dieters eat a million before they feel full.

8. RICE CAKES

These are low in calories, but they are also low in fiber and nutrients. Also beware of the added calories in butter, cream cheese, or jelly spread over the top.

9. SNACK BARS

Granola bars, breakfast bars, protein bars, and low-carb bars all sound healthy. But the low-fat bars typically add sugars and refined flour, while the low-carb bars usually have added fats.

ICE CREAM FLAVORS
Most Bizarre Treats for Your Taste Buds

There are ice cream purists out there to whom butter pecan seems a bit radical, with its utilization of nuts and other substances. Since the high priests of the culinary arts never settle for status quo, the endless pursuit of more exotic and titillating flavors will probably continue ad infinitum. Perhaps that would explain the introduction of horseradish, chili pepper, and squid flavored ice creams? Perhaps they are a testament to the seriously warped people who might actually enjoy them.

Here are some of the most hideous-sounding flavors that are guaranteed to curb appetites, in alphabetical order. No figures are available as to how long the flavors were on the market (that duration could rival those of "Celebrity Marriages" found elsewhere in this volume).

1. Carrot cake
2. Cheddar
3. Chili pepper
4. Eel
5. Garlic
6. Horseradish
7. Jalapeño pepper
8. Pickles and ice cream
9. Sesame
10. Squid

IDIOT INNOVATIONS
Biggest New Product Flops of All Time

For every wildly successful new product offered on the market à la Post-it Notes or Soft Soap, there's a resounding dud that sits on the shelf before being yanked off into oblivion. Haven't we all wondered how huge companies with access to top-rated marketing research could possibly have thought of such stupid ideas?

Here are eight flops that you may have heard of (and some that lived such a short life that you may have never seen them), in alphabetical order:

1. AVERT VIRUCIDAL TISSUE
Not such a bad mid-'80s idea (vitamin C derivatives included in the product), but Kimberly-Clark didn't realize that the name actually frightened people! Maybe they thought they'd be blowing their noses into chemically laden tissues that would hurt them.

2. BETAMAX
Remember the VHS vs. Betamax competition in the early '80s? While it's generally accepted that Betamax had better picture quality than VHS, it couldn't record nearly as much of a program or film as VHS. You could see it happening in the early video rental stores—Betamax just gradually disappeared from the shelves.

3. DRY BEER
In the early '90s, some of the big beer manufacturers introduced this product to the marketplace. It was supposed to have a cleaner finish than regular beer. Marketing consultant Jack Trout said, "Nobody can figure out what the hell dry beer is. The opposite of wet beer? It's never been explained."

4. EDSEL
When Ford Motor Company introduced this car model in the '50s, it was such a flop that the name is still synonymous with commercial failure.

5. NEW COKE
Hey, if it ain't broke, don't fix it. I don't remember anyone clamoring for a change in taste of the venerable soft drink, so why did they do it back in the mid-'80s? And yet, it got people talking about Coke and demanding the real thing again, so maybe it ended up being good for the company.

6. PREMIER CIGARETTES
You probably never lit up one of these babies because they vanished only 5 months after their late '80s debut. R. J. Reynolds spent more than $300 million on this reduced-smoke tobacco product. Guess smokers prefer full-fledged smoke in their cigarettes.

7. SEGWAY
You know, the motorized scooter for urban transportation that costs a mere 5 grand (more than many

decent used cars out there). Dare we call this one a flop already? Well, have you seen anyone riding around on one?

8. WINE & DINE DINNERS

Here's a fun one. Introduced in the mid-'70s, this box came with pasta, sauce mix, and a mini-bottle of salted wine for the sauce. What Heublein didn't realize was that consumers thought they were supposed to drink that wine! So much for that one.

INSECT ASIDES

Most Loathed Bugs

Few things evoke dread like the sight of cockroaches skittering across your kitchen floor. The bane of urban dwellers and restaurant owners, the lowly cockroach is conspicuously MIA from the following list of most hated insects, compiled with information from Csiro Entomology. Bugs are listed in descending order of sheer repulsiveness. Get your swatter and industrial-strength can of Raid before reading!

1. EARWIG

It's just a myth that they burrow into ears.

2. HORSEFLY

Yes, they do feast on blood after their wicked bites, but some species feed only on nectar.

3. TERMITE

There are more than 350 species of these creepy-crawly demolition experts.

4. BLACK WIDOW SPIDER

Besides eating their partners after mating, these 8-legged freaks even kill lizards and mice.

5. WASP

Beware its sting!

6. TICK

When they burrow into your scalp, they're using four pairs of legs. Eek!

7. *LEECH*

Still used on occasion for medicinal purposes, they have no obvious head or end.

8. MOSQUITO

They can be carriers for West Nile virus, yellow fever, and four strains of malaria.

9. CENTIPEDE

Despite their name, few actually have 100 legs.

10. LOCUST

Even though they do destroy crops and farmland, they can be an important source of food for certain animals.

JOB FATALITIES
The Most Deadly Occupations

For a policeman, "to protect and to serve" means putting your life on the line daily. The same can be said for firemen and members of the bomb squad. But are these high-risk jobs the most dangerous, in terms of the number of fatalities per 100,000 workers?

Not even close, according to a 2002 Bureau of Labor Statistics report. It's the timber cutters of America who—pardon the pun—log the highest death rates on the job. Fishermen and pilots round the top three.

The most common cause of death on the job for any worker is by car accident. Even policemen were more likely to be killed in a crash than by homicide. But murders ranked right up there, too. Surprisingly, you're actually safer being a cop than working at the mall. On average, only 50 policemen are killed in a year, compared to 205 sales clerks. Who knew that working retail could be so hazardous to your health?

Here's a look at America's most dangerous jobs and the most common cause of death, as ranked by the Bureau of Labor Statistics:

Job	Cause of Death
1. Timber Cutters	Struck by falling object
2. Fishermen	Drowning
3. Pilots	Plane crash
4. Structural Metal Workers	Falls
5. Extractive Occupations★	Falls or structural collapse
6. Roofers	Falls
7. Construction Workers	Vehicle accidents or falls
8. Truck Drivers	Highway accidents
9. Taxi Drivers	Homicide

★*Extractive occupations include mining and well drilling.*

JOB INTERVIEWS

Biggest Mistakes Job Interviewees Make

In a tight job market, even a tiny mistake can make or break a job offer. Sure, "who you know" can get your foot in the door. And a good resume may land you a first interview. But once you're face to face with your prospective boss, you're on you own—and on display. Better study up so you don't make one of these mistakes, as determined by career-builder.com in 2004. In alphabetical order:

1. ANSWERING YOUR CELL PHONE

Come on—who can be that important?

2. ARRIVING LATE FOR THE INTERVIEW

Make a test run if you need to, but there's really no good reason for showing up late.

3. BAD-MOUTHING YOUR LAST JOB

Even if your last gig was a bad one, prospective employers get uncomfortable with candidates who talk trash about a past boss. It makes you look negative and leaves them wondering what you'll say about them down the line.

4. BITING YOUR NAILS

This may not seem like a federal offense, but it does give the interviewer the impression that you may not be the most confident of candidates.

5. EATING A SANDWICH

"Who'd do that???" you may ask, but it's been done.

6. INAPPROPRIATE APPEARANCE

This isn't a cookout or a single's bar—so don't dress like it is. Oh, and a shower on the big day is kind of nice, too.

7. LYING ON YOUR RESUME OR DURING THE INTERVIEW

Lies have a way of catching up with you. Do not make up degrees or jobs you never had. The lies may get you hired, but they'll also get you fired.

8. NEGATIVE ATTITUDE

Maybe this isn't your ultimate dream job, but they don't have to know that. And they shouldn't. Don't swear or act bored. And remember there's a difference between being confident and acting cocky.

9. POOR COMMUNICATIONS SKILLS

While mumbling and bad grammar are definite no-no's, so is talking too much. Yes, answer the questions with confidence, but this is not the time to bare your soul.

10. POOR PERFORMANCE OR PREPARATION

Know what job you're applying for and why you'd be a perfect fit. Make eye contact and give 'em that firm handshake.

LAWS FOR LAUGHS
The Dumbest Statutes on the Books

Never let it be said that the Wisconsin penal system treats prisoners inhumanely. Sure, you may get locked up for life in a dank, claustrophobia-inducing cell with tattooed thugs the size of refrigerators, but at least you won't have to choke down—gasp—*margarine* in the prison cafeteria. The Dairy State lawmakers make such culinary abuses illegal: "Butter substitutes are not to be served in state prisons."

Some old laws on the books probably made sense when they were written. Others are just plain silly. Take this law from England: It is illegal to be a drunk in the possession of a cow. Or this one from Arizona: "No one is permitted to ride their horse up the stairs of the county court house."

Here are some of the dumbest laws on the books, listed alphabetically by location:

1. ALABAMA

It's illegal for a person to operate a motor vehicle while blindfolded.

2. CALIFORNIA

You can be fined $500 if you bother a butterfly in Pacific Grove, California.

3. CANADA

You may not pay for a 50-cent item with only pennies.

4. GEORGIA

Though it is illegal to spit from a car or bus, it's perfectly acceptable to spit from a truck.

5. IDAHO

It's illegal for a man to give his wife or girlfriend a box of candy weighing less than fifty pounds.

7. ILLINOIS

It's illegal for anyone to give

lighted cigars to dogs, cats, and other domesticated animals kept as pets.

8. ISRAEL
Picking your nose on the Sabbath is illegal.

9. KENTUCKY
It's illegal to transport an ice cream cone in your pocket.

10. MEXICO CITY
Bicycle riders may not lift either foot from the pedals, as it might result in a loss of control. You can also be arrested if you annoy a bicycle rider.

11. NEW JERSEY
Once you've been convicted of driving while intoxicated, you may never again apply for personalized license plates.

12. OHIO
It's illegal to fish for whales on Sunday.

13. SWEDEN
Prostitution is legal; however, it is illegal to use the services of a prostitute.

14. TENNESSEE
It's illegal to use a lasso to catch a fish.

15. WEST VIRGINIA
It's unlawful for chickens to lay eggs before 8 a.m. and after 4 p.m.

LAWSUITS
The Dumbest Legal Battles to Hit the Courts

Coffee too hot? Whatcha gonna do? Sue! Fall on an icy sidewalk while trying to rob someone? Whatcha gonna do? Sue! Can't get your wheelchair into the lap dancing room? Whatcha gonna do? Sue!

Absurdly groundless lawsuits clog the dockets of courtrooms around the world. For example, there's the lawsuit filed by a Mexico City burglar against his intended victim. He sued the 350-pound homeowner after she broke one of his ribs while sitting on him for a half-hour, waiting for the police to arrive.

Stupid lawsuits like this one have become so common, Colorado journalist Randy Cassingham created the annual Stella Awards as part of his "This is True" weekly news column. Named for Stella Liebeck,

who won a $2.9 million dollar lawsuit in 1992 after she spilled—you guessed it—hot McDonald's coffee in her lap, the awards recognize the dumbest lawsuits of the year. Here is a ranking of the 2003 honorees, in descending order:

1. MISTAKEN GUN

The City of Madera, California, is suing Taser International after a police officer there mistakenly shot and killed a suspect with her handgun, which the officer mistook for her stun gun. The city claims the company's product is too similar in appearance to the real thing, and therefore Taser is responsible for the death.

2. THE DOG FROM GOD

An Oregon man, who says God steered him to adopt a stray dog, is suing his dog sitter for $160,000 after the dog ran away. Where did he get that figure? It's the money he spent by running display ads in the paper and hiring four animal psychics and a witch to find the dog, plus loss of income and $100,000 in emotional damages. The owner later found the dog—exactly where the dog was first reported missing.

3. LOCK-IN

When a woman in Alabama lost her home in a foreclosure, she moved her things to a storage unit. One night she was inside the unit when the storage manager saw it partially open and closed and locked it. Although she denies being asleep, she didn't call for help or bang on the door. She survived on food stored in her unit, but when she was found 63 days later, she had lost almost 70 pounds. She sued the storage yard for $10 million dollars in damages and won $100,000.

4. CONFESSIONS

A Catholic priest who was involved in a sex-abuse scandal settled a lawsuit with a victim in 1990, with the condition that he not work with children anymore. When the victim discovered that the priest was back working with children, he confronted the priest, who said the church had assigned him to that post. The victim took his story to the press. In response, the priest is suing his former victim for $65,000 for violating his agreement to keep the settlement a secret.

5. PLAY BALL

A high school student who made $1 million in the stock market

was ordered to pay it back after the feds discovered he made it fraudulently. The fraud case violated his school's code of conduct and he was not allowed to play high school baseball. The boy claimed he had planned on a pro baseball career and would not be scouted if he wasn't on the team. He sued the school for $50 million, the amount he figures he will lose by not playing in the majors.

6. FAST-FOOD BLUES

A New Yorker who suffers from heart disease, diabetes, and obesity brought a lawsuit against McDonald's, Burger King, Wendy's, and KFC because the fast-food restaurants failed to inform him that junk food wasn't good for him.

7. LIGHTNING STRIKES

A man struck by lightning in an amusement park parking lot sued the park. Why? They should have warned the public that it's unsafe to be outside during a thunderstorm.

8. WHAT'S IN THE MIDDLE?

Hoping to draw attention to his mission to ban trans fats from processed foods, a California man filed a lawsuit against Oreo cookies, which use trans fats in the creamy center of their sandwich cookies. Thankfully, the suit attracted so much publicity that he dropped the suit after 13 days.

LINGUISTIC GARBAGE
The Ugliest Words in the English Language

There are certain words in the English language that some people consider inherently ugly. Why these words inspire such loathing is hard to explain. They may sound overly harsh or crude to the ear or denote something offensive or sordid. Whatever the reason, there's certainly no universal standard for determining a word's appeal. How could there be, when writer Willard R. Espy names "gonorrhea" as one of the ten most beautiful words in English language, as he did in the *Book of Lists Vol. 2*. Maybe we're wrong, but odds are if you drop "gonorrhea" into your conversation at a cocktail party, people will wince or cringe—and it won't be in appreciation of the word's poetic beauty.

For the 1990s update of *The Book of Lists*, editors David Wallechinsky and Amy Wallace recruited Espy to list the ten ugliest words in the

English language (barring profane and scatological terms). Here are the ten words as ranked by Espy:

1. Fructify
2. Kumquat
3. Quahog
4. Crepuscular
5. Kakkak
6. Gargoyle
7. Cacophonous
8. Aasvogel
9. Brobdingnagian
10. Jukebox

Not exactly beautiful to look at, and it doesn't sound pretty either. "Gargoyle," along with other English words such as "fructify," "kumquat," "aasvogel," and others listed in "Linguistic Garbage" in this volume are among the ugliest words in the English language.

Note: Kabbak is the word the people of Guam use in reference to the yellow bittern, a species of bird.

LONELY HEARTS CLUB PERSONALS
The Schmaltziest Ad Lines

More and more singles are logging on to the wild world of online dating. For the overworked "singleton" on the hunt, surfing online personal ads is a convenient way to separate the wheat from the chaff, the frogs from the princes. And then there's always the chance that the Internet Romeo who describes himself as "George Clooney's twin" is an overweight slob with algae in his ears. So how do you avoid meeting Mr. or Ms. Extremely Wrong? Start by looking at the subject header of the personal ad. If a personal begins with any of the following overused subject headers as ranked and compiled by *Online Dating Magazine*, go to the nearest bar and try your luck there.

1. I might be the one you're looking for!
2. Hi (or "Hello" or "Howdy" or "Hey there")
3. Seeking Prince Charming
4. I'm the one your mother warned you about
5. I can't believe I'm doing this!
6. Looking to meet new people
7. Looking for a partner in crime
8. Are you the one?
9. Just curious
10. Blah. Blah. Blah.

MEDICAL BILL BLOOPERS
Costliest Billing Errors for Hospital Procedures

Trying to make sense of medical bills could land you back in the hospital—the psychiatric ward. Instead of wading through these long and utterly confusing itemized documents written in hospital shorthand, many patients simply pay them or turn them over to their insurance companies.

Billing errors are lot more common than most people think. Even if the mere thought of reading all the fine print gives you a migraine, reviewing your medical bills can save you money *and* stress.

Here are the most common hospital billing mistakes, ranked according to bankrate.com, 2004. Don't let them happen to you.

1. DUPLICATE BILLING
Getting twice as much is a good thing—unless it's a bill.

2. NUMBER OF DAYS IN THE HOSPITAL
Don't let them bill you for the day you're sprung.

3. INCORRECT ROOM CHARGES
Make sure you don't get charged for a private room if you share, even if it's with an empty bed.

4. OPERATING-ROOM TIME
How long did it take them to patch you up?

5. UP CODING
Did you get a generic drug or the real thing? Pay for what you really get.

6. KEYSTROKE ERROR
Everybody makes mistakes. Don't pay for someone else's.

7. CANCELED WORK
If tests were canceled, be sure you aren't charged.

8. SERVICES NEVER RENDERED
Check and double check to be sure you really got all the medication and services billed.

MEDICAL REFERRAL LETTERS
The Most Alarming Doctors' Memos

If going to the doctor sends your blood pressure skyrocketing, then be forewarned: reading these excerpts from medical referral letters could prove hazardous to your health. A British healthcare company culled these hilariously unnerving samples of medical malaprops from actual interoffice memos and other correspondence between doctors. It's enough to put Hippocrates, the father of medicine, on the spin cycle in his grave!

Here are 10 doctors' notes, ranked from the least to the most alarming:

1. *Referral to outpatient clinic:*
"Dear Dr. W,
Regards Mrs. X, Bradford-upon-Avon,
Please see and advise."
Reply from outpatient clinic:
"Dear Dr. Y,
I have seen your patient and advise you to do the same."

2. "Dear Mr. X, I should be grateful if you could see Mrs. Y, who has halitosis of both great toes."

3. "Kindly see four-year-old James, who has had a cough since yesterday. Also, the family pet dog has had a similar barking cough for the last few days."

4. *Letter to a consultant radiologist:*
"Re: John Smith. This 57-year-old builder is requesting a CAT scan on his lumbar spine to be performed on a private, fee-paying basis. Mr. Smith is a malcontent of the highest order and holds a very warped view of life in general.
I see no harm in acceding to his request, although he expresses his contempt for orthopedic surgeons, chiropractors, osteopaths, acupuncturists, and, not least, GPs, so you might as well join the list."

5. *Referral to a urology clinic:*
"I would be grateful if you would see this man, who is complaining of impertinence."

Urology clinic summary:
"I saw Mr. X in my surgery on January 17. He complained of impudence during sexual intercourse and I wondered if this is related to his beta-blocker."

6. *Dermatology summary letter:*
"We investigated this patient for latex sensitivity. She gets pinking of the lips when she blows up balloons. She has also had problems with intercourse that may have been related to condom exposure. I could see no point in re-prick testing her."

7. *Letter sent by local health authority to an expectant mother:*
"Dear Lucy, we have been informed that you are pregnant by your GP. Your local team of midwives will be contacting you shortly."

8. "Dear Doctor, Please suture this man's hand. I couldn't be boddered [sic]."

9. *Referral to casualty unit, written on a torn piece of cereal packet:*
"Dear Doctor, Query Heart."
Reply:
"Dear Doctor, Heart Present."

10. "Dear colleague. Pain chest since long time. I think there might be something wrong with him. Hoping your kind attention."

MILITARY CASUALTIES
Most Combatant Deaths

Americans were horrified just before the 2004 U.S. Presidential election when it was reported that the 1,000th American soldier died. The previous war in the Persian Gulf in 1991 saw just a few hundred military deaths. Other military incursions into Panama and Grenada produced even fewer. But compared to previous conflicts, the toll was miniscule.

Nearly 16 million combatants worldwide died between 1939 and 1945. Factor in non-combatant deaths, and the number reaches upwards of 55 million!

In all of recorded history, no war has ever taken the lives of so many combatants as World War II, which involved 28 countries in the six-year struggle. From the Roman Empire to today, here are the 10 wars with the highest death rates, ranked in order:

War	Dates	Total Fatalities
1. World War II	1939–45	15,843,000
2. World War I	1914–18	8,545,000
3. Korean War	1950–53	1,893,100
4. Jewish Wars/Roman Empire	AD 66–70	1,000,000
War of Spanish Succession	1701–14	1,000,000
Sino-Japanese War	1937–41	1,000,000
7. Civil War (U.S.)	1861–65	647,528
8. Civil War (Spain)	1936–39	611,000
9. Vietnam War	1961–73	546,000
10. Wars of Liberation (Europe)	1813–14	545,000

MOVIE BLURBS
The Dumbest Movie Promos

When it comes to marketing grade-Z exploitation movies, it's a given that the cheaper the flick, the sillier the blurb. Pandering to the lowest common denominator certainly proved lucrative for schlock mavens like Roger Corman and William Castle, who never let a little thing like truth in advertising get in the way of making a fast buck.

Here are the 10 blurbs we found to be the very silliest, ranked in order of sheer inanity:

1. "Desperate scientists plead with EINSTEIN'S ILLEGITI-MATE DAUGHTER to save the Earth! SEE wimpy earth scientists sacrificed on the altar of atomic discovery!" (*Atomic Women*)

2. "The only people who will not be STERILZED with FEAR are those among you who are already DEAD!" (*The Flesh Eaters*)

3. "Tobacco chewin', gut chompin', cannibal kinfolk from hell!" (*Redneck Zombies*)

4. "There will be a special FRIGHT BREAK during the showing of *Homicidal*. All those too timid to take the climax will be welcomed to the COW-ARD'S CORNER!" (*Homicidal*)

5. "The film will satisfy every over-sexagesimal adult! In gor-

"They transplanted a white bigot's head on a soul brother's body!" So goes the movie promotion line, one of the 10 dumbest blurbs in cinematic history. The movie is The Thing with Two Heads *(1972), starring Roosevelt Grier (left) and Ray Milland.*

geous and shocking Astravision and Sexicolor." (*Orgy of the Dead*)

6. "Spine-shattering, bone-blasting, she's a one-mamma massacre squad!" (*T.N.T. Jackson*)

7. "Herbert West has a very good head on his shoulders—and another one in a dish on his desk." (*Re-Animator*)

8. "They transplanted a white bigot's head on a soul brother's body!" (*The Thing with Two Heads*)

9. "Due to the horrifying nature of this film, no one will be admitted to the theater." (*Schlock*)

10. "She was a preacher's daughter but . . . wilder than a peach orchard hog!" (*Girl from Tobacco Row*)

MOVIE MUSICALS
Worst Song-and-Dance Films Ever Produced

Fans of Hollywood's golden era often lament that "they don't make 'em like they used to." Take the musical, aka the film genre that wouldn't die, although quite a few filmmakers have tried to kill it over the years. For every classic like *Singin' in the Rain* (1952) or *Cabaret* (1972), there's a lumbering bore like *Paint Your Wagon* (1969), which features the song stylings of Lee Marvin and Clint Eastwood! Or *The Wiz* (1978), the misbegotten adaptation of the hit Broadway musical in which Diana Ross cries nonstop while singing and dancing her way to box office disaster.

Both *Paint Your Wagon* and *The Wiz* deservedly flopped, but they look like masterpieces compared to the following movie musicals, which the editors of *Consumer Guide* named the all-time worst in film history, in chronological order:

In this stinker, Madeline Kahn thoroughly embarrasses herself singing Cole Porter standards. At Long Last Love *(1975) is one of the 10 worst movie musicals of all time.*

1. *CHAINED FOR LIFE* (1951)

A tone-deaf curiosity item starring the Siamese twins Daisy and Violet Hilton, who sing and dance as vaudeville performers involved in murder.

2. *PAJAMA PARTY* (1964)

Tommy Kirk is a poor substitute for Frankie Avalon in this beach-blanket movie, the very nadir of the series starring Annette Funicello.

3. *MAN OF LA MANCHA* (1972)

"The Impossible Dream" turns out to be a nightmare in this adaptation of the hit Broadway musical, starring Peter O'Toole and Sophia Loren's cleavage.

4. *LOST HORIZON* (1973)

A perennial entry in lists of the worst movies, this stupefyingly bad musical remake of Frank Capra's 1937 classic tanked at the box office.

5. *AT LONG LAST LOVE* (1975)

Cybill Shepherd and Burt Reynolds thoroughly embarrass themselves "singing" Cole Porter standards in this stinker from director Peter Bogdanovich.

6. *LISZTOMANIA* (1975)

Leave it to lunatic British filmmaker Ken Russell to cast The Who's Roger Daltrey as composer Franz Liszt in this bizarre musical biography.

7. *SGT. PEPPER'S LONELY HEARTS CLUB BAND* (1978)

A soundtrack masquerading as a movie. Peter Frampton and The Bee Gees come across as a dinner theater version of The Beatles in this virtually plotless rock musical.

8. *XANADU* (1980)

Tacky roller disco fantasy starring Olivia Newton-John as a Greek muse in Los Angeles. Gene Kelly co-stars in this very sad epitaph to his film career.

9. *ANNIE* (1982)

Big-budget, all-star, all-bad adaptation of the hit Broadway musical wastes the talents of Albert Finney, Carol Burnett, and Bernadette Peters.

10. *YES, GIORGIO* (1982)

No, no, a thousand times no! Opera star Luciano Pavarotti sings arias and eats his way through this terrible musical romance.

MOVIE REMAKES
When Older Was Better

In Hollywood, where originality is often regarded as the kiss of box-office death, remakes of classic films appear each year with mind-numbing regularity. For the bean counters running the major movie studios, remakes have an immediate brand-name recognition that translates into healthy ticket sales—at least in theory, anyway.

Of course, for every remake that's a hit, like the 2004 "re-imagining" of George Romero's 1978 cult classic *Dawn of the Dead*, there's a long and sorry list of remakes that critics and audiences alike spurn, such as the expensive mega-flops *The Alamo* (2004) and *The Four Feathers (2003)*. Although these two historical epics are turgid bores from the first frame to the last, they didn't quite sink to the abysmal depths of the following remakes, which rank as the all-time worst in Hollywood history. As these terrible films demonstrate, imitation is *not* the sincerest form of flattery.

In alphabetical order:

It's cheesy, it's tongue-in-cheek, and it stars Jessica Lange. This 1976 remake of the 1933 classic King Kong *is one of the 10 worst movie remakes of all time.*

1. *DIABOLIQUE* (1996)

A campy, frequently nonsensical re-make of Henri-Georges Clouzot's 1956 classic, *Diabolique* strands Is-abelle Adjani and bad movie fixture Sharon Stone in a melodramatic tale of murder and intrigue at a ritzy private school.

2. *THE JAZZ SINGER* (1980)

The 1927 film starring Al Jolson made history as the first talkie. This awful, poorly-acted 1980 re-make starring Neil Diamond and a slumming Sir Laurence Olivier works better with the sound off.

3. *KING KONG* (1976)

Cheesy-looking, tongue-in-cheek update of the 1933 classic features such embarrassing moments as Jes-sica Lange calling her simian ad-mirer a "male chauvinist pig ape."

4. *THE LADY VANISHES* (1978)

Hitchcock's 1938 thriller is an elegant exercise in suspense. This misbegotten remake starring the chemistry-free duo of Elliot Gould and Cybill Shepherd is a laughable clunker that vanished quickly.

5. *LOST HORIZON* (1973)

All-star, all-bad, tone-deaf musical version of Frank Capra's 1937 ro-mantic fantasy set in the mythic Himalayan utopia of Shangri-La.

6. *MR. DEEDS* (2002)

Obnoxious one-trick pony Adam Sandler trashes the role Gary Cooper plays so memorably in the 1936 Frank Capra film, *Mr. Deeds Goes to Town.* Sandler's unfortu-nate co-star Winona Ryder looks like she'd rather be shoplifting than sharing the screen with the doofus comic.

7. *PLANET OF THE APES* (2001)

Mark Wahlberg, the "go-to" star for bad Hollywood remakes, takes over Charlton Heston's role in Tim Burton's botched and con-fusing remake of the 1968 science fiction film.

8. *THE PRISONER OF ZENDA* (1979)

Comic chameleon Peter Sellers plays two roles in this 6th film version of the classic swashbuck-ling yarn, but even he can't sal-vage this lavishly produced yawner.

9. *PSYCHO* (1998)

Director Gus Van Sant's pointless shot-by-shot, color remake of Hitchcock's legendary thriller is more irritating than frightening.

10. *THE TRUTH ABOUT CHARLIE* (2002)

Mark Wahlberg strikes again! This time, he sleepwalks through a role

Cary Grant plays to classy perfection in 1963's *Charade*. This leaden, charmless remake of *Cha-* *rade* deservedly tanked at the box office.

MOVIE SEQUELS
Rocky CXXXVIII and Other Lousy Film Sequels

Once in a proverbial blue moon, when the cinematic planets are in alignment, a sequel comes along that's as good or even better than the original film—think *The Godfather, Part II* (1974) or *Aliens* (1986). These two films are part of the handful of exceptions to that Hollywood rule that sequels are necessarily inferior or worse—much, much worse. Take *Exorcist II: The Heretic* (1977). While it didn't make E! Online's list of the 10 worst movie sequels ever made—an inexplicable oversight on the part of the list's compilers—this unintentionally hilarious follow-up to the 1973 classic is a total disaster that died at the box office. Just goes to show that lightning doesn't always strike twice in sequel-happy Hollywood.

Here are the 10 sequels in descending order of awfulness that made E! Online's list:

1. *STAR WARS EPISODE I: THE PHANTOM MENACE* (1999)

Even the faithful were disappointed by this lackluster and woodenly acted "prequel," which introduces the profoundly annoying CGI-generated character of Jar Jar Binks.

2. *BATMAN & ROBIN* (1997)

George Clooney takes over as the Caped Crusader and basically kills the franchise, with a generous assist from director Joel Schumacher and Akiva Goldsman's groaner of a screenplay.

3. *SPEED 2: CRUISE CONTROL* (1997)

A bloated and dull retread of the 1994 sleeper hit on the high seas. Keanu Reeves wisely took a pass, leaving Sandra Bullock to sink with this stinker.

4. *CADDYSHACK II* (1988)

More of the same golf hi-jinks, only minus the laughs. Chevy Chase looks especially pained in this turkey.

5. *BOOK OF SHADOWS: BLAIR WITCH 2* (2000)

The only thing scary about this sequel to the 1999 indie hit is just how stupid it is.

6. *JAWS: THE REVENGE* (1987)

Bruce the shark returns with a vendetta in this utterly dreadful and hopefully last sequel to the 1976 smash.

7. *LOOK WHO'S TALKING TOO* (1990)

Shut up!

8. *TRAIL OF THE PINK PANTHER* (1982)

Dud pieced together from leftover footage of the late Peter Sellers playing Inspector Clouseau.

9. *ROCKY V* (1990)

Pointless sequel with Stallone way past his prime as underdog boxer Rocky Balboa.

10. *THE COLOR OF MONEY* (1986)

Paul Newman won an Oscar, but this okay sequel to 1961's *The Hustler* pales significantly in comparison to the brilliant original.

MOVIES—CAMP CLASSICS
The Best of Schlock Cinema

Just as cinephiles speak of the glories of *Citizen Kane, La Dolce Vita*, and *The Seven Samurai* in hushed, reverent tones, bad-movie junkies wax poetic about the melodramatic excesses of *Mommie Dearest, Showgirls,* and *Valley of the Dolls*. These films belong to that special category of deliriously, hilariously bad movies that qualify as camp. Cult followings have sprung up around key camp classics that live on in infamy, not to mention DVD. Although some stars eventually come around to embrace their status as camp icons—heck, it beats being forgotten or slinging hash—most would rather be remembered as serious "artistes" (yeah, right). There's very little art on display, however, in these 10 camp classics that leave you speechless—with laughter.

In alphabetical order:

1. *THE BAD SEED* (1956)

Pseudo-Freudian melodramas were big in the 1950s, and none were bigger and sillier than *The Bad Seed*, which goes over the top and then some. Pigtailed darling Rhoda Penmark (Patty McCormack) is sweetness personified—until you

One of the 10 campiest movies ever, The Bad Seed *(1956) starred pigtailed darling Patty McCormack (left) and Nancy Kelly.*

get in her way and she becomes a raving homicidal maniac!

2. *BEYOND THE FOREST* (1949)

Looking like a drag queen in a black fright wig, a matronly Bette Davis struts through a small Wisconsin town as trampy Rosa Moline, uttering the immortal line, "Whatta dump!" This bizarre melodrama nearly KO'd Davis's career for good.

3. *GLITTER* (2001)

Pop diva Mariah Carey bears her soul and a lot of cleavage in this inadvertently hilarious movie, loosely based on her own rise to the top of the charts. A flop, *Glitter* has inspired a host of drinking games.

4. *MOMMIE DEAREST* (1981)

Faye Dunaway chews scenery with scary gusto as screen diva/camp icon Joan Crawford in this insane melodrama based on the exposé by Crawford's adopted daughter. "No wire hangers ever!" became a camp catchphrase.

5. *MYRA BRECKINRIDGE* (1970)

Any film starring Raquel Welch as a post-op transsexual on the loose in Hollywood just screams camp, but that's just the beginning. Throw in a mummified Mae West croaking her way through a rock-and-roll number while hunky men drool over her, and you have the special brand of hell that is *Myra Breckinridge*.

6. *REEFER MADNESS (1938)*

The evils of that demon weed, marijuana, make for a surreal exploitation film that later inspired a stage musical.

7. *SHOWGIRLS* (1995)

In a rare moment of good taste, Madonna actually turned down a role in this crude, nonsensical piece of big-budget trash about showbiz wannabes in Sin City. Offensive in the extreme, *Showgirls* also features the most unin-tentionally funny sex scene in the history of cinema.

8. *STRAIT-JACKET (1964)*

Playing a paroled ax-murderess, Joan Crawford goes hilariously bonkers when her past crimes come back to haunt her.

9. *VALLEY OF THE DOLLS* (1967)

A hoot from the opening credits to the last trashy frame, *Valley of the Dolls* is a laugh-out-loud compendium of classic bad-movie dialogue, most of which overwrought star Patty Duke shrieks, spits, and snarls in a performance that would make drag queens proud.

10. *WILD ORCHID (1990)*

A lurid, soft-core melodrama starring Mickey Rourke and an automaton named Carre Otis, *Wild Orchid* is howlingly bad and all the funnier for it.

MOVIES IN NEED OF A DIRECTOR
The Worst-Directed Films (by Actors)

Some people just shouldn't quit their day job—in particular, many of the actors who think they can direct a film. In a textbook example of "what were they thinking (or snorting)," the producers of the 1980s disco musical *Can't Stop the Music* hired actress Nancy Walker to direct this expensive bomb starring the three-hit wonder The Village People. A novice behind the camera, Walker was critically mauled for her monumental filmmaking ineptitude and wisely went back to hawking

Actress Nancy Walker might think of sticking to acting rather than directing flops like Can't Stop the Music *(1980), one of the 10 worst films directed by actors or actresses. Pictured here is Glenn Hughes (of the Village People), who starred in the bomb.*

Bounty paper towels on television. As for *Can't Stop the Music*, it's become a camp classic of the "so bad it's good" variety.

Actor-director hyphenates have been around since the silent cinema, when clowns par excellence Charlie Chaplin and Buster Keaton wrote, directed, produced, and starred in such landmark films as *The Gold Rush* (1925) and *The General* (1927). A few movie stars, like Clint Eastwood, Warren Beatty, and Robert Redford, have enjoyed a comparable degree of success behind the camera. And then there are the actors/aspiring auteurs whose films were savaged by critics and ignored by audiences. Here are 10 films directed by actors whose agents should have cut them off when they said, "But what I really want to do is direct."

In alphabetical order:

1. *BEAUTIFUL* (2000): SALLY FIELD
Butt Ugly would be a more appropriate title for this toothless satire of beauty pageants directed by the two-time Oscar winner.

2. *CAN'T STOP THE MUSIC* (1980): **NANCY WALKER**

All the Bounty towels in the world couldn't clean up the mess Walker made of this tacky disco musical starring the late-seventies novelty act The Village People.

3. *FAR OUT MAN* (1989): **THOMAS CHONG**

Half of the stoned comedy duo Cheech & Chong, Chong allegedly wrote and directed this aimless, laugh-free road movie about a hippie on a cross-country quest.

4. *HARLEM NIGHTS* (1989): **EDDIE MURPHY**

Writing, directing, producing, and starring in this expensive period comedy proved too much for Murphy, whose red-hot career hit a snag with this dud.

5. *ISHTAR* (1987): **ELAINE MAY**

Celebrated for her hilarious stand-up comedy with Mike Nichols, Elaine May took a beating for writing and directing this legendary fiasco starring Warren Beatty and Dustin Hoffman, a lame attempt at a modern-day Hope and Crosby film.

6. *THE LAST MOVIE* (1971): **DENNIS HOPPER**

Hot off the surprise success of *Easy Rider*, actor/director/recovering freak Dennis Hopper became a persona non grata in Hollywood for many years after bombing with this self-indulgent and incoherent mess about a film crew in Peru.

7. *NORTH (1994)*: **ROB REINER**

Reiner, aka Meathead on *All in the Family*, crashed and burned with this disastrously unfunny family comedy lambasted by the critics.

8. *NOTHING BUT TROUBLE* (1991): **DAN AYKROYD**

Saturday Night Live veteran Aykroyd got nothing but grief from critics and audiences for this inane comedy about yuppies trapped in a scary backwater town.

9. *THE POSTMAN* (1997): **KEVIN COSTNER**

After striking Oscar gold with *Dances With Wolves*, Costner swept the 1997 Razzies for the year's worst films with this tedious vanity piece, a sci-fi/western.

10. *TARZAN THE APE MAN* (1984): **JOHN DEREK**

A fifties-era heartthrob turned Svengali, Derek directed his gorgeous but talentless wife Bo in this deadly dull softcore jungle movie.

MUSICAL MONIKERS
Weirdest Names for Rock Bands

You know you're getting older when the names of certain rock bands sound downright ridiculous. Or could it be that some of these band names truly are weird, even to the most jaded of the hipsters? Back in the late 1970s, a punk band raised more than a few eyebrows by calling itself The Dead Kennedys. Nowadays, bands steer clear of such overtly political names to revel in the just plain crazy, naming bands things like Nasal Sex With Broken Glass or Shower With Goats (sounds kinda dirty, huh!).

If one of your worst nightmares is a leather-clad, tattooed dude with a pierced tongue coming to your door to pick up your daughter, odds are he and your daughter are fans of one the groups below, ranked in ascending order of weirdness:

1. Fallopian Breakdance
2. Phlegm
3. Seagull Screaming Kiss Her, Kiss Her
4. My Wife Was Breathing Just Fine When You Borrowed Her
5. Nasal Sex with Broken Glass
6. Aardvark Spleen
7. A Cat Born in an Oven Isn't a Cake
8. Gee That's a Large Beetle I Wonder If It's Poisonous
9. People with Chairs Up Their Noses
10. Shower with Goats

NOTES FROM YOUR MOTHER
Oddest Correspondences from Parents to Teachers

Multi-tasking 24/7 can take a toll on even the most articulate parent. How else to explain these unintentionally hilarious notes to kids' teachers, scribbled by obviously preoccupied parents—we hope. In the following ranking of actual excuse notes, sometimes the most innocent explanations for school absences sound positively warped.

In descending order:

1. Maryann was absent December 11–16, because she had a fever, sore throat, headache and upset stomach. Her sister was also sick, fever and sore throat, her brother had a low-grade fever and ached

all over. I wasn't the best either, sore throat and fever. There must be something going around, her father even got hot last night.

2. Please excuse Mary for being absent yesterday. She was in bed with gramps.

3. My son is under a doctor's care and should not take P.E. to-day. Please execute him.

4. Please excuse Lisa for being absent. She was sick and I had her shot.

5. Please excuse Jason for being absent yesterday. He had a cold and could not breed well.

6. My daughter was absent yes-terday because she was tired. She spent a weekend with the Marines.

7. Please excuse Jennifer for missing school yesterday. We forgot to get the Sunday paper off the porch, and when we found it Monday, we thought it was Sunday.

8. Please excuse Roland from P.E. for a few days. Yesterday he fell out of a tree and misplaced his hip.

9. I kept Billie home because she had to go Christmas shopping because I don't know what size she wears.

10. Dear School: Please ekscuse John being absent on Jan. 28, 29, 30, 31, 32, and also 33.

NUCLEAR POWER PLANT DISASTERS
Worst Nuclear Accidents of All Time

On June 27, 1954, the Soviets became the first to use nuclear power to generate electricity for commercial use. Three years later, the United States' first nuclear power plant became operational in Pennsylvania. Since that time, the nuclear power industry has experienced rapid growth, strict government regulation, and epic tragedy. The latter oc-curred in 1986 at the Chernobyl reactor near Kiev in the Ukraine. One of four reactors began a nuclear meltdown, which in turn created ex-plosions and a massive fire. Thirty-one workers died from radiation ex-posure; thousands more from nearby towns had to be evacuated. The real impact of the Chernobyl nuclear reactor disaster, however, is yet to

be felt. Cancer deaths in the area of the plant are expected to rise in the next few years due to the radiation debris from the accident.

Here are the worst nuclear power plant accidents that have occurred over the last half-century, in chronological order:

1. 1952, CHALK RIVER (NEAR OTTAWA, CANADA)

A partial meltdown of the reactor's uranium fuel core resulted in the accumulation of millions of gallons of radioactive water, but no injuries.

2. 1957, WINDSCALE PILE NO. 1 (NORTH OF LIVERPOOL, ENGLAND)

Fire in a reactor spread radiation through the countryside, contaminating a 200-square-mile area.

3. 1957, SOUTH URAL MOUNTAINS (NEAR KYSHTYM, SOVIET UNION)

An explosion of radioactive waste at a nuclear weapons factory spurred the evacuation of 10,000 people from the contaminated area. No injuries were reported.

Ukrainian mother places a photo of her son who died following the worst nuclear power plant disaster in history in 1986 at Chernobyl in the former Soviet Union.

4. 1976, GREIFSWALD, EAST GERMANY

A safety failure resulted in a near meltdown in the radioactive core of the reactor at this nuclear power plant.

5. 1979, THREE MILE ISLAND (NEAR HARRISBURG, PENNSYLVANIA)

A reactor lost its coolant, resulting in overheating and partial meltdown of the uranium core. Radioactive water and gases were released but no one was injured.

6. 1986, CHERNOBYL (NEAR KIEV, UKRAINE)

In the worst nuclear accident to date, 31 people died and others were injured when an explosion and fire in one of 4 nuclear reactors released radioactive materials that spread over the Soviet Union and parts of Europe.

7. 1999, TOKAIMURA, JAPAN

Japan's worst nuclear disaster left one worker dead and two others injured when a uranium-processing fuel plant spit high levels of radioactive gases into the air.

PHOBIAS
The Most Common Paralyzing Fears

Toddlers are usually terrified of the dark, where they're convinced monsters lurk just under the bed or inside closets. Although most children eventually outgrow their fear of the dark, some people remain in the grip of this particular phobia well into adulthood. Suffering from morbid, often paralyzing fears they regard as both irrational and embarrassing, many people find relief only through cognitive-behavioral therapy, which gives them invaluable coping mechanisms for quelling anxiety.

There are scores of phobias, ranging from the bizarre—peladophobia, the fear of bald people—to the understandable, like ophiophobia, the fear of snakes. On the Web site athealth.com, Dr. John L. Miller contributed a list of what are generally considered to be the eight most common phobias, listed in alphabetical order:

1. Achluophobia: fear of being in darkness
2. Acrophobia: fear of heights
3. Agoraphobia: fear of open spaces or fear of leaving home

Achluophobia (fear of being in the darkness) is the number-one phobia.

4. Claustrophobia: fear of being in closed spaces
5. Demophobia: fear of being in crowded places
6. Mysophobia: fear of germs or dirt
7. Social phobia: fear of being around unfamiliar people in social situations
8. Xenophobia: fear of strangers

PICKER-UPPERS?

The Worst Lines Ever Heard at Singles Bars

There are so many bad lines out there, how do you determine the worst of all? The number of slaps in the face they produce? Or kicks in the shins? (This was cleaned up a bit for family audiences who may be reading this book.)

Revealed, however, is where they came from: the Web site Anime Chains Forum (www.animechains.net), which compiled them and as-

sures they represent genuine attempts to be cool. Here is a ranking of the best of them, with a few remarks to meditate on if you're considering trying them out at your favorite pickup joint. In no particular order:

1. "Hey baby, are you tired? Because you've been running through my mind all day."
(Please run as fast as you can—in the other direction.)

2. "Hey baby, you dropped something . . . my heart."
(Actually, I dropped my mace. Please help me find it so I can spray you.)

3. "Hey, wanna give me your number, cause I lost mine."
(Sure, I'll do that—it's 000-0000. Oh, too many zeroes? Must be like you.)

4. "Did it hurt when you fell out of heaven and into my life?"
(No, it just hurts to hear you speak and waste my valuable time.)

5. "Can I borrow a quarter? I told my mom I'd call her when I fell in love."
(This one will disappear as cell phones become ever more ubiquitous.)

6. "I have a magic watch. It says you're naked. (Response: 'I'm not naked.') Oh, must be an hour fast."
(Maybe so, honey, but that doesn't mean you'll be with me in an hour—or even in another minute.)

7. "If I could rewrite the alphabet, I'd put U and I together."
(Just put a P before the U and that'll give you my response.)

8. "My love for you is like diarrhea, I just can't hold it in."
(A load of crap is one thing, but being firm counts for something, doesn't it?)

9. "Hey, I don't have a library card, but do you mind if I check you out?"
(Go to the checkout counter and ask if they can give you a five for two tens if you're stupid enough to think this one will work.)

10. "How'd you get through security, because baby, you're a bombshell!"
(There are bombs that go "boom" and bombs that go "scram;" guess which one we have here.)

POISONS TO PICK

Most Common Causes of Poisoning

As if the parents of toddlers need any more reason to be hyper-vigilant at childproofing the house! In a September 1995 *Journal of Emergency Medicine* report on the 10 most common causes of poisoning, household cleaning products top the list. To keep those nightmarish trips to the emergency room to an absolute minimum, lock up anything toxic a small child might swig in the mistaken assumption that, for example, glass cleaner is blue juice. As the saying goes, an ounce of prevention is worth a pound of cure.

Here is the study's ranking of the 10 most common causes of poisoning. In descending order:

1. Household cleaning products
2. Analgesics
3. Cosmetics and personal-care products
4. Plants
5. Congestion/cold-relief products
6. Bites and venom
7. Creams and ointments
8. Pesticides
9. Foreign bodies
10. Food products/food poisoning

PRISONER LAWSUITS

Dumbest Legal Proceedings from the Slammer

Whatever happened to paying your debt to society? Apparently, the concept of "doing time for your crime" is lost on these litigious-minded inmates, who feel entitled to reparations for wrongs they suffered behind bars. Maybe it's just the inmates' creative juices flowing. If they can't con someone on the outside, they may as well create as much havoc as they can from inside.

From Harris Creative Group in 2001, here are 10 dumb (but true) lawsuits filed by prisoners, ranked in descending order of groundlessness. Makes you kind of wonder about the lawyers who accept these cases, doesn't it?

1. Inmate Kirk Livingood tried suing his cellmate for beating him.

2. An inmate sued for $8.5 million in damages after he smuggled

a gun into prison—and accidentally shot himself. How could officials have been so irresponsible?

3. A guard at Mohawk Correctional Facility near Syracuse, New York, was just asking for this million-dollar lawsuit. He refused to put an inmate's ice cream in the freezer and it melted.

4. Richard Loritz filed a lawsuit for $2,000 against the South Bay Detention Center in California for refusing to let him use dental floss.

5. A prisoner in Utah sued the state for $1 million for suspending a program providing hair transplants for inmates. He said it caused him emotional suffering.

6. A group of inmates got together on a lawsuit that claimed a limit on Kool-Aid refills was "cruel and unusual punishment."

7. Melvin Leroy Tyler filed a lawsuit for $129 million demanding that prisoners get salad bars and brunches on Sundays and holidays. Doesn't every rapist, robber, and kidnapper (he was all three) deserve that type of perk?

8. One prisoner sued for his constitutional right to use pink towels instead of the prison-supplied white ones. And no, it was not Martha Stewart.

9. Douglas Jackson is somewhat famous for his multiple lawsuits, including one because he was served cold food and another because he had to watch "junk TV" since he didn't have access to public television.

10. And finally, here's one that the inmate actually won. A prisoner in New York sued the prison, claiming he was locked in his cell for taking an extra piece of cake to his cell. He was awarded $200 in damage. That'll buy a lot of cake.

PRODUCT WARNINGS
The Most Idiotic Disclaimers

IQs must be spiraling downward at ever-increasing rates, if these actual product warning labels are any indication. On their Web site Dumblaws.com, Jeff Koon and Andy Powell have compiled a list of warning labels that are so breathtakingly stupid, you'd swear they were the work

of some marketing prankster. After reviewing the 25 dumbest product warning labels posted on the site—and picking our jaws off the floor—we selected the 10 dumbest of the bunch, which are listed below in descending order of sheer stupidity. But before you read on, we must issue a warning of our own: we're not responsible if you choose to ignore any of the sage advice offered below.

1. Trojan condoms: "Use for sex only—not to be eaten."

2. Windex: "Do not spray in eyes."

3. Marks and Spencer bread pudding: "Product will be hot after heating."

4. Dremel electric rotary tool: "This product is not intended for use as a dental drill."

5. Air conditioner [brand unknown]: "Avoid dropping air conditioner out of windows."

6. Ansell condoms: "Do not return used condoms to the manufacturer through the mail."

7. Toilet plunger [brand unknown]: "Do not use near power lines."

8. Wheelbarrow [brand unknown]: "Do not use when tem-

"Not to be eaten," warns Trojan, one of the largest manufacturers of condoms, making the caveat one of the most idiotic disclaimers found on packaging.

perature exceeds 140 degrees Fahrenheit."

9. Bowl Fresh: "Safe to use around pets and children, although it is not recommended that either be permitted to drink water from toilet."

10. Sainsbury Mineral Water: "Suitable for vegetarians."

PSYCHIC PREDICTIONS
The Nuttiest Crystal-Ball Visions (That Never Happened)

Of all the charlatans and con artists who passed themselves off as psychics with the gift of extraordinary foresight in the 20th century, the looniest by far was Criswell. An effete dandy who got his start as a television weatherman in the 1950s, Criswell parlayed this gig into a lucrative television spot as a psychic. Delivering his bizarre predictions in a breathless, borderline hysterical tone of voice, Criswell milked his 15 minutes of fame into a film career—that is, if you consider narrating the grade-Z camp classic *Plan 9 from Outer Space* to be a good career move.

Although Criswell faded from the limelight, he continued issuing his zany predictions of mysterious gases, zombies, and mass female pattern baldness, which he compiled in a 1968 book *Criswell Predicts: Your Future from Now to 2000!* Here are ten of his nuttiest predictions, listed chronologically by the year these events were supposed to happen:

1. 1973: Mississippi becomes an all-black state and secedes from the country.

2. 1979: Scientists will turn incorrigible juvenile delinquents into meek, law-abiding conformists through a "ray treatment."

3. 1980: A gas release from a mysterious chamber turns thousands of men in Pittsburgh into cannibals.

4. 1981: Contraceptives will be dissolved in the water supply, taking the place of all other forms of birth control.

5. 1982: The rogue planet Bullarion zooms past Earth, causing all sorts of mass destruction and last but not least, the rise of Atlantis.

6. 1983: *Another* gas release, this time in St. Louis, creates widespread female pattern baldness, which in turn sends divorce rates through the roof.

7. 1988: An "aphrodisiacal" fragrance prompts men to expose themselves in public.

8. 1988: The bad news: London gets clobbered by a huge meteor. The good news: a public park built around the crater becomes a popular tourist attraction.

9. 1995: Life is pretty darn close to idyllic on Earth, since

mankind finally wised up and eliminated pajamas, fossil fuels, disease, crime, and nudity taboos.

10. 1999: The party's over! A mysterious space force sucks up all the oxygen on Earth. Fortunately, mankind has established 200 space colonies, so life will go on—just not on Earth, which has also lost its gravity and floated off into the dark void.

RAILROAD WRECKS
Worst Train Accidents of All Time

When the Little Engine That Could said, "I think I can, I think I can," the locomotive hero of the popular children's book wasn't just blowing smoke. In fact, train travel has long been one of the most efficient and safest means of transportation. Prior to 1900, trains rarely ran at night and collisions were infrequent. Since that time, however, there have been several catastrophic railroad accidents, with hundreds of fatalities.

Here is a list of the worst railroad accidents of all time:

1. MODANE, FRANCE, DECEMBER 12, 1917
A train carrying soldiers derailed near the Mt. Cenis Tunnel, killing 550.

2. SALERNO, ITALY, MARCH 2, 1944
More than 520 people suffocated when a train stalled in a tunnel.

3. VIRILLA RIVER CANYON, COSTA RICA, MARCH 14, 1926
Over 300 were killed and hundreds more injured when a train derailed while crossing the Colima Bridge.

4. MONTGOMERY, WEST PAKISTAN, SEPTEMBER 29, 1957
An express train crashed into an oil train, leaving 300 dead.

5. AYYAT, EGYPT, FEBRUARY 20, 2002
This was Egypt's worst train disaster. A gas cylinder used for cooking exploded, killing 361 in the ensuing fire.

6. FIROZABAD, INDIA, AUGUST 20, 1995
A fast-moving passenger train rammed into another train that stalled after hitting a cow. More

than 300 people were killed and 400 injured.

7. MANSI, INDIA, JUNE 6, 1961
In an attempt to avoid a cow on the tracks, the engineer braked suddenly, sending the train off a bridge. At least 268 passengers were killed and another 300 were reported missing.

8. GRETNA, SCOTLAND, MAY 22, 1915
Two trains collided, killing 227.

9. SANGI VILLAGE, PAKISTAN, JANUARY 4, 1990
In Pakistan's worst train disaster, a passenger train rammed into a freight train, leaving 210 dead and another 700 injured.

10. SALTILLO, MEXICO, OCTOBER 6, 1972
A train that derailed caught fire and killed 204, while injuring more than 1,000.

RAIN STORMS
When It Rained, It Poured

There are lovely little soft spring rains that make you feel refreshed and peaceful; this is about their polar opposites, downpours that border on Biblical floods, far beyond the merely annoying rains that make for bad hair days.

Can you imagine a deluge that produced over an inch of rain in *one minute*? One such downpour was recorded in 1956 in Maryland. Another produced six feet (yes, *72 inches*) of rain in 24 hours in Foc-Foc, La Reunion in 1966; they are probably still wringing out their clothes.

Here are the worst downpours in history, ranked by the amount of precipitation that fell relative to the length of time it rained:

Duration	Location	Date	Precipitation (inches)
1. 1 minute	Unionville, Maryland	July 4, 1956	1.23
2. 20 minutes	Curtea-de-Arges, Romania	July 7, 1889	8.1
3. 42 minutes	Holt, Missouri	June 22, 1947	12
4. 12 hours	Grand Ilet, La Reunion	Jan. 26, 1980	46

Duration	Location	Date	Precipitation (inches)
5. 24 hours	Foc-Foc, La Reunion	Jan. 7–8, 1966	72
6. 24 hours (U.S.)	Alvin, Texas	July 25–26, 1979	43
7. 5 days	Commerson, La Reunion	Jan. 23–28, 1980	156
8. 1 month	Cherrapunji, India	July, 1861	366
9. 12 months (U.S.)	Puu Kukui, Maui, Hawaii	Dec. 1981– Dec. 1982	739
10. 12 months	Cherrapunji, India	Aug. 1860– Aug. 1861	1,042

RAZZIES
Celebrating Hollywood's Worsts

A welcome antidote to the pomp and circumstance of the Academy Awards, the Razzies honor the worst films of the year—the big-budget, ego-driven flops that regularly send audiences running for the exits or doubled over with laughter. The inspiration of writer and longtime film buff John Wilson, the Razzies began as a potluck in Wilson's Hollywood living room in 1980; that year, Wilson and a group of friends "honored" Neil Diamond and Brooke Shields for their dreadful performances in *The Jazz Singer* and *The Blue Lagoon*, respectively. Since then, Wilson's friendly gathering has become the Golden Raspberry Award Foundation, with over 500 voting members around the world. Traditionally held the day before the Academy Awards, the Razzies are now a bona-fide media event, covered by all the major newspapers and wire services.

Over the years, Wilson's Golden Raspberry Award Foundation has recognized everyone from Pia Zadora to Sir Laurence Olivier to the Spice Girls, who were collectively awarded the Worst Actress prize for *Spice World*. Such Hollywood turkeys as *Howard the Duck*, *The Wild Wild West*, and *Gigli* also took the prize, which is a gold spray-painted plastic raspberry atop a mangled Super-8 film reel (street value: $4.89, accord-

ing to the foundation's Web site). To date, only one honoree has actually shown up to collect his Razzie: comedian Tom Green, who took the award for the box office bomb *Freddy Got Fingered* (2000).

Here are some of the more notable Razzie recipients:

1. WORST ACTOR OF THE CENTURY
Sylvester Stallone, who has won 10 Razzies to date, more than any other performer!

2. WORST ACTRESS OF THE CENTURY
Madonna, for her body of work.

3. ALL-TIME WORST FILM
A tie: *Battlefield Earth* and *Showgirls* both won a record 7 Razzies each.

4. CAREER ACHIEVEMENT RAZZIES
1981: Ronald Reagan—as an actor; he was a good president.

1983: Irwin Allen—disaster movie maven behind such bad movie classics as *The Swarm* and *When Time Ran Out*.

1985: Linda Blair—possessed by poor taste in scripts, i.e., *Roller Boogie, Airport 1975*, and a host of grade-Z turkeys.

1987: Bruce The (obviously) Rubber Shark—after *Jaws*, it was all down hill for Bruce in the abysmal sequels *Jaws2, Jaws 3D*, and *Jaws 4: The Revenge*.

SEXUALLY TRANSMITTED DISEASES

Most Common Ailments (Hickeys and Love Bites Not Included)

"Worst sexually transmitted disease" is probably redundant. After all, what STD would be considered "good"? They're all pretty bad and regrettably quite prevalent. It's difficult to calculate the exact number of people affected by STDs, partly because of the stigma attached to the disease. Many people are embarrassed to see their doctor for these types of symptoms—if they even have symptoms. Unfortunately, many STDs are silent, with no noticeable symptoms at all. People may have an infection and pass it on, without knowing until the later stages of the disease. Less than half of adults between 18 and 44 have ever been tested for any STD other than AIDS.

No one thinks it could happen to them, but one in four Americans have genital herpes; more than 80% are unaware that they have it. This is the most common STD in the United States and it accounts for 25% of all sexually transmitted diseases in Europe. HIV and AIDS are of course concerns throughout the world. While there are currently 900,000 people living with the virus in the United States, South Africa tops the list with an astonishing 5 million people with the disease. India and Nigeria come in second with more than 3.5 million each. Those stats are probably not surprising considering the population of those nations. Botswana ranks first in terms of HIV/AIDS per capita, with more than one-fifth of the country's approximately 1.5 million citizens infected.

Overall, more than 65 million people in the United States are currently living with an incurable STD, with 15 million new cases cropping up annually. It's no surprise then, that STDs cost a whopping $8 billion to diagnose and treat each year—not even counting HIV and AIDS.

Here are some of the most common STDs in the United States, ranked by the American Social Health Association by the estimated number of new cases annually:

STD	New Cases Per Year
1. Chlamydia	4 million
2. Pubic lice (crabs) and scabies	3 million
3. Trichomonas	2 million
4. Gonorrhea	1 to 2 million
5. Genital warts (HPV)	1 million
6. Herpes	More than 500,000
7. Hepatitis	500,000 (includes all types)
8. Syphilis	40,000
9. HIV/AIDS	40,000
10. Chancroid	1,500

SHARKS
Ten Deadliest Species

One of the most heart-stopping sights in the world must be a dorsal fin slicing through the ocean waves toward you. Arguably the most feared

predator on the planet, the shark evokes equal parts dread and loathing in the heart of even the most committed landlubber. Although the actual number of recorded shark attacks each year around the world is statistically small, the headline-driven media treats each incident as proof positive that these misunderstood creatures have replaced us at the top of the food chain. The box office blockbuster *Jaws* only reinforced the baseless fear that great white sharks lurk off beaches in droves, picking off hapless swimmers like appetizers from a buffet table.

Growing upwards of 20 feet, the great white shark is undoubtedly public enemy no. 1 of the high seas. Most commonly found in temperate waters, the great white shark usually feeds on sea lions, seals, elephant seals, and dolphins. In the annals of recorded shark attacks dating from 1580 to the present, the great white tops the list with 377 attacks on humans—205 being fatal. According to the International Shark Attack File, here are the 10 shark species that have turned people into "chicken of the sea" for the past 400-odd years:

Shark Species	Recorded Attacks	Fatalities
1. Great white	377	205
2. Tiger	137	82
3. Bull	90	64
4. Requiem	51	33
5. Sand tiger	70	29
6. Blacktip	31	21
7. Hammerhead	38	17
8. Spinner	14	13
9. Blue	33	13
10. Blacktip reef	16	11

SHIPWRECKS
Most Fatalities in Modern Maritime History

Ninety-three years after it struck an iceberg and sank on its maiden voyage, the "unsinkable" *Titanic* continues to fascinate people around the world. Its enduring hold on the popular imagination grew even stronger with the phenomenal success of the 1997 film about the

doomed luxury liner. But while 1,500 of *Titanic*'s passengers and crew went down with the ship, the sinking of the Titanic ranks only fifth on the list of the 10 worst shipwrecks of the modern era:

1. *WILHELM GUSTLOFF*, JANUARY 30, 1945
More than 9,000 passengers were killed when a German cruise ship carrying refugees and soldiers was torpedoed by a Soviet submarine.

2. *DONA PAZ*, DECEMBER 20, 1987
A passenger ferry collided with an oil tanker near the Philippines, killing more than 4,000.

3. *JOOLA*, SEPTEMBER 26, 2002
An overloaded Senegalese ferry went down off the coast of Gambia, killing 1,863 people.

4. *SULTANA*, APRIL 27, 1865
A boiler explosion was responsible for the deaths of 1,547 Union soldiers on this Mississippi River steamboat after the Civil War.

When the Wilhelm Gustloff *was sunk by Soviet torpedoes in 1945, more than 9,000 died, making it the worst shipwreck in history with six times more fatalities than the* Titanic.

5. *TITANIC*, APRIL 15, 1912
The most famous shipwreck of all time, this "unsinkable" boat went down after hitting an iceberg, killing 1,500 passengers and crew.

6. *LUSITANIA*, MAY 7, 1915
This British luxury liner was sunk by a German submarine off the coast of Ireland, killing 1,195.

7. *EMPRESS OF IRELAND*, MAY 29, 1914
A collision on the St. Lawrence River left 1,024 dead.

8. *GENERAL SLOCAM*, JUNE 15, 1904
An estimated 1,021 people were killed when this excursion steamer burned in New York's East River.

9. *TOYA MARU*, SEPTEMBER 26, 1954
More than 1,000 people were killed when this commercial ferry sank in Tsugaru Strait, Japan.

10. *NEPTUNE*, FEBRUARY 17, 1993
A squall in Haiti caused a triple-decker ferry to capsize, drowning 1,000.

SIGNS OFF
The Most Nonsensical Notices Ever Posted

Remember that catchy song from the '70s one-hit wonder, The Five Man Electrical Band? "Sign, sign, everywhere a sign . . . do this don't do that, can't you read the sign." Okay, maybe the band only had a flair for the obvious. But at least their reasoning was sound, which is more than you can say for any of these utterly nonsensical signs, compiled by the Vancouver English Centre from around the world. Think twice before taking any of them literally. In order of increasing absurdity:

1. CAUTION: ROAD SLIPPERY FROM GRAPE JUICE.
Road sign on the island of Cyprus (translation of the Greek)

2. TAKE ONE OF OUR HORSE-DRIVEN CITY TOURS—WE GUARANTEE NO MISCARRIAGES.
Sign in a Czech tourist agency

3. SPECIAL TODAY—NO ICE CREAM.
Sign in a Swiss mountain inn

4. WE TAKE YOUR BAGS AND SEND THEM IN ALL DIRECTIONS.
Sign in a Copenhagen airline ticket office

5. NO JUMPING FROM THE LIFT. SURVIVORS WILL BE PROSECUTED.
Warning sign on a ski lift in Taos, New Mexico

6. IF THIS IS YOUR FIRST VISIT TO USSR, YOU ARE WELCOME TO IT.
Sign on the door of a Moscow hotel room

7. LADIES ARE REQUESTED NOT TO HAVE CHILDREN AT THE BAR.
Sign posted in a Norwegian cocktail lounge

8. PLEASE DO NOT FEED THE ANIMALS. IF YOU HAVE ANY SUITABLE FOOD, GIVE IT TO THE GUARD ON DUTY.
Sign in a Budapest zoo

9. SPECIALIST IN WOMEN AND OTHER DISEASES.
Sign in the office of a Roman doctor

10. THE MANAGER HAS PERSONALLY PASSED ALL THE WATER SERVED HERE.
Sign in an Acapulco hotel

SINS
You Might As Well Pick a Good One

What, only *seven* deadly sins? That's just a mere drop in the damnation bucket, or so say the 1,000 *People Magazine* readers, who rated 51 activities on morality basis for a 1986 poll. Their rankings are illuminating to say the least, as to what people consider sinful behavior and how they rank them on a scale of 1 to 10, 10 getting you a one-way ticket to hell. Of the top 20 vote-getters, "Parking in handicapped zone" just edged out "Killing to protect your property," with scores of 5.53 and 5.47, respectively. Neither of them made the top 10, which are listed here:

Sin	Score
1. Murder	9.84
2. Rape	9.77
3. Incest	9.68
4. Child ab*use*	9.59

Sin	Score
5. Spying against your country	8.98
6. Drug dealing	8.83
7. Embezzlement	8.49
8. Pederasty	8.30
9. Spouse swapping	8.09
10. Adultery	7.63

SONG TITLES
The Most Ridiculous Tune Names

Since he first took to the airwaves in 1970, kitsch connoisseur Dr. Demento has introduced listeners to tuneful little ditties like Tom Lehrer's "Poisoning Pigeons in the Park." He also gave top-40 parodist Weird Al Yankovic his big break, so you have a rough idea of his tastes. Some suggestions for the list of dumb song titles below were inspired by his picks, but he missed a few that are even more sordid and shameful.

Here, in alphabetical order, are the song titles that are the most moronic, nonsensical, tasteless, and forgettable (no, I guess we mean *un*forgettable):

1. "Dead Skunk in the Middle of the Road" by Loudon Wainwright III

2. "Don't Eat the Yellow Snow" by Frank Zappa

3. "Here We Sit Like Birds in the Wilderness" (folk song)

4. "I Like Bananas Because They Have No Bones" by the Hoosier Hot Shots

5. "It's So Hard to Say I Love You (When You're Sitting On My Face)" by Marty and the Muff Tones

6. "Jesus Loves Me (But He Can't Stand You)" by the Austin Lounge Lizards

7. "Why Don't We Get Drunk (and Screw)" by Jimmy Buffett

8. "Mama Get Your Hammer (There's a Fly on Baby's Head)" by the Bobby Peterson Quintet

9. "Santa Claus Has Got AIDS This Year" by Tiny Tim

10. "When There's Tears in the Eyes of a Potato" by the Hoosier Hot Shots

SONGS SUNG WRONG
The 25 Dumbest Ditties Ever Sung

You know when you get some insufferably catchy song stuck in your head? The type of witless and profoundly annoying hit single that you find yourself humming relentlessly, to the point that only a lobotomy will put an end to this musical madness? The powers-that-be/pop culture arbiters at VH1 know your pain intimately and have identified the most egregious offenders. But be forewarned: reading the following list of 25 titles may trigger snatches of lyrics or melody that you thought you'd banished to the farthest corners of your mind.

From the most criminally awful to the merely irritating, here are the songs that VH1 enshrined in their Hall of Shame:

1. Starship, "We Built This City"
2. Billy Ray Cyrus, "Achy Breaky Heart"
3. Wang Chung, "Everybody Have Fun Tonight"
4. Limp Bizkit, "Rollin'"
5. Vanilla Ice, "Ice Ice Baby"
6. Deep Blue Something, "Breakfast at Tiffany's"
7. Eddie Murphy, "Party All The Time"
8. Ricky Martin, "She Bangs"
9. Bobby McFerrin, "Don't Worry, Be Happy"
10. Huey Lewis & the News, "Heart of Rock and Roll"

Rather than having a Grammy Award, singer Vanilla Ice has something more within his reach, which is appropriate for someone foolish enough to have sung "Ice Ice Baby," one of the 25 dumbest songs ever sung.

11. Gerardo, "Rico Suave"
12. New Kids on the Block, "Hangin' Tough"
13. Aqua, "Barbie Girl"
14. Will Smith, "Will2K"
15. Crash Test Dummies, "Mmm, Mmm, Mmm, Mmm"
16. Europe, "The Final Countdown"
17. Right Said Fred, "I'm Too Sexy"
18. MC Hammer, "Pumps and a Bump"
19. Chicago, "You're the Inspiration"
20. Toby Keith, "Courtesy of the Red, White and Blue"
21. The Rembrandts, "I'll Be There For You"
22. Lionel Richie, "Dancing on the Ceiling"
23. Sisqo, "The Thong Song"
24. Phil Collins, "Sussudio"
25. Michael Jackson, "You Rock My World"

SPACE ACCIDENTS
Deadliest Tragedies on the Final Frontier

The race to go where no man has gone before began in the 1950s, when America and the Soviet Union both jump-started their space programs. Many years and botched attempts later, American astronaut Neil Armstrong took a historic step for mankind with his walk on the moon in 1969.

Since the early 1960s, man's quest to explore space has been a mixture of triumph and tragedy. Who can forget that awful moment on a chilly January morning in 1986 when the *Challenger* space shuttle exploded? Or the sudden fire on *Apollo 1* in 1967 that killed three astronauts, including Virgil "Gus" Grissom, whom Tom Wolfe immortalized in his classic best seller, *The Right Stuff*?

Accidents like these have been relatively few and far between, but each time one occurs, new fears and questions emerge. What went wrong? Whose fault was it? Are we doing enough to insure something like this will never happen again?

Here's a list of the worst space accidents of the last 50 years, in chronological order. Bet you remember where you were when some of these occurred.

1. JANUARY 27, 1967, *APOLLO 1*
In the first real tragedy of the U.S. space program, a fire ignited before launch aboard the *Apollo 1* space capsule at Cape Kennedy, Florida, killing 3 American astronauts.

2. APRIL 23–24, 1967, *SOYUZ 1*
One cosmonaut was killed when his parachute lines released for reentry and became tangled at 23,000 feet, causing the spacecraft to crash.

3. JUNE 6–30, 1971, *SOYUZ 11*
After more than 3 weeks in space, 3 cosmonauts were found dead when their spacecraft landed. The cause is thought to be a loss of pressurization in the craft during reentry.

4. MARCH 18, 1980, USSR
Fifty people were killed at the Plesetsk Space Center in the USSR when a Vostok rocket exploded on the launch pad while being refueled.

5. JANUARY 26, 1986, *CHALLENGER* SPACE SHUTTLE
The country was in shock when this shuttle exploded 73 seconds after takeoff, killing all 7 crew members. Investigators later discovered that a booster leak ignited the fuel and caused the explosion.

6. FEBRUARY 1, 2003, *COLUMBIA* SPACE SHUTTLE
Not as dramatic as the *Challenger* accident, but every bit as deadly, the *Columbia* shuttle broke up as it reentered the earth's atmosphere. All 7 crew members were killed. Unbeknownst to both the ground crew and those aboard, foam insulation fell from the shuttle during the launch. On reentry, hot gases entered the wing, destroying the spacecraft.

SPORTS FLICKS
Worst Sports Movies in Cinematic History

Even the most macho sports nut gets a little teary-eyed watching Kevin Costner play catch with his late dad in the baseball fantasy *Field of Dreams* (1989). Over the years, America's favorite pastime has inspired some classic films, like *Pride of the Yankees* (1942) and *Bull Durham* (1988). Unfortunately, baseball has also figured prominently in some real Hollywood turkeys, like the laughably bad thriller *The Fan* (1996), which the editors of ESPN.com's Page 2 named *the* worst sports film

of all time. Here are their 10 picks for the absolute nadir of sports films:

1. *THE FAN* (1996)
Robert De Niro chews the scenery as a deranged fan stalking baseball star Wesley Snipes. Unbelievable and unintentionally hilarious.

2. *ANY GIVEN SUNDAY* (1999)
If you buy Al Pacino as a pro football coach, then have we got some real estate in Love Canal to sell you!

3. *ROCKY V* (1990)
Time to hang up the gloves, Rocky.

4. *CADDYSHACK II* (1988)
Bill Murray and Rodney Dangerfield wisely bowed out of appearing in this exceedingly lame sequel to the 1980 hit.

5. *ROLLERBALL* (2001)
This remake of the 1975 futuristic sports drama deservedly came and went very quickly.

6. *THE BAD NEWS BEARS GO TO JAPAN* (1978)
A desperate-looking Tony Curtis took over coaching duties from Walter Matthau for this dismal sequel to 1975's *The Bad News Bears*.

7. *THE BABE* (1992)
Glossy, unconvincing Babe Ruth bio drama, with John Goodman miscast as the legendary home run king.

8. *AMAZING GRACE AND CHUCK* (1987)
Odd, antiwar film in which star athletes go on strike to protest the nuclear arms race. Huh?

9. *THE MAIN EVENT* (1979)
Ryan O'Neal plays a down-on-his-luck boxer managed by Barbra Streisand in this shrill romantic comedy.

10. *THE SLUGGER'S WIFE* (1985)
One of Neil Simon's weakest efforts, with Michael O'Keefe as a pro baseball player romancing Rebecca De Mornay.

SPORTS INJURIES
Most Common Causes of Maladies for Middle-Aged Jocks

The Consumer Product Safety Commission took a look at the injuries of patients 35–55 years old who were treated in the emergency room in 2003. The following sports, ranked in order, caused the most injuries among baby boomers. But don't stop playing now—the couch potatoes will join us in the emergency room in no time. And they'll be the ones with a heart attack.

1. Bicycling
2. Basketball
3. Baseball or softball
4. Exercise and running
5. Skiing
6. Weight lifting
7. Football
8. Golf
9. In-line skating
10. Soccer

STARVATION WAGES
The Lowest-Paying Jobs

If being a blackjack dealer sounds like a fun job to you, you'd better hope to win a bundle at the slot machines in your off hours. The Bureau of Labor Statistics puts that job 2nd on its list of lowest-paying jobs.

And being a cashier must be a bit like undergoing Chinese water torture. Cashiers handle money all day long, but take home less than $13,000 per year.

Here are the 10 worst-paying jobs in America, according to a 2000 Bureau of Labor Statistics list:

Job	Pay
1. Cashier	$12,980
2. Casino dealer	$13,330
3. Waiter	$13,350
4. Fast-food server	$13,550
5. Cafeteria worker	$13,580
6. Fast-food cook	$13,590
7. Vet assistant	$14,560
Teacher assistant	$14,560
Nurses' aide	$14,560
Shipping and receiving clerk	$14,560

SUPER BOWL SNOOZE
Most Uninspired Games in Super Bowl History

With the possible exception of the Olympics, is there any sporting event as universally anticipated as the Super Bowl? It's the cherry on top of the regular pro football season, watched by upwards of 140 million people. No other occasion besides graduation inspires so many parties—or armchair quarterbacks.

Sure, it helps that the Super Bowl is also the platform for advertising's biggest commercial rollout of the year. But some viewers want more from the game itself. Fans want more strategy. More touchdowns. A few breakaway runs or maybe a Hail Mary or two. Is that too much to ask from the NFL? According to the gridiron pundits at ESPN, the NFL teams failed to make the grade at the following Super Bowls, which rank as the biggest flops in the game's 38-year history:

1. SUPER BOWL V: COLTS 16, COWBOYS 13
ESPN Grade: F

Sure, this game meets the "close game" criteria, but that's about all. You'd never guess these were the season's two best teams on the field. They combined for a total of 10 turnovers. Colts defensive end Bubba Smith even refused to wear his championship ring on the grounds that the game was just too ugly.

2. SUPER BOWL IX: STEELERS 16, VIKINGS 6
ESPN Grade: F

The Vikings were less than inspired, chalking up just 119 total yards, with only 17 yards on the ground. And the winners? The Steelers weren't really much better. At halftime, the score was a pitiful 2–0 in their favor.

3. SUPER BOWL XXIV: 49ERS 55, BRONCOS 10
ESPN Grade: F

Check out the score. Enough said?

4. SUPER BOWL XXVII: COWBOYS 52, BILLS 17
ESPN Grade: F

The Cowboys were on a roll, but the Bills' Don Beebe made one great play to keep the score within 35. Cowboy Leon Lett wasn't protecting the ball when Beebe chased him down and knocked it away to prevent another touchdown.

5. SUPER BOWL XX: BEARS 46, PATRIOTS 10
ESPN Grade: F+

No score for standout Walter Payton, but plenty of other Bears got on the scoreboard—including Refrigerator Perry. The Patriots couldn't get anything going.

6. SUPER BOWL XXIX: 49ERS 49, CHARGERS 26
ESPN Grade: F+

Everyone likes to root for the underdog, and in this case the Chargers were expected to lose by 18. Unfortunately, they were down by 14 in the first 5 minutes, leaving fans with nothing to cheer about. The plus on this grade is for Steve Young's 6 touchdown passes.

7. SUPER BOWL VIII: DOLPHINS 24, VIKINGS 7
ESPN Grade: D–

A lack of action is what earned this game such a low score. The Dolphins were ahead 24–0 by the third quarter and the Vikings threw only 7 passes in the entire game.

8. SUPER BOWL XXXV: RAVENS 34, GIANTS 7
ESPN Grade: D

The score doesn't tell the whole story. Two lackluster offenses kept the score low until the 3rd quarter, when the teams traded touchdowns on an interception and two kickoff returns.

9. SUPER BOWL XVIII: RAIDERS 38, REDSKINS 9
ESPN Grade: D+

Poor action all around until Marcus Allen made a ballet-inspired turn and ran 74 yards for a touchdown.

SURGICAL MISTAKES
The Most Botched Operations

If you were having knee surgery tomorrow, would you write "Not this leg" on the good knee? Maybe you should. In fact, even hospitals nowadays are advising patients to do all they can to minimize surgical errors.

Editors may miss a typo and it's a little embarrassing. Accountants might add some figures incorrectly and their clients may threaten to take their business elsewhere. But when mistakes occur in a hospital, it can literally be a matter of life and death.

The Australian government says that medical errors are responsible for 11% of all deaths in Australia. A British journal finds that 1 in 10—or 70,000—patients are harmed in the hospital each year. And about 185,000 Canadian patients are harmed while hospitalized, with more than 9,000 dying as a result of surgical errors or medical oversight. A U.S. government report states that hospital errors are the eighth leading cause of death. Obviously medical errors are widespread.

Here is a ranking of the worst surgical mistakes that have made the news. In descending order:

1. JUST A SIMPLE SURGERY

A routine surgery for a 7-year-old boy with a history of ear problems resulted in tragedy when Ben Kolb underwent one last operation for a benign growth in his ear. Two clear liquid medications were mixed up, so Ben received a stimulant rather than a local anesthetic. Both his heart rate and blood pressure skyrocketed and he lapsed into a coma. Although he was rushed to another hospital, Ben never regained consciousness and was pronounced dead the following day.

2. DRUGS CAN BE A HEALTH HAZARD, TOO

Health writer and 39-year-old mother of two, Betsy Lehman died shortly before she was about to be discharged following her third round of chemotherapy. Her heart simply gave out. A routine check of her charts months later revealed that she had been pre-scribed a toxic dose of her chemo medication—4 times the appropriate amount for 4 straight days.

3. HOW FAST IS FAST?

A new doctor, who ordered an MRI "stat," discovered that there is a discrepancy between what he meant by that and how the radiology department interpreted his order. His patient Joe Deocampo was left a paraplegic after 8 hours passed between the time he was given a blood thinner for a mild heart attack and the MRI was perfomed. In that time, the drug caused bleeding in his spine that ultimately left him paralyzed.

4. SLIDE MIX-UP

Linda McDougal was recovering from a double mastectomy when her doctor walked in with a confession. There had been an accidental switch of a couple of slides in the lab. It was actually another patient who turned out to have

cancer. Linda did not have it and never had.

5. THE GOOD NEWS—NO CANCER

Frank Barerra received good news while at the hospital: his slides showed no cancer. The bad news: he was already in the middle of a surgery to have his prostate removed.

6. BUT THE CANCER'S GONE

When 67-year-old Hurshell Ralls checked into the hospital with bladder cancer, he hoped doctors would be able to get all the cancer during surgery. They did. But he also emerged without his penis or testicles (neither of which were found to have even a trace of cancer cells).

7. NO LEG TO STAND ON

Diabetic and suffering from gangrene in one leg, Willie King entered the hospital to have it amputated. Mr. King woke up to find the wrong leg had been removed.

8. LOST AND FOUND

Joyce Foster had a successful hysterectomy in 2001 but began to have abdominal pain a couple of months later. X-rays revealed a mass that doctors thought might be cancerous. But when they cut her open, they discovered a 3-inch by 2-foot surgical sponge left behind from her previous surgery. She was not amused.

9. NO PAIN, NO GAIN

If a mistake doesn't hurt, is it still a mistake? Jeffery Baber, who underwent surgery for multiple gunshot wounds, emerged presumably healed. He later had an X-ray for a separate problem with his leg, and the film showed a 5-inch clamp that was left from the previous surgery. He was in no pain, but had to undergo another operation for the sole purpose of removing the clamp.

10. THE LOOK AND FEEL OF COTTON

A towel may come in handy to soak up blood and other moisture during surgery, but it's probably safe to say William Barlow didn't need it after his surgery for an aortic aneurism was complete. The 16 × 28-inch surgical towel was indeed left in his abdomen, but doctors waited 3 months to break the news.

TELEVISION SHOWS
The Most Moronic TV Programs

Essayist, social critic, and all-around misanthrope H. L. Mencken reportedly quipped that "no one ever went broke underestimating the intelligence of the American public." Case in point: *The Jerry Springer Show,* the long-running syndicated talk show catering to the very lowest common denominator. Each day, a sad parade of trailer trash desperate for their 15 minutes of fame air their extremely dirty laundry on Springer's show to cheers from the studio audience. On air since 1991, the show is so phenomenally popular that it's now seen in over 30 countries and has inspired an opera!

Of course, not everyone is so enamored of Springer's daily freak show. In 2002 the editors of the venerable *TV Guide* selected *The Jerry Springer Show* the all-time worst television series. Pulling no punches, *TV Guide*'s editor-in-chief Steven Reddicliffe summed up the public's enduring fascination for Springer: "Awful television shows are a storied part of our society. Some of them actually are very successful and are great guilty pleasures. And no one has turned guilty-pleasure TV into more of an art form than Jerry Springer."

Here are the 10 series that *TV Guide* selected as the all-time worst. Running the gamut from sitcoms to sports, these series prove why television is often called the idiot box. In descending order:

1. *THE JERRY SPRINGER SHOW,* SYNDICATED (1991–PRESENT)

Of all the talk shows littering the airwaves (and we do mean littering), Springer's daily dip into America's lunatic fringe is hands-down the trashiest. You'll want to shower after watching Springer bait his guests into making pathetic spectacles of themselves.

2. *MY MOTHER THE CAR,* NBC (1965–66)

This numbskull series has ac-quired near-legendary status for its sheer awfulness. Jerry Van Dyke and Ann Southern got stuck behind the wheel of this wreck of a sitcom about a man whose late mother has been reincarnated as—you guessed it.

3. *XFL,* NBC, UPN, AND TNN (2001)

The brainchild of World Wrestling Federation chairman Vince McMahon, the alternative football league premiered with a flurry of

hype and died after a season. Packaged like a glitzy Vegas spectacle and rife with moronic double entendres from screaming football "analysts" like pro wrestler/Minnesota governer Jesse Ventura, the *XFL* became an expensive punchline for Jay Leno and other comics.

4. *THE BRADY BUNCH HOUR*, ABC (1977)

Just when America thought it was finally rid of the irritating Brady clan, ABC brings them back for a tacky variety series so bad that actress Eve Plumb refused to participate. A look-alike was hired to fill Plumb's role as the whiny middle daughter Jan, but this amateurish variety show mercifully perished after a single tone-deaf season.

Poster boy for trash TV, Jerry Springer proves why television is often called the idiot box. The Jerry Springer Show *tops the list of the most moronic television series.*

5. *HOGAN'S HEROES*, CBS (1965–71)

Although fans of the long-running series balked at its inclusion on *TV Guide*'s list, *Hogan's Heroes* was critically savaged during its run for making light of the Nazi prisoner-of-war camps.

6. *CELEBRITY BOXING*, FOX (2002)

Watching showbiz has-beens and never-weres pummel each other in the boxing ring may be the sleazy nadir of Fox's reality television series.

7. *AFTER MASH*, CBS (1983–84)

"Aftermath" would be a better title for this witless and ill-conceived sequel to the classic series starring Alan Alda as Hawkeye.

8. *COP ROCK*, ABC (1990)

Even the greats like *Hill Street Blues* writer/producer Steven

Bochco sometime strike out. Case in point: this hour-long musical comedy featuring singing and dancing cops!

9. *YOU'RE IN THE PICTURE*, CBS (1961)

This live game show was such a disaster in its initial airing, the show's red-faced host Jackie Glea- son apologized to viewers the following week. It was canceled after 8 weeks.

10. *HEE HAW HONEYS*, SYNDICATED (1978–79)

Before she tangled with Regis Philbin, Kathie Lee Gifford embarrassed herself in this moronic spin-off of *Hee Haw* set in a truck stop.

THEME PARK IRRITANTS
What's Guaranteed to Goad

The roller coasters, the music, the bright lights of America's popular theme parks—they offer the perfect package for family fun. Or do they? Could there be a dark side to some of the happiest places on earth?

If your heart is closer to that of a grinch than a teddy bear, you may choose to focus on long lines and overpriced, rinky-dink souvenirs. According to Arthur Levine, a self-described "theme park-aholic," these are the things that can turn a day in the park into an endurance test for even the most fun-loving families. In alphabetical order (since they're all equally irritating):

1. CROWD CONTROL

In Theme Park 101, it should be taught that only so many people are allowed into the park at a given time to prevent over-crowding.

2. DRINKS

You can't bring in your own, so you're forced to pay dearly for even a bottle of water.

3. DUELING DISCOUNTS

You're paying full price, while the obnoxious family ahead of you got a discount coupon you never received.

4. FOOD

Refreshments are generally over-priced and bland—it's tough to pay 6 dollars for a slice of cardboard pizza made with imitation cheese.

5. FRONT-GATE SLOWDOWNS

The writhing mass of humanity waiting impatiently to enter is being funneled through two gates, with ticket-takers who look like they're competing to see who can be the slowest.

6. LAZY RIDE OPERATORS

They actually let rides leave the station with empty seats, even with lines waiting.

7. LINE CUTTING

Even Buddhists would be driven to violence when people cut in line before them.

8. PARKING FEES

Get ready to pay big bucks for parking before you max out your credit card on admission.

9. WATER TUBE UP-CHARGES

Come on, rental fees for floating tubes *after* you've paid to get in?

10. WEATHER

Perhaps someday they will be able to control it, but there's nothing more pathetic than riding a large motorized fiberglass animal in pouring rain.

TRANSLATION MOST TANGLED
The Most Confusing English Translations

Traveling abroad is both exciting and slightly unnerving, particularly if you're not fluent in another language. There's only so much you can convey by smiling and nodding. When that fails, many tourists foolishly resort to speaking LOUDER, as if cranking up the volume will miraculously bridge the language gap.

In the spirit of welcoming tourists and their money, many countries try to help English-speaking tourists by posting signs to make their travel as easy as possible. Sometimes, though, the signs read as though someone wrote them with a dictionary in one hand and a pen in the other, rather than being written by someone who truly knows the language.

The following signs were compiled by the Vancouver English Centre. You might need a translator to figure out what they were trying to say. In alphabetical order:

1. Because of a fallibility in our phone system, for room service step outside your door and shout "ROOM Service?" (sign in Turkey)

2. Because of the impropriety of entertaining guests of the opposite sex in the bedroom, it is suggested that the lobby be used for this purpose. (in a Swiss hotel)

3. Coolers and Heaters: If you want just condition of warm air in your room, please control yourself. (from a Japanese information booklet about using a hotel air conditioner)

4. English well talking. Here speeching American. (two signs from a shop in Majorca)

5. Is forbidden to steal hotel towels please. If you are not a person to do such thing is please not to read notis. (sign in a Tokyo Hotel)

6. Our nylons cost more than common, but you'll find they are best in the long run. (in a Tokyo shop)

7. This lift is being fixed for the next day. During that time we regret that you will be unbearable. (from a hotel in Belgrade)

8. To move the cabin, push button for wishing floor. If the cabin should enter more persons, each one should press a number of wishing floor. Driving is then going alphabetically by national order. (in a Belgrade hotel elevator)

9. Visitors are expected to complain at the office between the hours of 9 am and 11 am. (sign in an Athens hotel)

10. When passenger of foot heave in sight, tootle the horn. Trumpet himmelodiously at first, but if he still obstacles your passage then tootle him with vigor. (from a brochure of a car rental firm in Tokyo)

TRAVEL MALADIES
Most Common Travelers' Illnesses

It's every world traveler's nightmare: you've scrimped and saved to take that dream vacation to some exotic getaway, only to spend most of it in

your hotel room bathroom, in the painful throes of diarrhea. According to the Centers for Disease Control, 20% to 40% of all travelers report being stricken with diarrhea while on vacation. This debilitating and humiliating illness can be avoided by following this simple rule: "Don't drink the (tap) water." If you also avoid raw fruits and vegetables, uncooked meats, and dairy products, you should be free to see the sights without a flask of Pepto-Bismol at your side.

In a 2003 *Forbes* article, writer Christina Valhouli provided an alphabetical list of the 10 most common travel diseases, according to the CDC. If you're planning a trip abroad to any of the regions listed below, get the proper immunizations before you leave.

Disease	Region
1. Cholera	Africa, Asia (specifically Indonesia), and Eastern Europe
2. Diarrhea	Worldwide
3. Hepatitis A	Africa, India, Latin America (specifically Mexico)
4. Hepatitis B	Africa, India, Middle East, Pacific Islands, and Southeast Asia
5. Japanese encephalitis	Agricultural regions of Asia
6. Malaria	Sub-Saharan Africa, Central/South America, India, Middle East, and Oceania
7. Meningitis	Sub-Saharan Africa and Saudi Arabia
8. Tetanus	Worldwide
9. Typhoid fever	Africa, Asia, Central/South America, and the Indian subcontinent
10. Yellow fever	Sub-Saharan Africa, tropical South America

TRAVEL TROUBLE

The Most Dreaded Snafus While En Route

In Neil Simon's classic comedy *The Out-of-Towners*, a suburban couple's dream vacation quickly turns into the trip from hell. Murphy's Law rules the day for the hapless couple, whose comic nightmare never fails to get a laugh.

Of course, it's not so funny when it happens to you—lost luggage, delayed or canceled flights, Montezuma's Revenge—especially if you've scrimped and saved to take what was supposed to be an idyllic vacation, far from the daily pressures of the 9-to-5 grind.

The American Society of Travel Agents, along with Fodor's, Travelocity, and the U.S. Customs Service, came up with 10 travel snags guaranteed to wreak havoc for travelers the world over. The 2004 rankings below are based on worst-case scenarios. *Bon voyage*. In no particular order:

1. Delayed or canceled flight
2. Overbooked flight
3. Getting sick
4. Lost or stolen money
5. Lost or damaged luggage
6. Passport or customs complication

7. Bad weather
8. Overbooked hotel
9. Language barriers
10. Car rental cancellations

TRUCKS, SUVS, AND VANS
Worst Gas Mileage

Despite gas prices hitting unprecedented highs, drivers haven't lost their infatuation with trucks, SUVs, and vans, which get bigger and more plush with every passing year. Although environmentalists and road-safety advocates rail against these "road hogs" with reliable stridency, they keep rolling off the assembly line.

But before you take that SUV or van out for a test spin, you might want to review the findings in the latest Fuel Economy Guide from the U.S. Department of Energy and Environmental Protection Agency. According to their annual study, these are the least fuel-efficient trucks, SUVs, and vans:

Size	Model	Mileage City/Hwy
1. Pickup truck	Ford F150 Pickup	12/16
2. SUV	Land Rover Discovery Series II	12/16
3. SUV	Land Rover Range Rover	12/16

Size	Model	Mileage City/Hwy
4. Minivan	Kia Sedona	16/22
5. Passenger van	Ford E150 Club Wagon	13/17
6. Cargo van	Chevrolet Astro	14/17
7. Cargo van	Ford E150 Econoline	14/17
8. Cargo van	GMC Safari	14/17